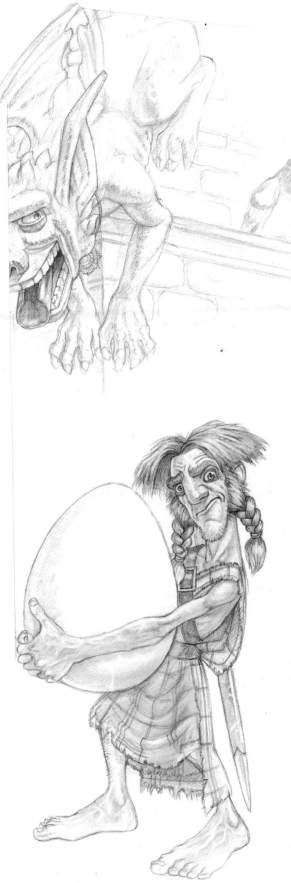

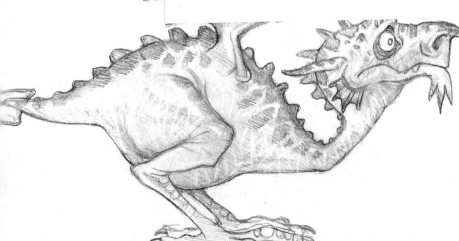

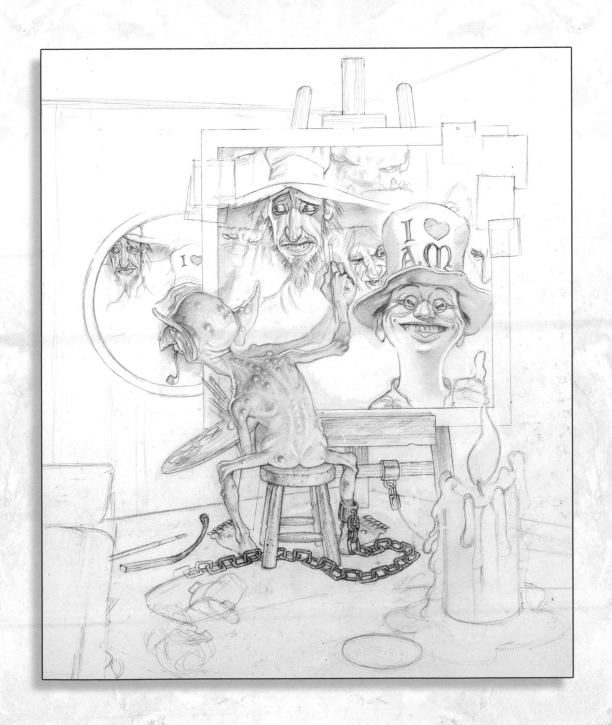

Also by Terry Pratchett

TERRY PRATCHETT

The Art of DISCWORLD

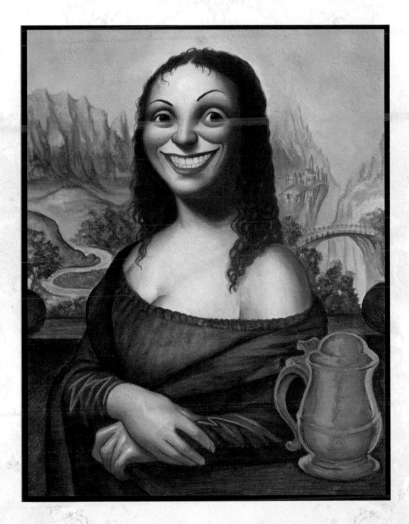

Illustrated by PAUL KIDBY

GOLLANCZ

LONDON

Copyright © Terry and Lyn Pratchett and Paul Kidby
Illustrations © Paul Kidby

Discworld ® is a trademark registered by Terry Pratchett

The right of Terry Pratchett to be identified as the author of this work
and Paul Kidby to be identified as the illustrator of this work has been
asserted by them in accordance with the
Copyright, Designs and Patents Act 1988.

Layout, design and computer manipulation by Rob Wilkins

First published in Great Britain in 2004 by
Victor Gollancz Ltd
A subsidiary of the Orion Publishing Group
Orion House, 5 Upper St Martin's Lane, London WC2H 9EA

A CIP catalogue record for this book is available
from the British Library

ISBN 0 575 07511 2

Printed and bound in Italy

www.paulkidby.com
www.turtlesalltheway.com
www.orionbooks.co.uk

For Sandra

The publishers would like to thank particularly
Rob Wilkins and Sandra Kidby, without whom this
book would not have happened.

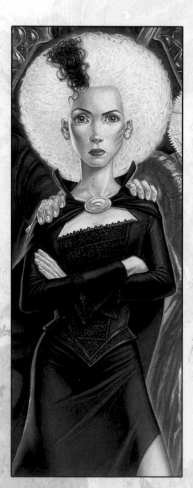

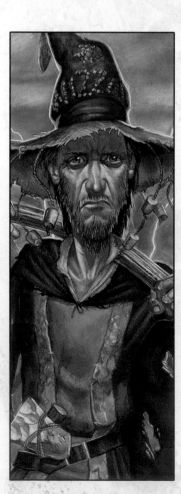
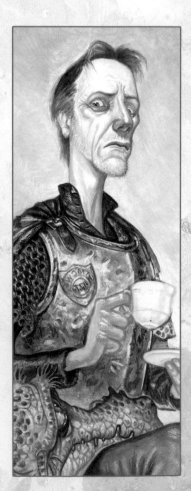

DISCWORLD INTRODUCTION – TERRY

Discworld is this fantasy world, yeah, yeah, which goes through space on the back of a giant turtle, etc, etc. You know this already, which is why you bought the book, unless you picked it up in mistake for *Help, I'm Not A Celebrity: Get Me An Agent.*

Sometimes I wish I'd left out the bit about the giant turtle. It's a respectable world myth, but it might lead some prospective readers to think it is, well, not serious.

In truth, the turtle doesn't have anything to do with most of the stories except, as it were, to carry the plot. I used it to signal that this *is* a fantasy world, with all the unusual suspects: wizards, witches, gods and heroes. The twist is that it is taken seriously; not taken seriously as a fantasy, but taken seriously as a world.

In this I owe a debt to G. K. Chesterton, who pointed out on many occasions that the fantastic, when looked at properly, is much less interesting (and a lot less fantastic) than the everyday.

Take magical lights, for example. A wizard snaps his fingers and light appears. Where's the fun in that? He's only doing what wizards do. But a bunch of apes *weren't* doing what apes do when they learned, over half a million years, how to take the universe apart and put it together again so that a bit of it was now the electric light bulb.

So Discworld works, more or less. People plough fields, file things, make candles, deliver letters and babies, produce newspapers, perform daily the thousand minor miracles that keep a city fed. Magic has pretty much the same status as nuclear power: under control it is useful, perhaps even essential, but too much reliance on it comes with a disproportionally high price tag, and only a loony would use it to catch fish . . .

Discworld now consists of some thirty-plus books, along with maps, diaries, the obligatory cookbook, *The Discworld Companion* . . . even quiz books and play texts. At any one time there are maybe twenty plays in planning or production by amateur dramatic groups

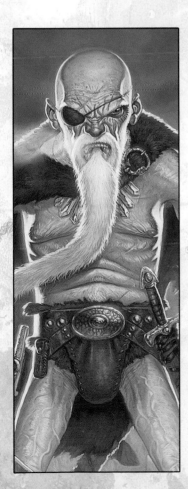 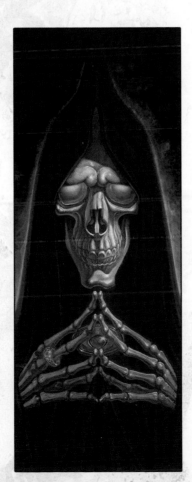

around the world. It's surely only a matter of time before someone wants to do Discworld wallpaper – quite a long time, I hope. All in all, it's pretty busy, in a cottage industry kind of way.

But there is no big-screen movie. We've come quite close a few times, and very close once, but as one of those involved said ruefully: 'By the time you've worked your way up through the underlings, there's a new boss in charge (actually he said 'By the time you've dealt with all the Treens they've changed the Mekon', but I've translated for children and foreigners . . .). *Mort* ended up *morte*, possibly to rise again one day.

But to me, Discworld has always been a movie. I've seen the characters on the inside of my eyelids, I've heard them speak. I've even tried a few movies tricks in the way the text is constructed, although I didn't realise that's what they were at the time.

And I'm always very interested in how various artists have represented the characters. They're pictures in *my* head, after all.

For many years the man who painted Discworld was the late Josh Kirby, who, until his death in 2001, had done the cover illustrations for all the Discworld novels.

Josh was out to paint pictures and was very *polite* about my tentative suggestions, and even followed them on occasion (and once even painted himself onto a book. If the wizard on the back of the UK paperback edition of *Equal Rites* is not Josh, then . . . well he *is* Josh, that's all there is to it). But Josh knew what he was doing, which was producing a cover, and while he didn't want to get a *fact* wrong (a dress a different colour from the description in the book) he quietly guarded his right to see things *his* way.

Paul sees thing my way about seventy-five per cent of the time, which suggests either mind-reading is happening or that my vision of my characters is really rather vague until I see his drawings. And he remembers the history of the characters in a way that's almost frightening, so that a simple illustration will contain little details mentioned in half a dozen books.

So, since there's no movie and the day when you can buy a Nanny Ogg toilet roll cover is still some way off, here is a visual Discworld to be going on with, without all the bother of having to park your car and fight your way to *Screen W* and keep the popcorn off your jacket . . .

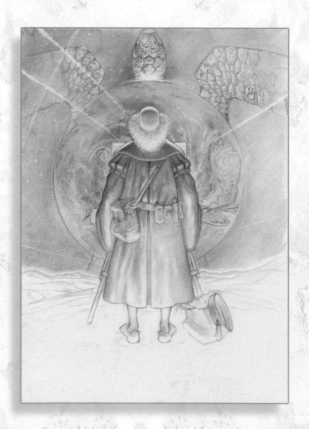

DISCWORLD INTRODUCTION – PAUL

It has been more than ten years since I first discovered Discworld, when my sister sent me The Colour of Magic for my birthday. Until then I had been working freelance in advertising and product design; the work wasn't exactly creative and I was at a low ebb. Discworld gave me the inspiration I craved.

The characters were so fully realised in Terry's writing that I felt drawing them was merely translating word to line. Terry's creation is underpinned by a logic that makes it believable; I strive to achieve a realism that complements the text. And painting such a huge variety of subjects is great fun.

It's always rewarding when people say my character designs remind them of someone, but the best compliment is always when someone says my drawings look like how they imagine the character themselves.

I grew up in West London, but was fortunate enough to spend holidays in Scotland and Wales. City living was claustrophobic, so I left London behind in 1988. I'm now based in rural Wiltshire. The surrounding countryside is hugely inspirational and has crept into many paintings and drawings, especially The Wee Free Men and A Hat Full of Sky.

When I'm out and about, I am always taking visual notes and observing people's faces and characteristics, constantly wondering which of the Discworld cast these attributes will fit.

I'm notoriously slow, but meticulous in trying to get the picture right. I want to capture a historical feel more than anything, which is why the colours I use are often subdued – a contentious issue in an industry where colours are expected to be bold, bright and eye-catching. I work with paper, pencil, paint and board, working in oils or acrylic; in today's multi-media world full of digital imagery I'm probably considered a dinosaur – but to me, nothing compares to the satisfaction of holding the finished article. Creating something with nothing more than a brush, pigment and time will always be my first love.

Within these pages is the work-in-progress for many of my colour paintings; I will spend as much time as possible on the pencil sketch, and many of these are published here for the first time. The next stage is the under-painting, before I finally put in contrast and colour.

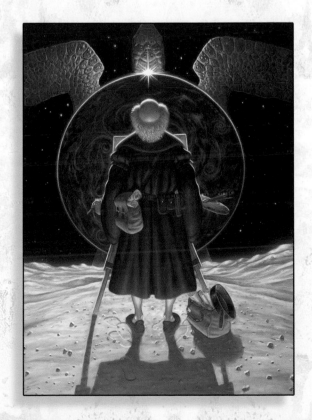

Great A'Tuin

What I really wanted to achieve in this picture was a sense of the astronomical scale.

After ploughing through as many books on turtles as I could find, the Green Turtle seemed appropriate to paint, as it fits most people's conception of how a turtle really looks. I then researched pictures of the moon and its craters. This research was in turn applied to the surface of the turtle to give it a feeling of having swum through the depths of space and been bombarded by all sorts of debris. Also to enhance the scale, one of the flippers was placed in front of the Disc. The movement of a sea turtle is very close to flying through water, and this was a feeling that I wanted to convey in the picture: the feeling that Great A'Tuin is swimming through the cosmos.

The four elephants that carry the disc on their shoulders are based on African elephants: I felt they were grander, but they have a slightly sad appearance, as if they are fully aware of the complexities of life.

The sun has just risen and the light is moving slowly across the Disc, so that one half appears lit by the dawn, and the other is still in night.

Commissioned by SFX Magazine. Terry now owns the original.

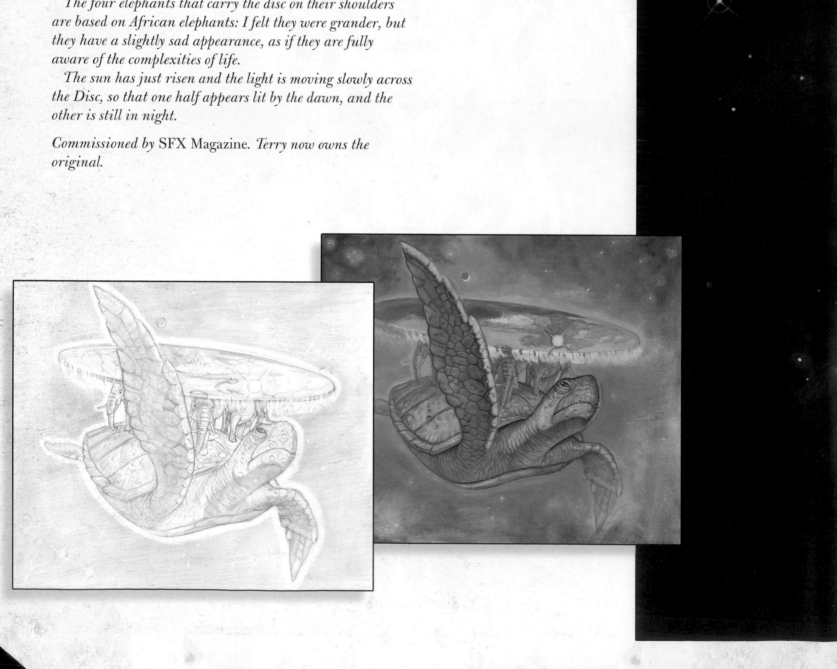

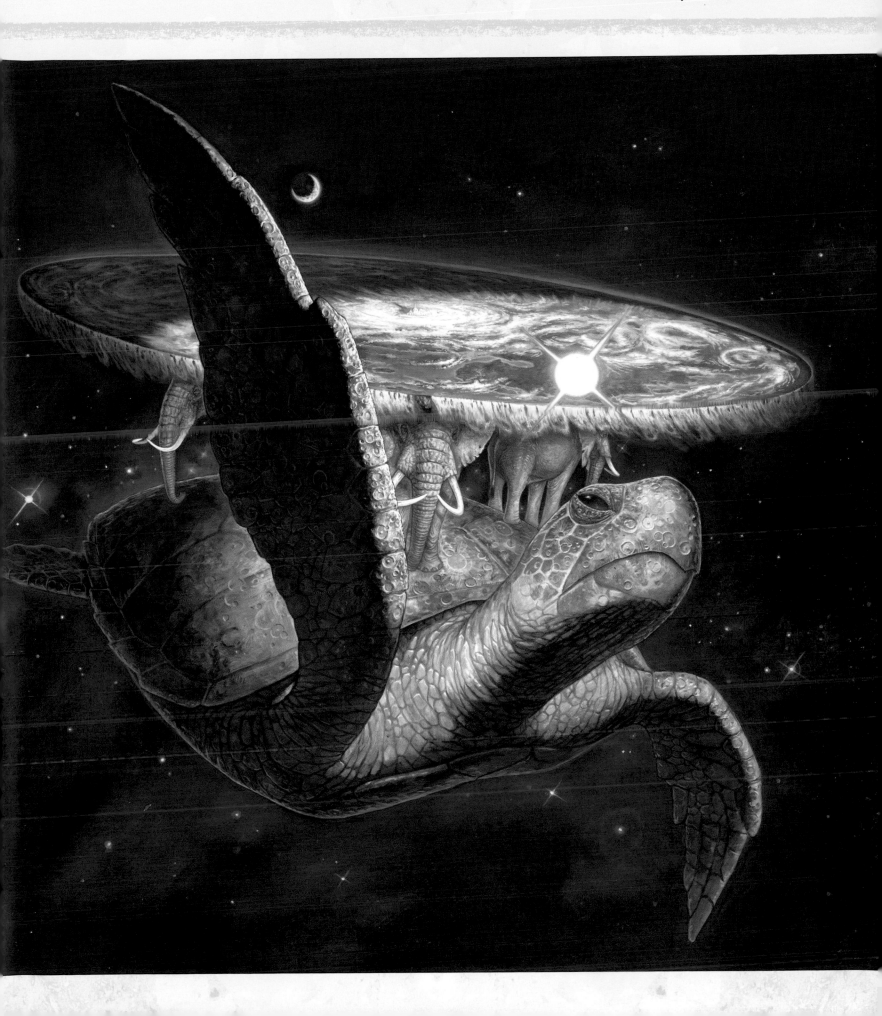

. . . So Good They Named It Ankh-Morpork

I tended to distrust fantasy cities when I was a kid. They were too much like stage sets. They didn't seem to *operate*. A city of even half a million takes a hidden army of farmers, fishermen and carters just to see it through the day. We have lost sight of that, now that food grows on supermarket shelves and there are bright kids who don't know what 'ploughing' means. But a humdrum city day requires a thousand unseen things to happen like clockwork, because it is only a couple of meals away from chaos. To quote from *Night Watch*:

'Every day, maybe a hundred cows died for Ankh-Morpork. So did a flock of sheep and a herd of pigs and the gods alone knew how many ducks, chickens and geese. Flour? He'd heard it was eighty tons, and about the same amount of potatoes and maybe twenty tons of herring. Every day, forty thousand eggs were laid for the city. Every day, hundreds, thousands of carts and boats and barges converged on the city with fish and honey and oysters and olives and eels and lobsters. And then think of the horses dragging this stuff, and the windmills . . . and the wool coming in, too, every day, the cloth, the tobacco, the spices, the ore, the timber, the cheese, the coal, the fat, the tallow, the hay EVERY DAMN DAY . . .'

Over the series I've tried to capture the feeling of a city that would go on running *even if the story stopped*. Somewhere in the background all those people would go on baking bread, making pins, shoeing horses – and bringing in the food.

The *City Mapp*, which was designed with the considerable help of Stephen Briggs, was of massive assistance. Instead of limiting my options, which I'd feared, it opened them up. I began to see the neighbourhoods, the villages that had been swallowed by the sprawl, the way the city had grown. We had to build in the evidence of past ages – street names that didn't mean anything now, odd lanes, streets that curved around city wall that were moved centuries ago. Since then I've become quite obsessive about getting things

right in the books. In *The Colour of Magic*, Rincewind could run where he liked, because the city was still only vaguely mapped in my head; by *Night Watch*, the movements of Sam Vimes were plotted and timed on the *Mapp*. Indeed, the rooftop chase across Unseen University at the start of that book was written with reference to the *Mapp and* the limited-edition model made by Bernard Pearson. The route and the lines of sight had to be right, otherwise people *would* complain.

I had no particular city in mind when I designed Ankh-Morpork; it was just the stock Mediaeval European city inside a wall; a wiggly river runs through it. But in my mind's eyes you'd get a pretty good attempt at replicating A-M if you could splice together the great trading city of

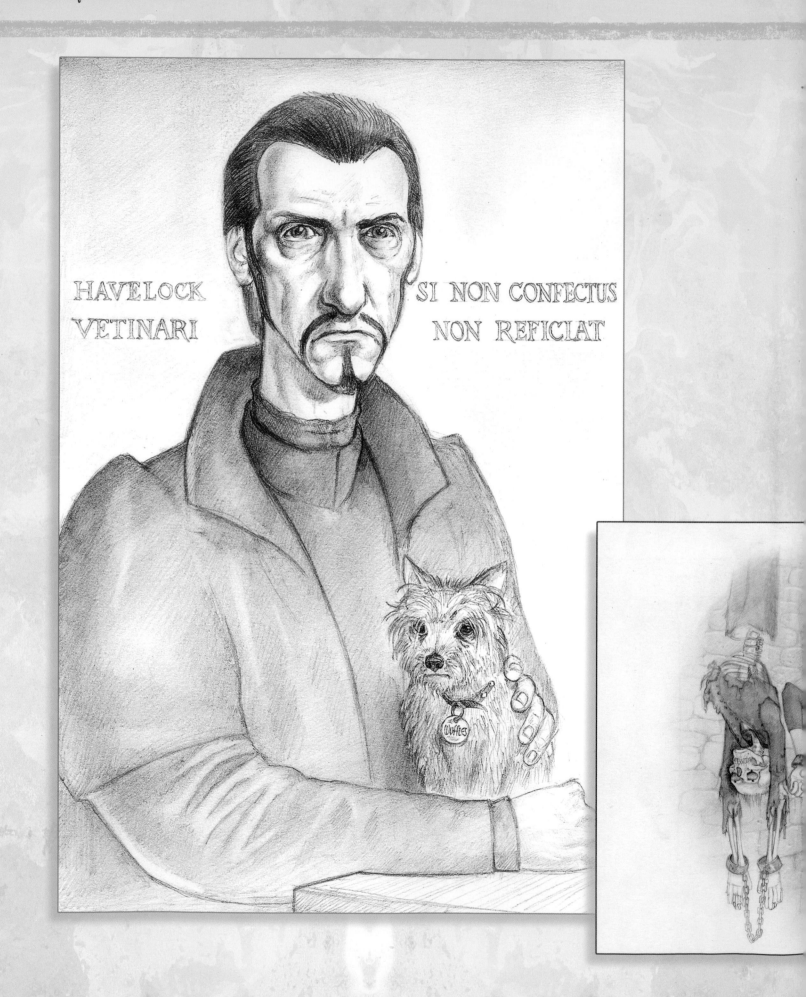

HAVELOCK VETINARI

SI NON CONFECTUS NON REFICIAT

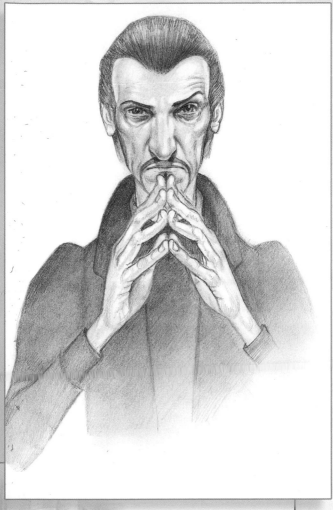

Tallinn with large parts of central Prague – the Charles Bridge needs only the hippos to become the Brass Bridge. I visited both of those cities because of Discworld, and it was like going home. Mind you, for the perfect Ankh-Morpork cocktail you'd have to find a way of distilling into the mix something from eighteenth-century London, nineteenth-century Seattle and twentieth-century New York . . .

In the end, cities are not about towering spires. Mostly they're about merchants, the ships unloading in the docks and the distillation of wealth. I like Ankh-Morpork. It's the archetypal City that Never Sleeps. Admittedly, this is because of the fleas.

'A thinking tyrant, it seemed to Vetinari, had a much harder job than a ruler raised to power by some idiot system like democracy. At least *he* could tell the people he was *their* fault.'

People call Lord Vetinari a Machiavellian figure, and indeed he is – but only for a given value of Machiavelli. A true student of *The Prince* would be a lot more brutal, and would firmly believe that it is better to be feared than loved. Vetinari firmly believes it is better to be permanent than either.

He deals with big problems while they are still small problems, plays off powerful interest groups against one other and makes certain that everyone else is too busy making money or plotting against their rival to find it convenient, right now, to remove him. He is the ringmaster, and entirely without scruple in his efforts to preserve the city; he relies on an innate ability to know every man's desire and, possibly, every woman's weakness. In reality, his grip is fragile, but so is a spider's web. In short, he has made himself indispensable.

Again, the stories evolved him. He began as an off-the-peg tyrant and became this urbane, complex man because that's what he needed to be. Like Death and the Librarian, I tend to use him sparingly, lest he take over every plot.

I understand he has his own, all-female, fan club.

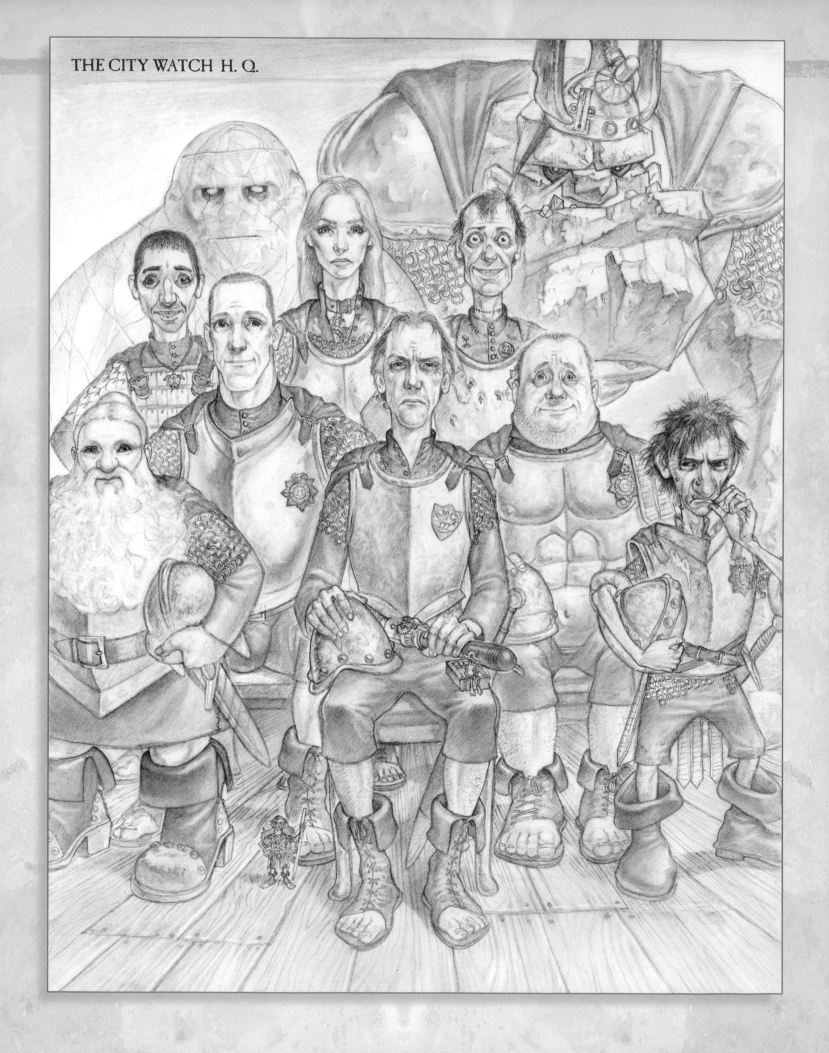

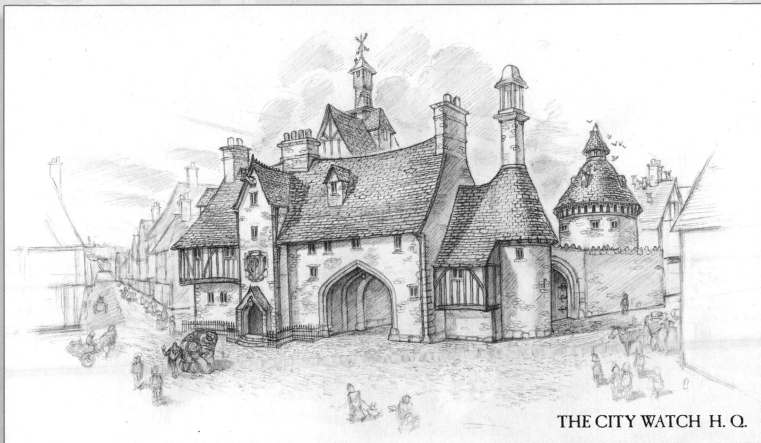

THE CITY WATCH H. Q.

Ankh-Morpork's Finest: the City Watch

Once the unregarded dregs of society, now important players in the game of city Realpolitik. Once there were four, now there're more than a hundred. The catalyst of the change was of course the arrival of Lance-constable (later Captain) Carrot, but it's Commander Sam Vimes who has shaped it into a force to be reckoned with.

It must be the city's most multi-racial organisation, and just about the only major Discworld species not represented in the ranks are the vampires. This is partly because Vimes is suspicious of them, but possibly also because vampires are extremely intelligent and therefore have no interest in becoming coppers. Still, it's probably only a matter of time.

A fine body of . . . well, people, the Watch now solve far more crimes than they commit.

They were originally used because watchmen in classic fantasy generally end up as sword fodder. The average hero can take on four of them at a time. I wanted to give them a moment in the sun, but it turned out to be a full tropical holiday.

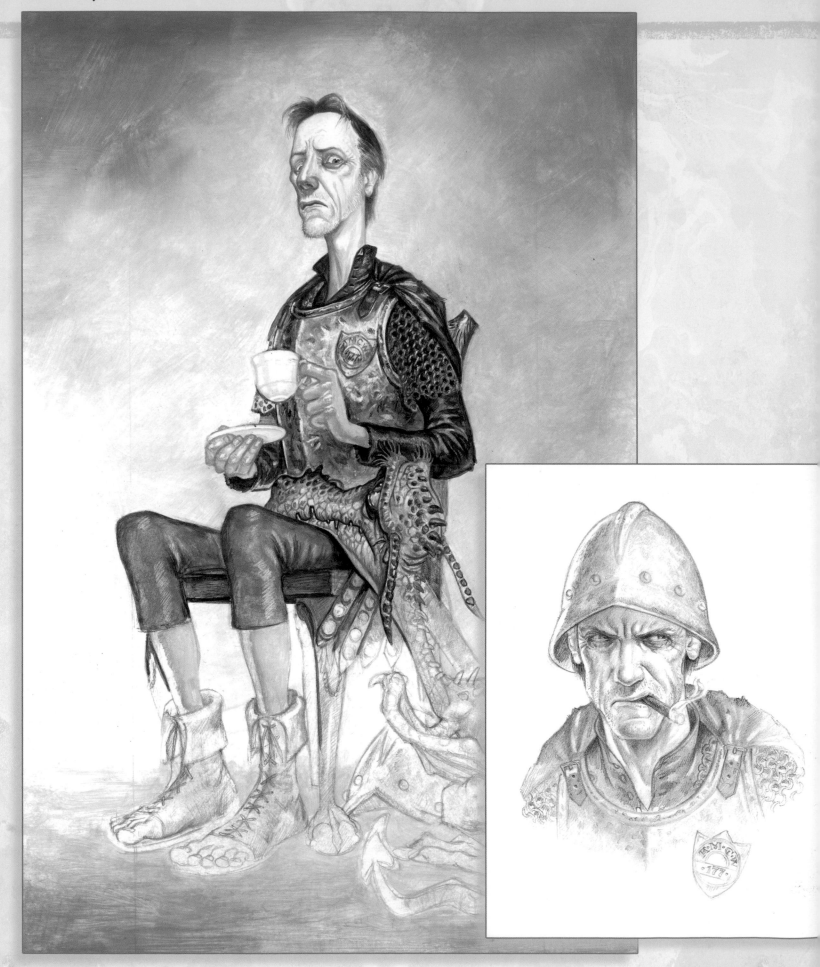

Once Captain Sam Vimes, now His Grace Sir Samuel Vimes, Commander of the City Watch . . .

. . . but still a street copper at heart. He's come a long way. This is partly because it was in the interests of various people that he did, but he has grown into the job and thinks of himself as no man's puppet (which shows how good Vetinari is at pulling strings, but Vimes still has the capacity to surprise).

Vimes was never intended to be a major character; I began the first draft of *Guards! Guards!* with the assumption that Captain Carrot would be the lead. He was, in a way, but only in the sense that Zeppo Marx plays the lead in a Marx Brothers movie; technically, he sometimes did, but no one ever went to see a movie just because Zeppo was in it. I needed a head to get into, and Vimes' was empty at the time, so suddenly we began to hear his thoughts . . .

It always seemed to me that Sam had the same character structure as Granny Weatherwax: they both believe and fear they have something of the night about their souls, and look for structures that will fence it off. For Vimes, it's his badge. It's a shield, and he uses it as much to protect himself as the public. It keeps him legal, or so he thinks.

Paul always makes him look a bit like Clint Eastwood, but I've always imagined him as a younger, slightly bulkier Peter Postlethwaite.

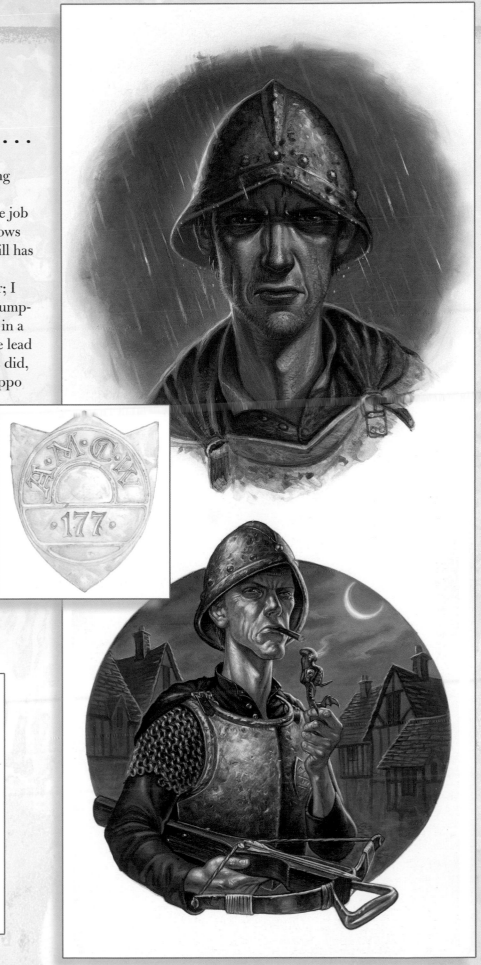

Nobby Nobbs and Sergeant Colon

Once a bad copper invented in a hurry from raw material hallowed by time, Nobby has become a popular character because of his sheer inefficiency – he's a picker-up of unconsidered trifles rather than a real thief.

Maybe it's because everyone's met a Nobby, certainly if they've ever been in the armed forces. He wangles, skives, ducks and weaves, he knows every wheeze and fiddle, and he can smoke a cigarette as though it's a conspiracy. Nobby is the man bright enough to take one step back when volunteers are called for.

And yet, Nobby never seems to do any real harm, and can be quite brave when cornered. He has mercifully hidden depths: he *might* have aristocratic blood in him – after all, he appears to have every other kind – and never does a stroke of work if he can avoid it. And his liking for folk dance, weaponry and dressing-up hint at a complex side to his nature which Paul fortunately cannot get down on paper.

He is mostly seen in the company of Sergeant Fred Colon, a placid old street monster of minimal courage, moderate intellect and impressive girth. The chief function of their friendship is to prevent either of them thinking originally for any length of time.

Coppers who come to book signings (they never queue in uniform, but sneak in through the back of the shop, very quietly) tell me that every police station has its Colon or its Nobby. Oddly enough, once it was a clear Nobby who told me this.

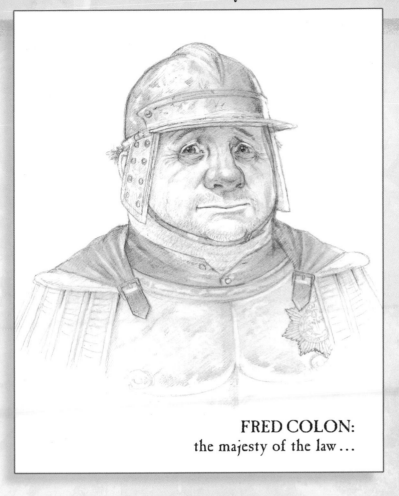

FRED COLON:
the majesty of the law …

NOBBY NOBBS:
If you want to know the time, it may
be because he's pinched your watch

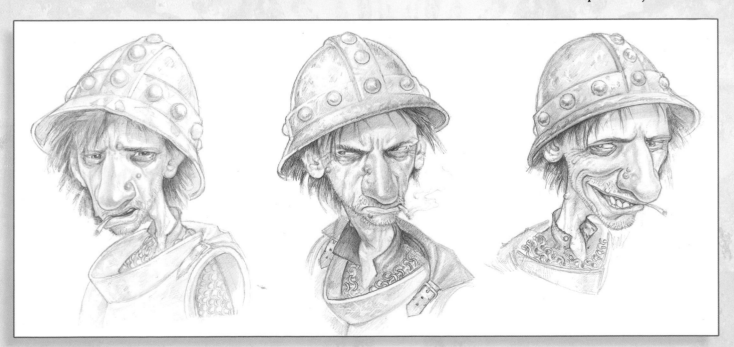

Captain Carrot Ironfounderson

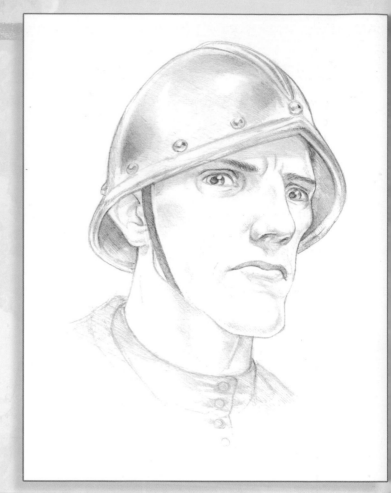

Can there be anyone in Ankh-Morpork now who does *not* know that a common watchman is heir to the city's ancient and woodwormy throne? But he does not wish to do anything about it, and seems quite happy where he is. Destiny is optional, he feels. On the other hand, one can only speculate what will happen if ever the city is run in a way not to his liking and, maybe one day, one will.

Carrot got his name because while I was writing *Guards! Guards!* we had some work done on the house by a builder with a red-headed apprentice nicknamed Carrot, and that struck me as such a good name for a man of young Ironfounderson's build.

He was created as a well-built but innocent young man to drop into the middle of Ankh-Morpork's institutionally corrupt society, in the knowledge that practically anything that happened next would be interesting. He seems to have become rather less innocent as the series has progressed, since you can either be a policemen or innocent but not both. There's clearly something going on behind that boyish face, while his destiny keeps him alive and sees to it that bad things happen to his enemies. Paul gets him just right – you can practically smell the soap.

Future propects: Good. He is No. 2 in the City Watch, well thought of by all, a young man with the world at his feet. If Lord Vetinari fails to survive the next assination attempt, his future is bright. But could his destiny as heir to the throne survive marriage to a werewolf? People are funny about dogs on the furniture, expecially when the furniture is a throne . . .

Carrot
Popular opinion compares Carrot with Arnold Schwarzenegger, but I feel that the closest film star would be a young Liam Neeson.

Flying Squad

Ever pushing back the boundaries of modern policing, the City Watch now has gnome officer Buggy Swires as its eye in the sky. Carrier pigeon interception and traffic reports are all in a day's work for six-inch-high Buggy (who, strictly speaking, is the highest-earning copper in the world; it's amazing how far your pay will go when a penny buys you a day's food.)

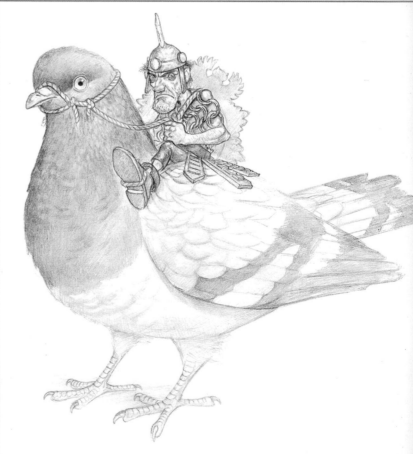

One Long Bad Hair Day

Sergeant Angua of the Watch is a werewolf. The trouble is, that's all most people want to know. They don't stay to hear that you're a vegetarian by day, and very careful to stay legal at full moon (don't ask about the chickens). You get more stick than vampires (and you *have* to catch it, it's just something about the dog in you) because vampires at least look cool and don't pant. Well, not most of the time.

The one bright point in Angua's career is that although by now most people in the city a) know there's a werewolf in the Watch they b) think it's Corporal Nobbs, for obvious reasons. Also, the city being what it is, aniseed bombs and peppermint spray are part of the arsenal of the modern criminal, so the advantage of that wonderful nose is not as great as it was. On the other hand, she is pretty bright in any shape, and the de facto No. 3 in the Watch hierarchy.

She's in a stable relationship, or at least as stable as any relationship can be in the circumstances, with Captain Carrot.

Paul's version of her always has a slightly uneasy feel, as if she's about to turn and run. That makes sense, come to think of it . . .

People ask about the name. I made it up, but it's hard to imagine any other name for her now. Future prospects: Questionable. She's got no real home to go back to, and the Watch is her life. On the other hand, her romance with Captain Carrot has got to go somewhere or stop pretty soon. I have one or two ideas in that direction . . .

Angua
I wanted Angua to have the same expression in her eyes in human and wolf form so that there was a recognisable element between the two.

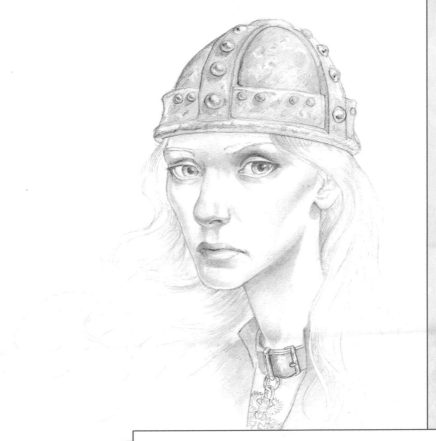

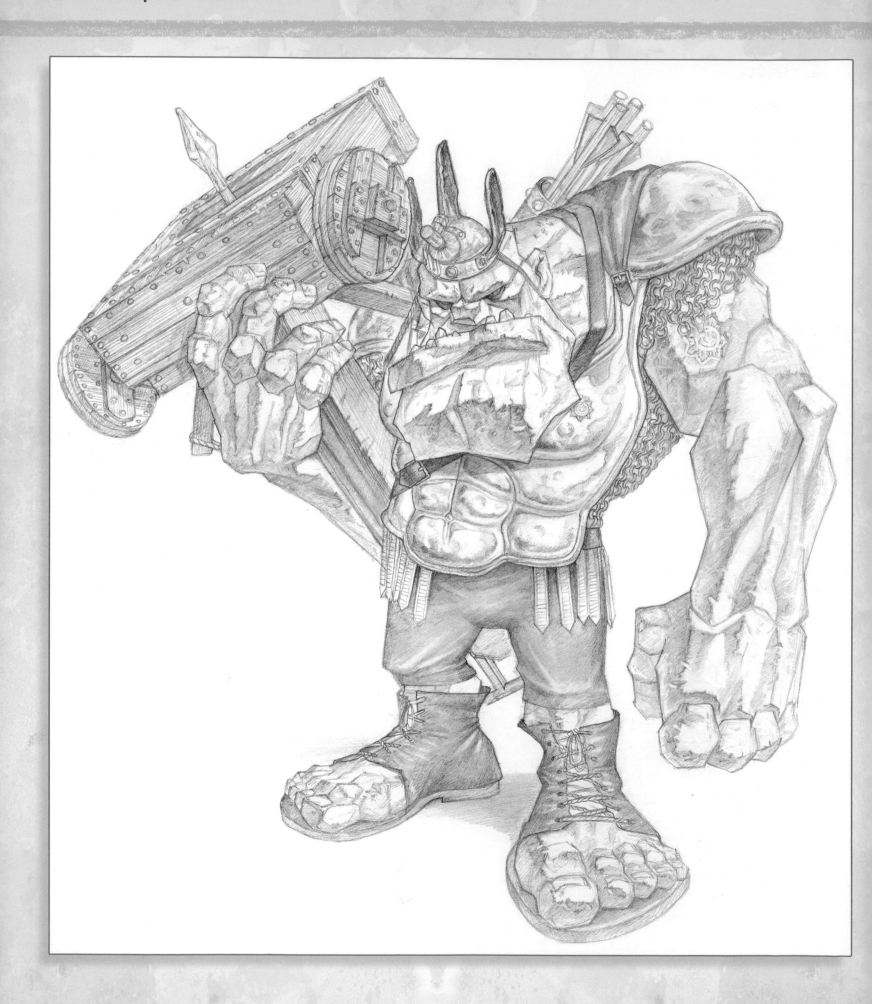

Detritus

Perhaps the most personally successful character in the entire series, since he was introduced in *The Colour of Magic* chained to the doorway of a pub as a splatter (like a bouncer, but throws harder). He is now a senior sergeant in the City Watch. He's a dependable character – gets on with the job, obeys orders, is quite clever in an oblique troll way and, all in all, is one of the city's success stories.

Discworld trolls were designed as a logical answer to the question: why, classically, do trolls turn to stone in the morning? And the answer is: not because of the sunlight, as believed, but because too much heat forces their silicon brains to shut down (this doesn't stop them drinking molten minerals for recreation, of course – too much alcohol causes human brains to shut down, too, but somehow that's part of the attraction).

I used to draw Detritus and his fellow trolls in my schoolbooks when I was a kid, and write fantasy stories from their point of view. It offended me that the stories I was reading portrayed trolls as big and fick and *therefore* bad. Don't ogres love their children too? And that, therefore, is why Ankh-Morpork is the headquarters of the Silicon Anti-Defamation League . . .

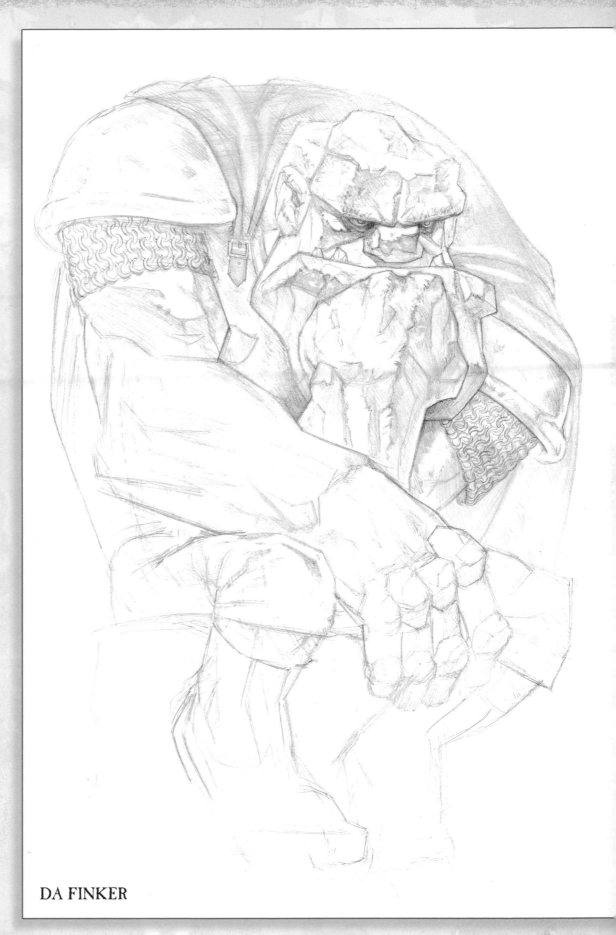

DA FINKER

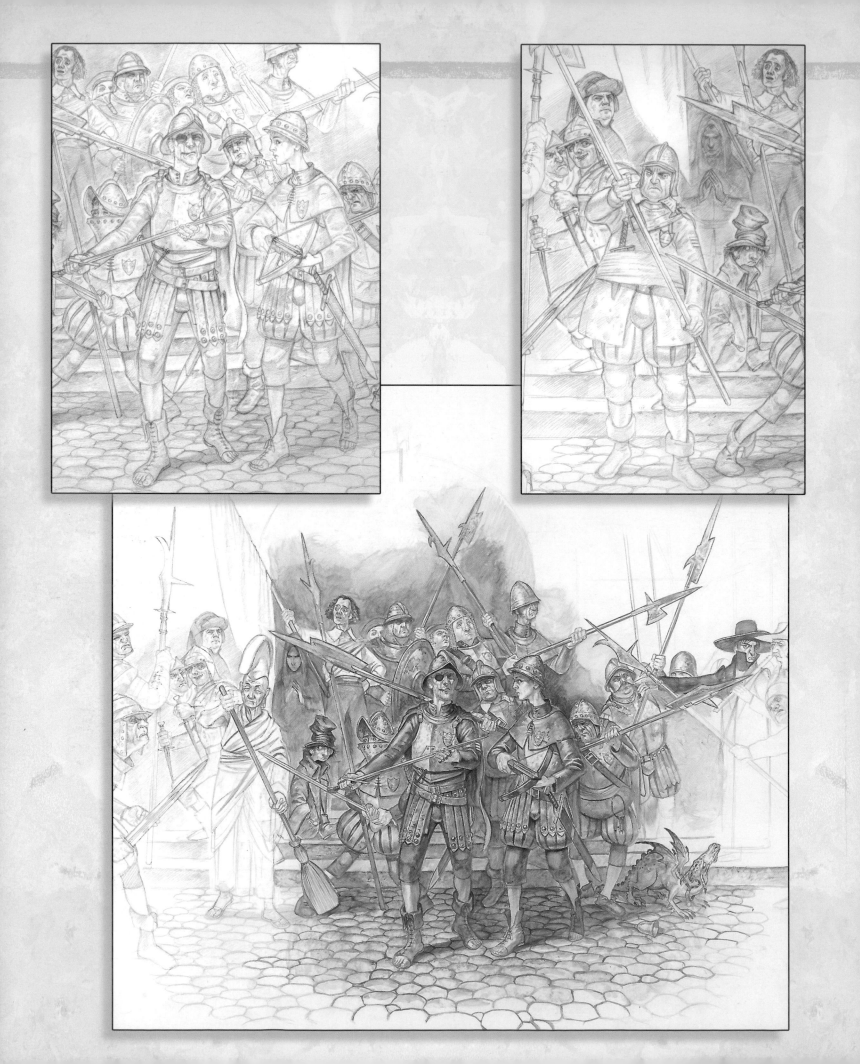

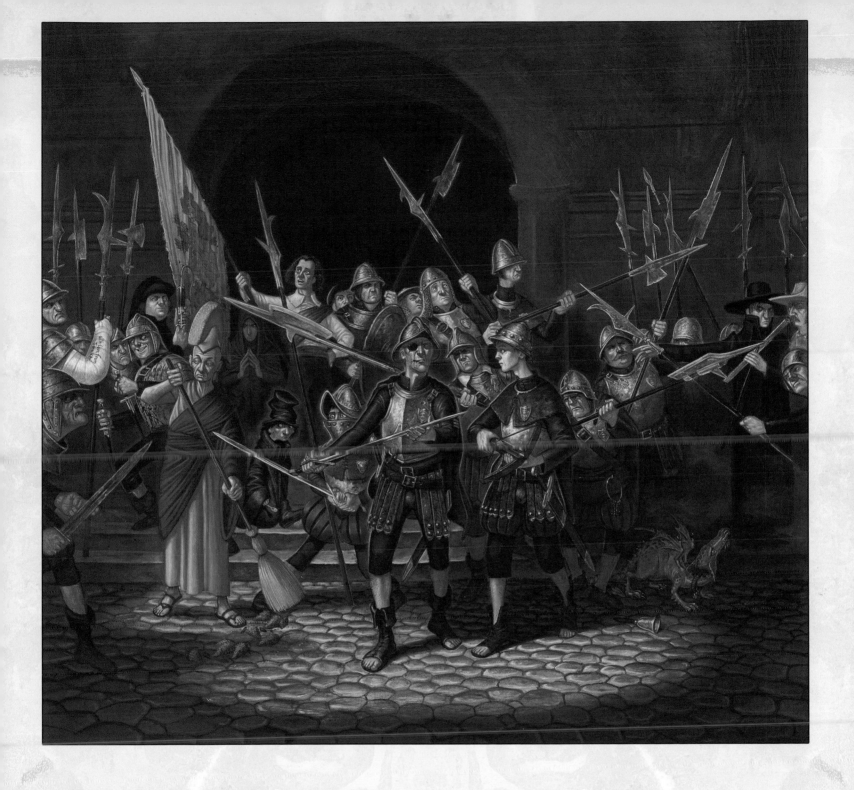

The Unusual Suspects

The fact that the City Watch is a genuinely equal opportunity employer has a lot to do with Commander Vimes' blinkered and cynical view of people in general: there are coppers, and there is everyone else. Trolls, gnomes, dwarfs, golems . . . whatever you're made off, he'll see to it you become solid copper, all the way through.

It is, in its way, a very modern force, with an airborne patrol (gnome Constable Swires, on a variety of birds) and even the equivalent of speed cameras.

There is, in the Old Lemonade Factory near the headquarters in Pseudopolis Yard, a small training school for Watch recruits. Other cities even pay to send their watchmen there, and Lord Vetinari sees to it that they get a very reasonable rate. After all, it's no bad thing that policemen in cities all the way to the mountains have been trained to salute Commander Vimes.

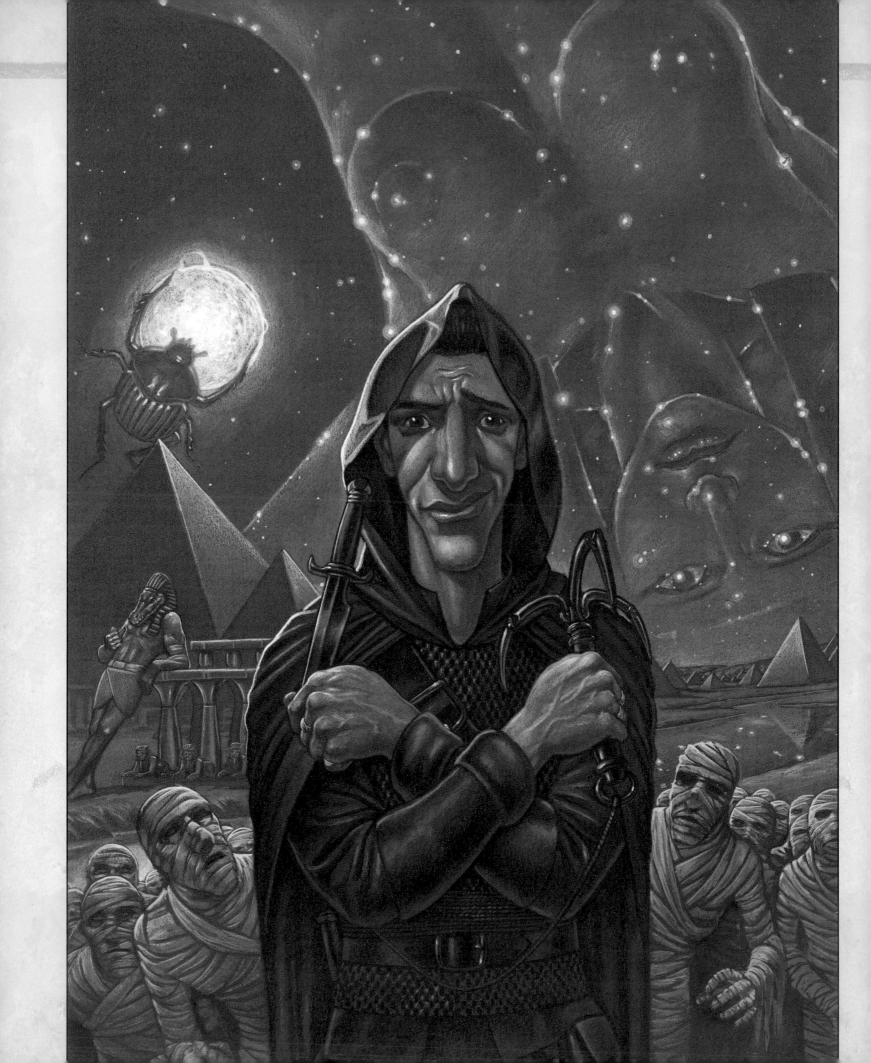

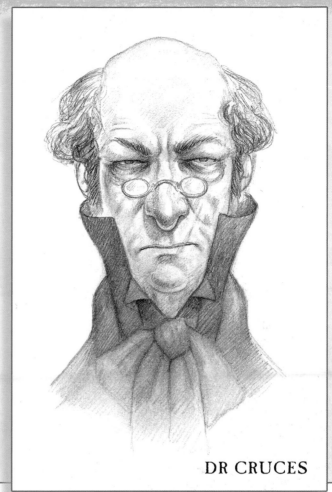

DR CRUCES

The Assassins' Guild: Hold Up Someone Else's Head With Pride

The Assassins' Guild is the richest and certainly the most exclusive guild in the guild-ridden city of Ankh-Morpork. As pupils are told when they enter the guild's famous school, assassination is not a mere job, it is a pursuit for gentlemen, and increasingly (since the opening of the school's Black Widow and Mantis Houses) for ladies, too. The Guild these days is always keen to distance itself from mere thugs who kill for money; Guild members kill for *a great deal* of money.

In fact, although assassination has always been an important political tool, with its own rigid and more-or-less-gentlemanly (or ladylike) rules, many members might barely touch a dagger from one year to the next. It's *belonging* that counts, and indeed, attendance at the school and a knowledge of what it teaches is reckoned to be worthwhile for anyone likely, one day, to be an assassin's 'client'. Beside, it's always preferable to be killed by someone of one's own social class, who can be relied upon not to be messy.

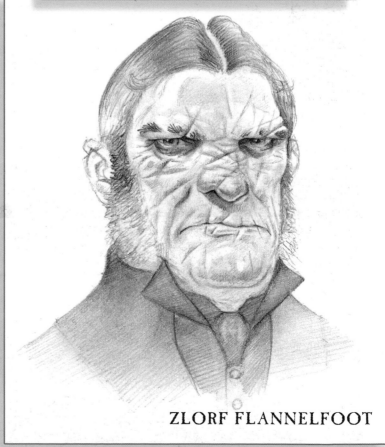

ZLORF FLANNELFOOT

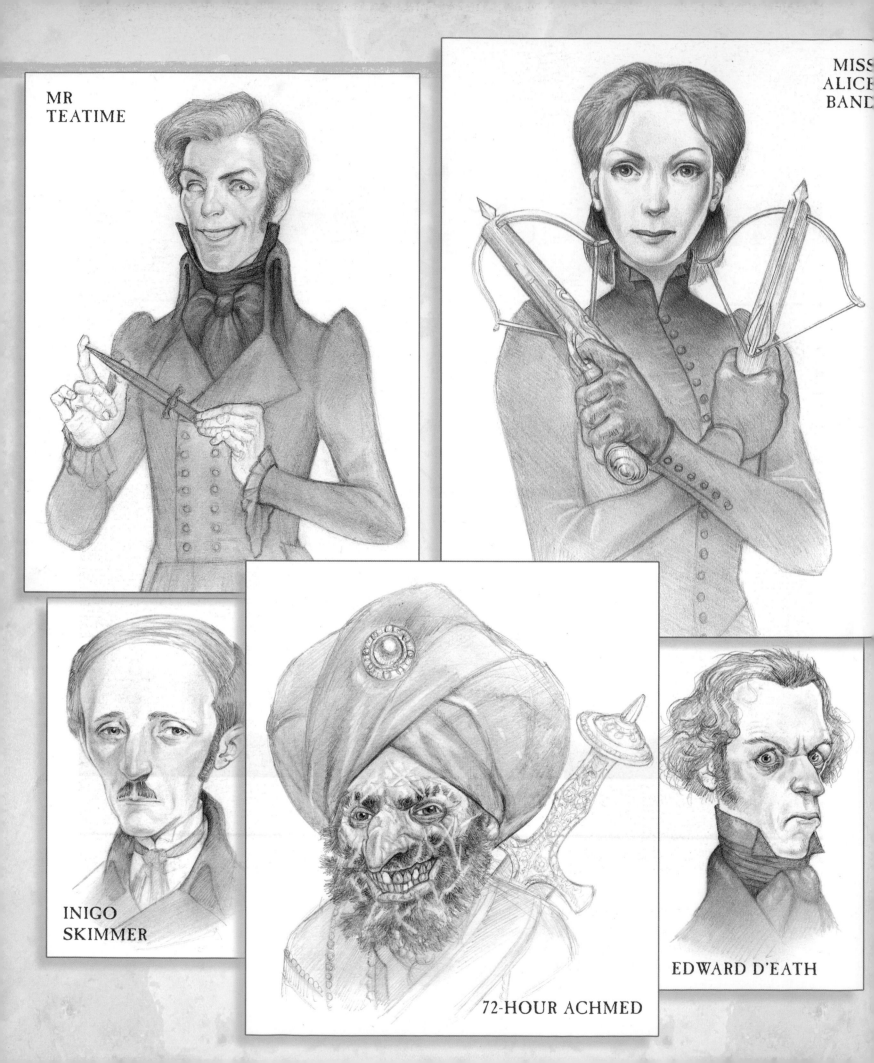

MR
TEATIME

MISS
ALICE
BAND

INIGO
SKIMMER

72-HOUR ACHMED

EDWARD D'EATH

The head of the Guild is Lord Downey, who took over following the tragic death of Dr Cruces, a loyal servant of the Guild who unfortunately was one of the victims of the city's first – and thus far only – 'gonne'. Downey, even more than his predecessor, is an urbane man who is one of the city's major political players. He is a skilled poisoner, although no one found dead in circumstances connected with him has ever been found to have been poisoned. Quite possibly he is, therefore, an *extremely* skilled poisoner.

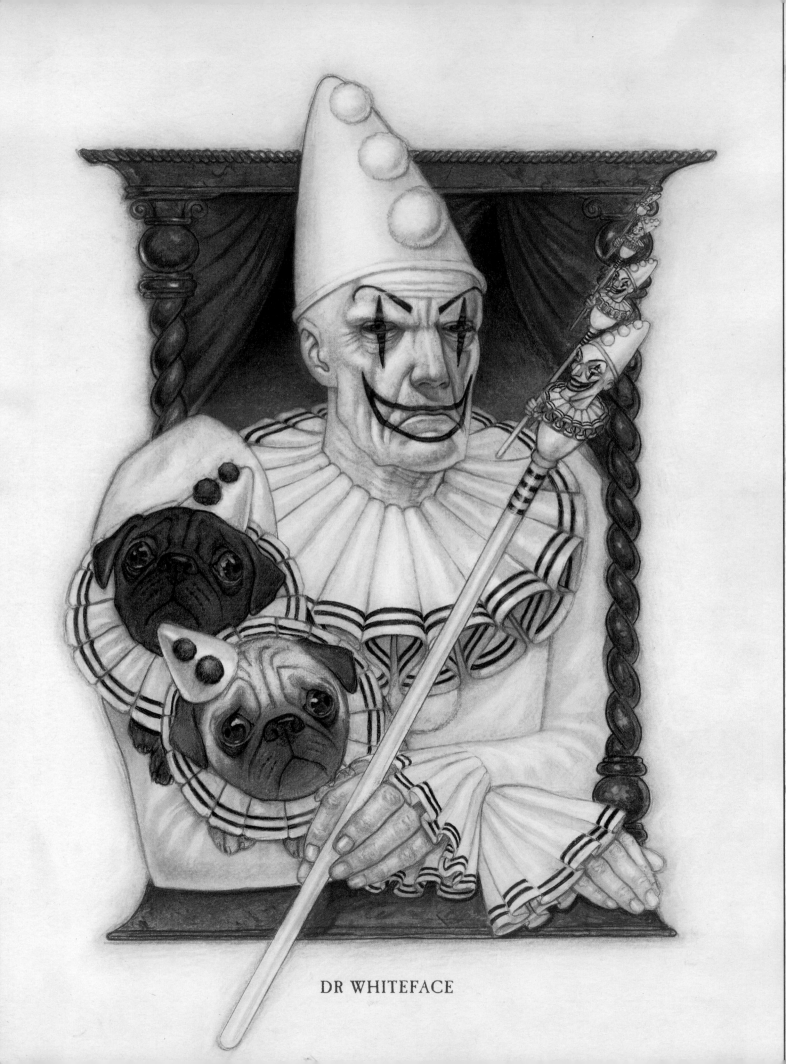

DR WHITEFACE

The House of Mirth

The Assassins' Guild was created by taking a classic British public school and turning all the knobs up to eleven, especially the one marked 'violence'.

The Fools' Guild is based simply on two truisms: humour as a profession is hard, and clowns worry people. There's a sense that they're getting messages from somewhere Out There. Perhaps it's the fixed grin, like the one on a skull. Somehow the laugh is on us, and the clown knows it. They're in touch with something ancient and uncontrolled.

So the Guild is a miserable place, with old jokes and comedy routines taught by rote and new ones disallowed for use until they have been tested for decades. It's like the stricter type of mediaeval monastery, without the latter's non-stop boffo laughs. Many trained clowns go on to be Fools in the houses of the mighty, thus giving the Guild Council a spy at every court. No wonder the Guild is rich. But it didn't get that way by laughing.

Lord Vetinari, an easy-going man by the standards of tyranny, has mime artists hunted down and locked up. There's a man who knows something.

Paul's drawing of Dr Whiteface sums it up completely. There's a sinister face behind the smile, of a man who is deadly serious. On Discworld, as elsewhere, a clown is his face, but a mere design of make-up can be inherited. *Someone* has been Dr Whiteface for more than three hundred years. Men come and go, but the clown goes on.

WAGGY RACES

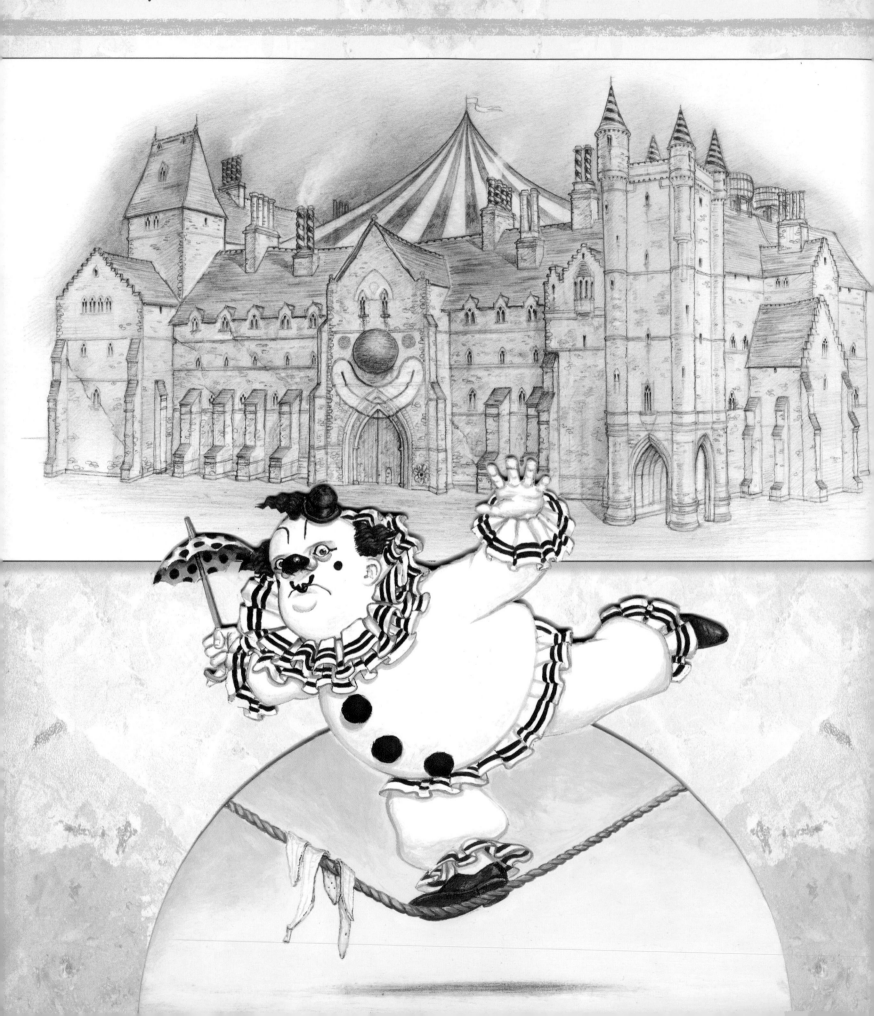

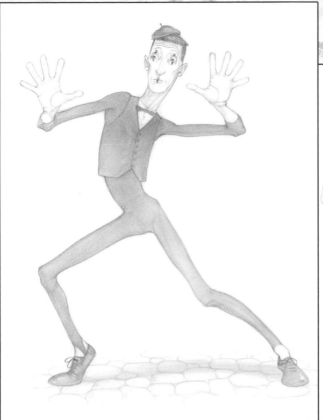

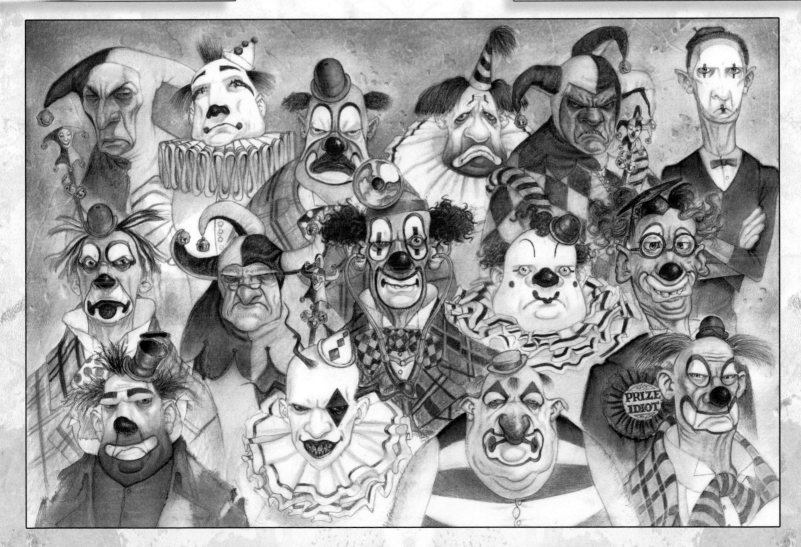

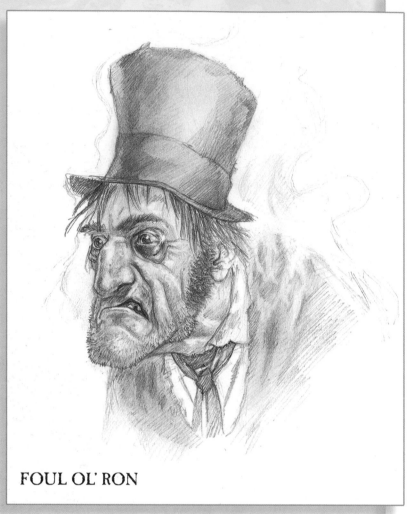

FOUL OL' RON

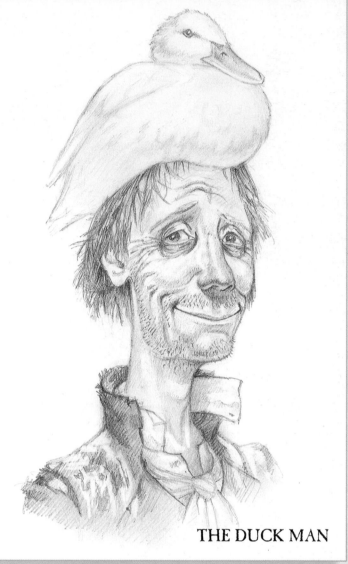

THE DUCK MAN

The Beggars' Guild: Down on Your Luck

The Beggars' Guild is the oldest guild in Ankh-Morpork and quite powerful, if only because it has so many members. I based them loosely on the old beggars' 'guilds' that flourished, more or less, for several hundred years up until Tudor times.

Beggars get everywhere and hear many things and thus, on their shambling beats around the city, act, as it were, like Town Whispers. The beggars know what's going on, who's in, who's out, who said what about whom, where the bodies are buried . . .

The tattered velvet gown of the Head Beggar is currently worn by Queen Molly, an astute lady under all those warts. She wields another power not normally associated with beggary – the Guild is immensely rich because beggars, by definition, don't buy anything. All

those charitable pennies, therefore, add up over the years, invested well at compound interest. There are people renting very posh houses indeed in the city who would be shocked to know who (at the other end of a string of agents and holding companies) their landlords are. Kicking beggars in the street is not wise, and it is best to donate a few pence. Karma in Ankh-Morpork has a habit of coming around quickly, sometimes with the bailiffs.

Oddly enough, the city's most famous beggars – Foul Ol' Ron and the Canting Crew, the core members of which are Arnold Sideways, Coffin' Henry and the Duck Man, are only honorary members of the Guild, because their natural genius cannot be constrained by mere rules. They even go *into* the Guild to beg, and come out the richer. Everyone has their heroes.

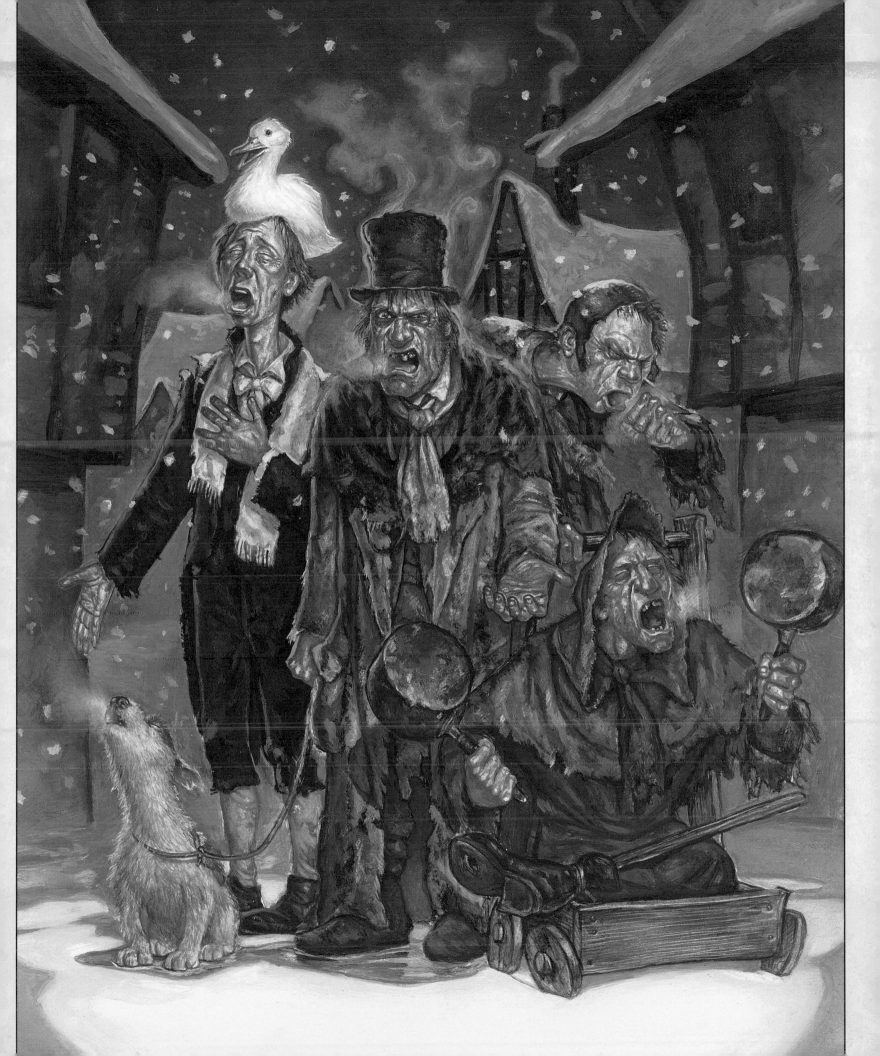

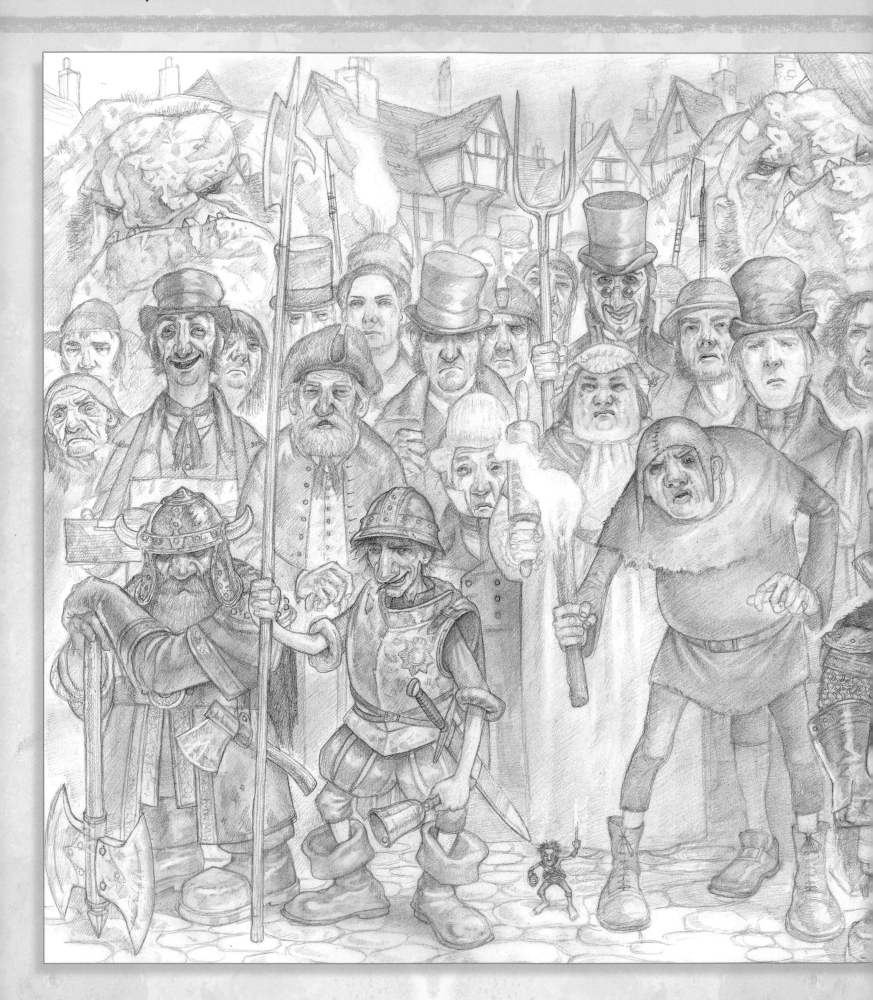

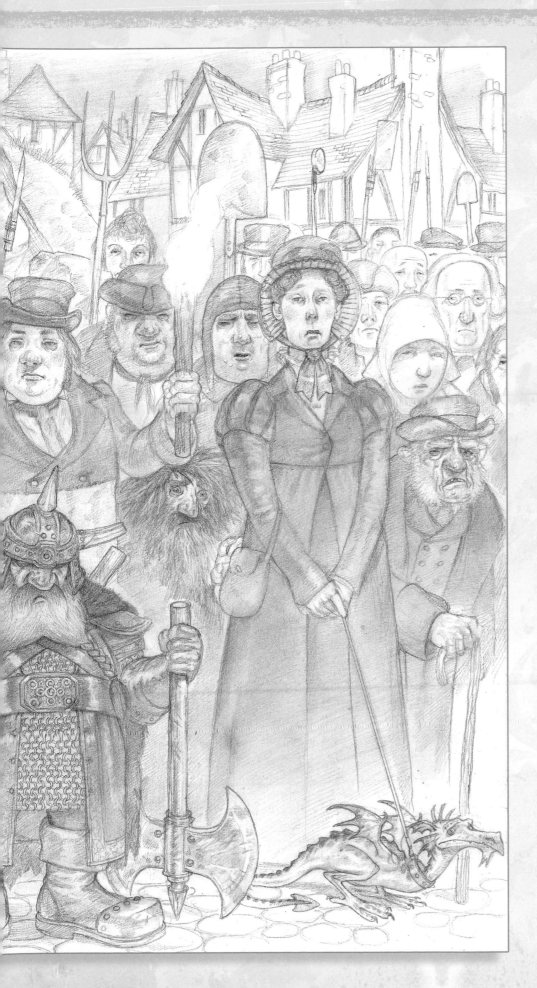

The Mob

Ankh-Morpork lives on the street. The housing shortage stopped being acute some time again; now, it's practically metaphysical. The street is where you live, eat and get your entertainment while waiting for your turn in the bed.

The whole of the city is, in fact, a proto-mob. News travels fast on the grapevine when the grapes are so close together, and anything will cause it to contract around some new point of interest. And then all those people, many of them in possession of a fully functioning brain of their own, become: The Mob, with the IQ of something scraped off the bottom of a farmer's boot.

What it craves, what it lives on, is entertainment. It is, generally, friendly. It'll cheer as readily at a wedding as at a hanging. It laughs at jokes and weeps at funerals. Nothing makes its day so much as a good suicide, especially from somewhere high, but a daring rescue will be equally applauded. It is easily panicked but will flow right back again to see what it was running away from. The mob likes bright colours and easily understood things.

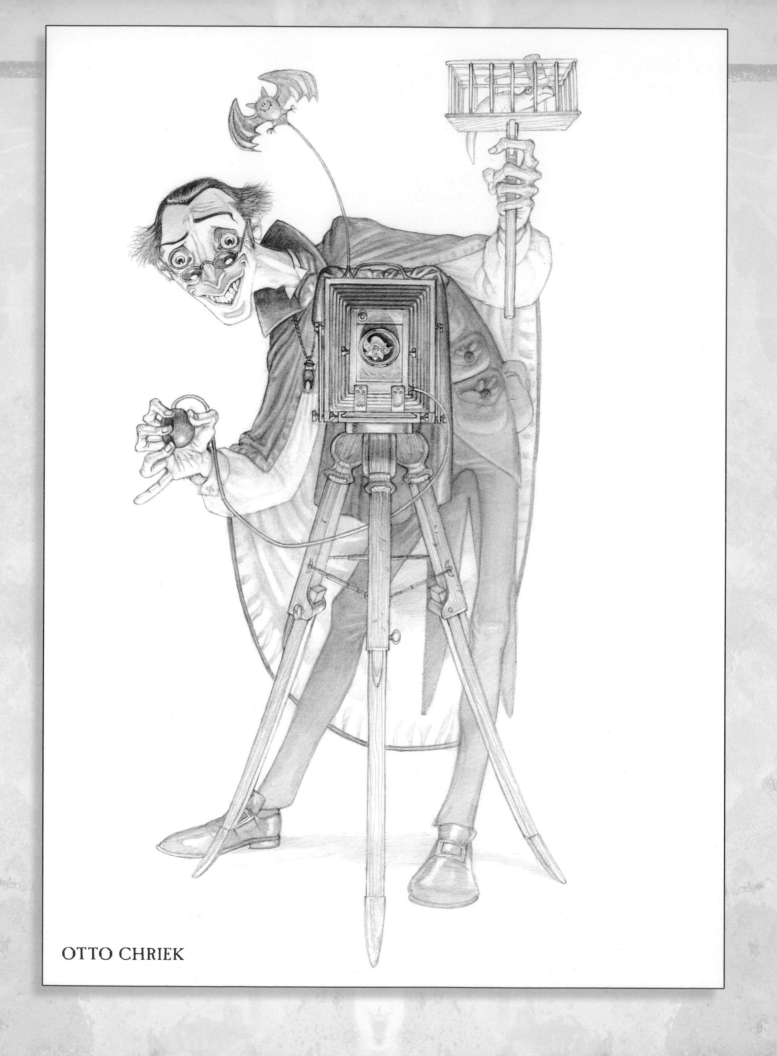

OTTO CHRIEK

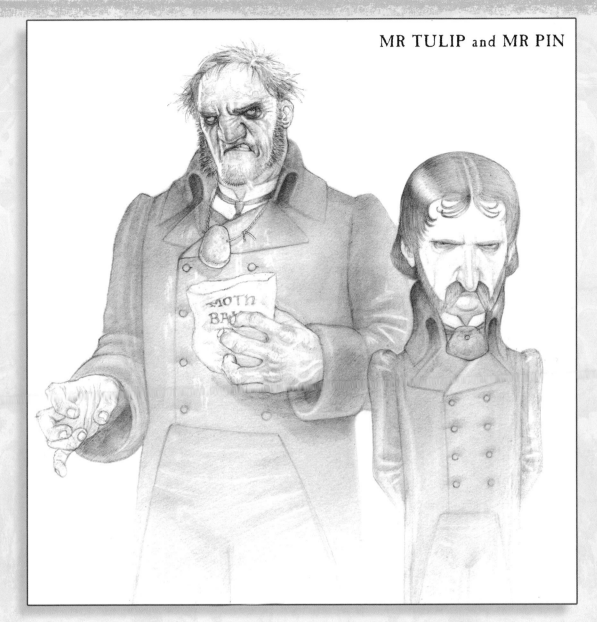

MR TULIP and MR PIN

Make Him an Offer He Can't Understand

People say: 'Did you get the idea of Tulip and Pin from . . .' and then fill in the names of any of half-a-dozen fictional criminal duos. And the answer is no, but I probably got them from the same equation. It's a Law of Narrative that if your gang consists of two people (a gangette) one will be the brains of the outfit and one will supply the muscle and speak like dat. They must both, of course, wear black suits. If there are three of them, that still applies but the new guy will be called Fingers.

Mr Tulip's ineffective drugs habit and high-quality art appreciation just seemed to work, as did his use of *precisely* the adjective '—ing', which I've heard beautifully reproduced on stage so that it sounded like the Essex equivalent of the Bushman's 'click' language. Mr Tulip staggering about

in an art museum, trailing powdered mothballs yet delivering —ing lectures on the finer —ing points of 8th C Agatean ceramics, was a vision I had to get down on —ing paper.

It was quite embarrassing to get a wad of letters from a class of eleven-year-olds who had read it at school. They thought Mr Tulip was great. Some adults, on the other hand, objected to '—ing' – which is a little odd, given that it's nothing but one short, gulped syllable.

TRADE SECRET: my editor at the time was adamant that Mr Tulip should not die. She felt sorry for him because of his terrible childhood. She wanted to see him brought back in another book. I couldn't face that worried smile, so the compromise was worked in on the final draft.

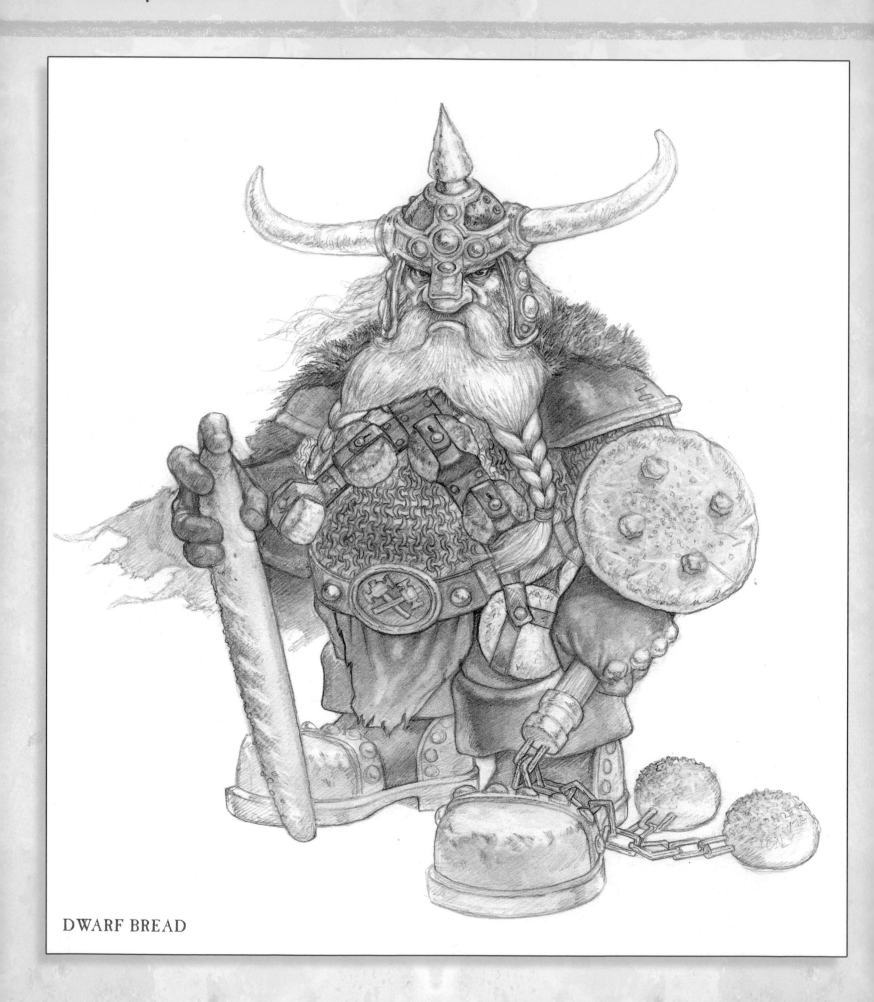

DWARF BREAD

The Melting Pot With Big Lumps

Ankh-Morpork is a multi-cultural society, enriched and enhanced by the mix of many races. Of course, that's claimed for other societies too, but in Ankh-Morpork it's possible to claim it with a straight face and without crossed fingers. It is a free city. Admittedly, freedom might consist of being knifed in an alley, swindled or starved to death, but that's because 'freedom' is a dangerous thing and, according to Lord Vetinari, doesn't just consist of the nice bits. The only guarantee – well, it's more an understanding – is that you are very unlikely to be knifed, staked, hewn, shot with a silver bullet or used as a lawn ornament *as a matter of government policy*, and thus the city looks very attractive to refugees from less enlightened societies.

The anthem of the city state of Ankh-Morpork was not even written by one of its sons, but by a visitor – the vampire Count Henrik Shline von Überwald (born 1703, died 1782, died again 1784, and also in 1788, 1791, 1802/4/7/8, then 1821, 1830, 1861, staked 1872). He had taken a long holiday to get away from some people who wanted earnestly to talk to him about cutting his head off, and declared himself very impressed at the city's policy of keeping the peace by bribery, financial corruption and ultimately by making unbeatable offers for the opponents' weapons, most of which had been made in Ankh-Morpork in the first place.

Although there are probably representatives of least ten races there now, it's the dwarfs and the trolls that have really established themselves. The trolls are, strictly speaking, in a minority, but it's hard to think like that after you've met your first troll in the street.

There's a school of thought that says that Discworld dwarfs are Jewish, although the Jewish fans who have said so seem quite content with this (the dwarfs are hard-working, you see, and law-abiding, argumentative; they pay great heed to written tradition – while arguing about it – and feel mildly guilty about working in cities a long way from the mountains and mines, and respect the ultra-traditionalists back home even though they seem unable to move with the times . . .) Each to their own; I was just trying to come up with dwarfs that fitted the modern fantasy tradition but *worked*.

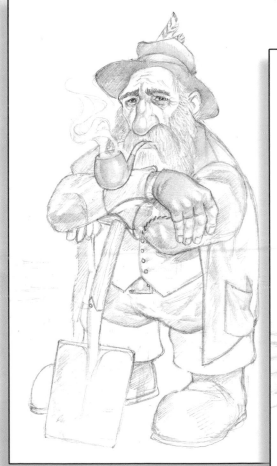

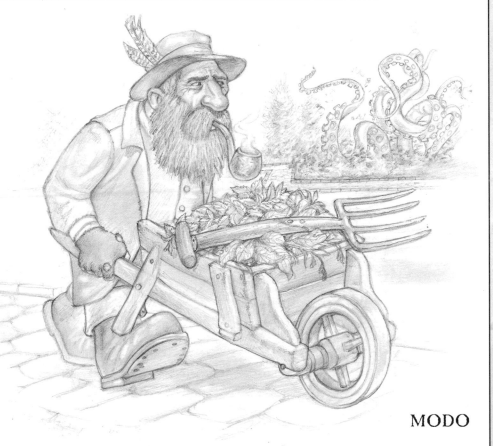

MODO

Trolls

The Trolls have evolved visually from my earliest sketches of Detritus, and sometimes I'll make a large leap forward in capturing my perception. As a child I spent a lot of time collecting rocks and thought I might end up a geologist. I still have the tendency to fill my pockets with rocks and stones when I'm out, and I used my collection for reference when working on the Trolls.

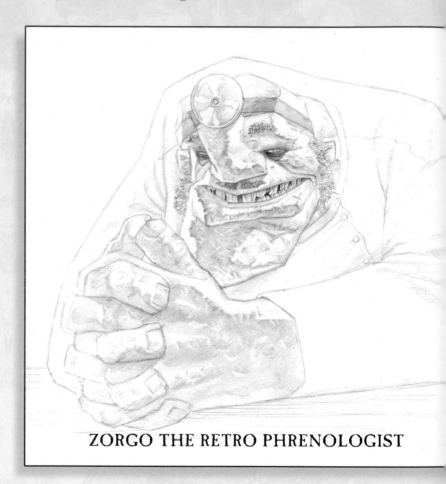

ZORGO THE RETRO PHRENOLOGIST

Ruby

I used Terry's reference, which describes her as akin to a cave man's fertility goddess, with large hips and a large rocky bust.

No one can spend all their time hacking at rocks. There's more to life than axes. That's why there are now second- or third-generation dwarfs in Ankh-Morpork who have never seen a mine and have no intention of going down one. And there are even humans who love dwarf food. Well, quite like it. Will eat it, anyway. If starving.

Ankh-Morpork now has such a huge population of 'modern' dwarfs that they're having a major effect on dwarf society thousands of miles away. The world changes.

Trolls are a later arrival. Again, they're a slightly adjusted version of classic trolls, who were hairy. They were back-formed from the known narrative fact that trolls turn to stone in daylight or, to put it another way, when it gets warmer or, to put it a third way, their brains warm up and shut down.

No doubt in the far mountains trolls still act trollishly, but those who've made it down to what's hopefully known as civilisation have learned to tread carefully around The Squashy People. They tread even more carefully around dwarfs, since the two species intensely dislike one another with amazing venom; they have been fighting one another in self-defence for so long that no one has had time to do any attacking.

The guarded dislike they show one another in Ankh-Morpork is brotherly love by comparison.

Chrysophrase is chairman of the Silicon Anti-Defamation League, owner of the Cavern Club and a leading figure in Ankh-Morpork's troll community. Completely not involved at all in all kinds of underhand dealings, and do not suggest this unless you are prepared to put your ears where your mouth is.

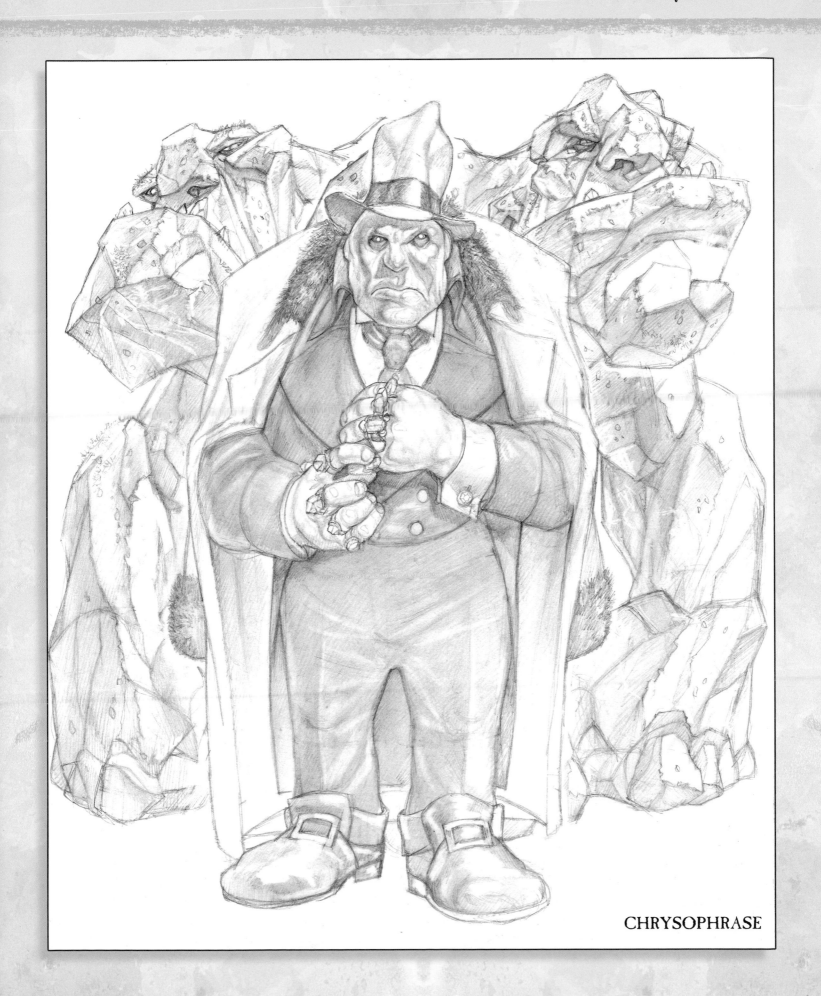

CHRYSOPHRASE

You've Got to Have Dragons . . .

Otherwise how can you tell it's fantasy? To fit all the corners Discworld has two species. There are the noble dragons, which are the classic 'flying dinosaur' variety. They're imaginary, which is certainly not the same as saying that they don't exist. They're rather dull and familiar.

Then there are the swamp dragons, which probably originated in space, where they grow up to several miles long (Errol, the backwards-flaming dragon of *Guards! Guards!*, is a throwback rather than a mutant). They can eat just about anything, are hugely adaptable, breed quickly and enthusiastically, and most of the males blow themselves up in the breeding season, owning to a combination of hair-trigger nerves and a digestive system that is in effect one big unstable chemical plant. I think they're more interesting.

I can't remember how I came to devise them. As so often happens, they were developed by taking seriously something not intended to be serious. But I was greatly impressed by Peter Dickinson's *The Flight Of Dragons*, which sought, gloriously, to explain everything about dragons, from how such big things could stay airborne (they were more or less dirigible) to why no bones have been found.

Paul likes drawing dragons.

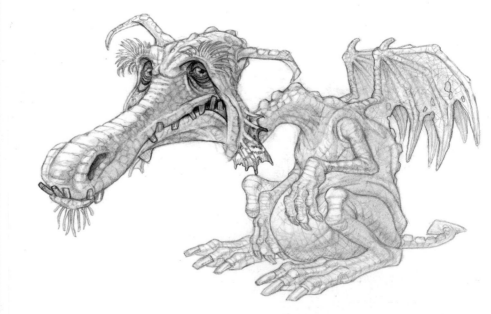

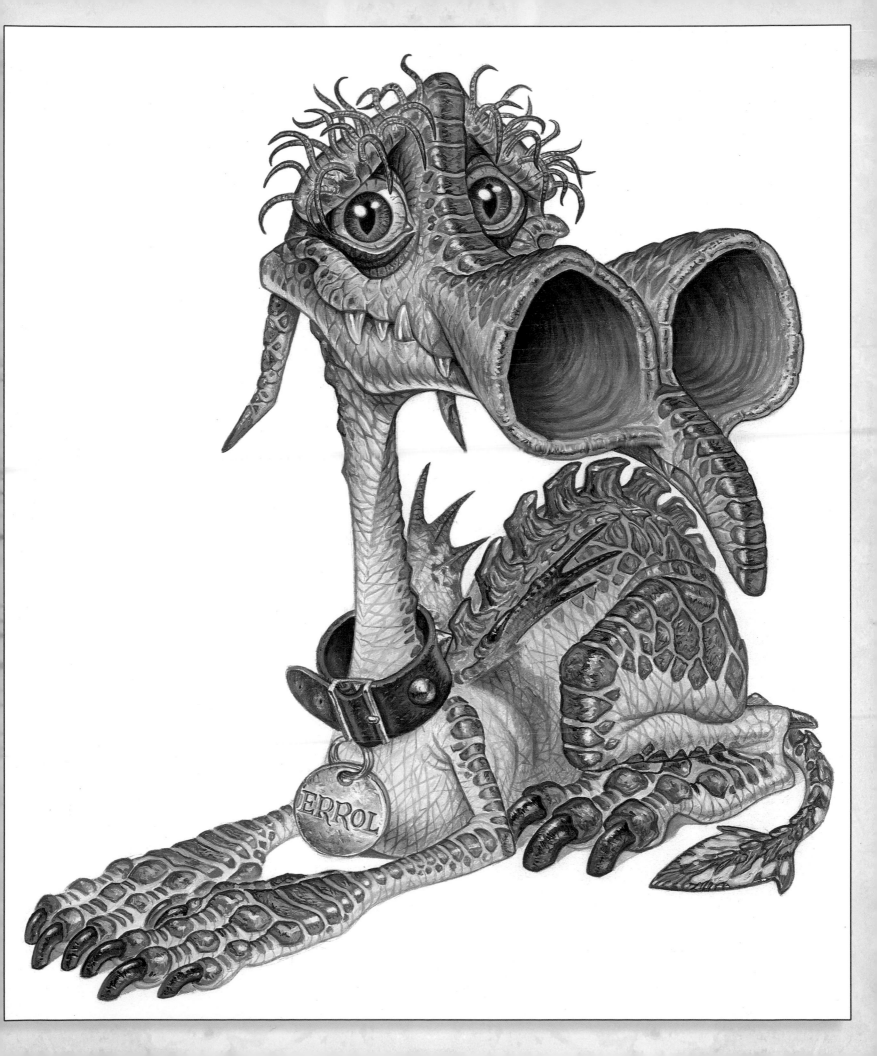

Round-trip Ticket

Discworld began as a genuine tourist trap. I wanted to journey through a familiar fantasy universe where the people didn't stay in character, where barbarian heroes could be old men, wizards could run away and Death could hold a conversation.

A tourist seemed like a good idea, especially if he believes in heroes and wizards and can't quite seem to take on board the fact that the ones he meets aren't like the ones in the books. Hence Twoflower: perennially optimistic, generous, good-natured and firm in his belief that there is something good in everyone. Most of the people he meets, on the other hand, believe that if there is anything good in anyone, it should be found and stolen.

The makings of Twoflower began when, as a young reporter, I used to visit 'newsworthy' local citizens, accompanied by a photographer. I was always amazed at the easy control the man with the camera had with people who really did not want to be photographed. 'Just to your left, just one more, can we have one with the cat, just one more, wider, just one more, that's great, just one more . . .' It must have gone genetic in the twentieth century: anywhere outside an actual war zone, people in the western world are inclined to do what some twit with a camera says.

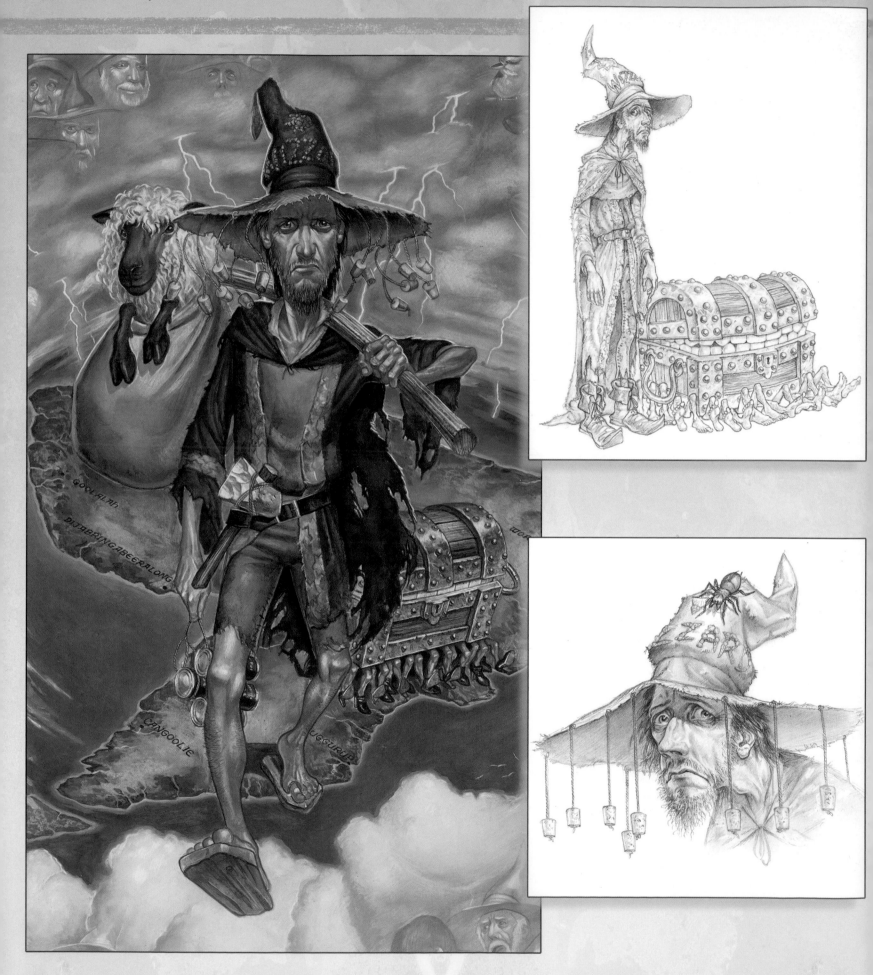

Rincewind

Rincewind's job is to meet more interesting people. Readers still ask for more stories about him, but there's a limited amount you can do with a character who is a coward and doesn't care who knows it. The problem is that he has not much of an inner monologue. He just wants to be left alone cataloguing uninteresting rocks (those who haven't read either of the *Science of Discworld* books should know that he is now the Egregious Professor of Cruel and Unusual Geography, since he's fled over so much of it). He and the Luggage remain icons of the series, though, despite the fact that they are minor players.

The trouble is that people who don't want to be heroes tend to make the best ones, so – sigh – there is at least one future outing lined up for him. He's one of the characters that Paul gets spot-on; Rincewind in Fourecks is exactly right.

I make up or forget explanations about how I invented the Luggage, but somewhere close to the truth is: it was a trick I used when I wrote role-playing games for friends. As you explored your imaginary dungeon, you stored all your loot, spare underwear and weaponry in the Luggage, which, while very useful, *would only and exclusively do what it was told*. At some point you would forget to give it an instruction and it would carry everything away over a cliff. Oh how we laughed. Of course, we had to make our own entertainment in those days.

Really it just turned up from the rather better author who has my brain in timeshare when I'm asleep. All the best ideas happen within a few minutes of waking up in the morning . . .

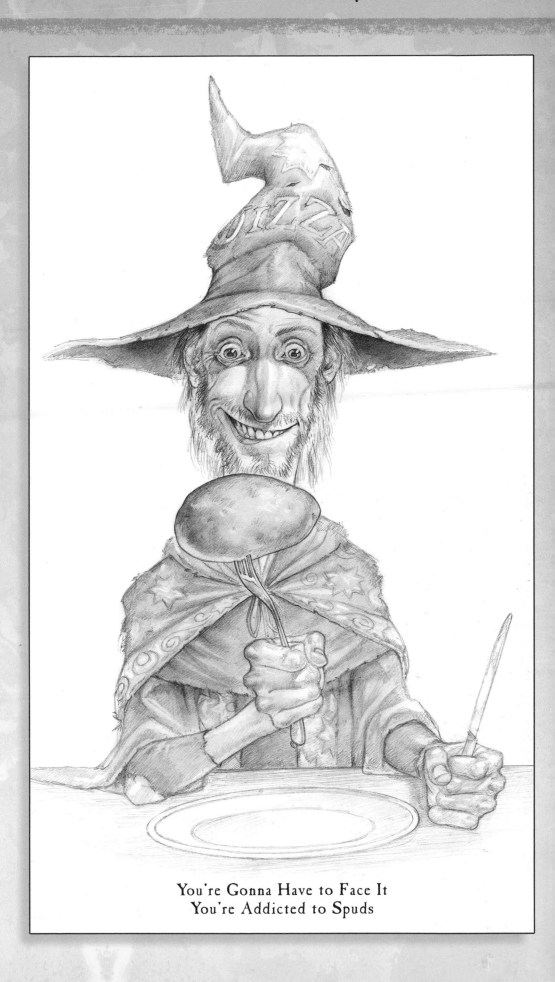

You're Gonna Have to Face It
You're Addicted to Spuds

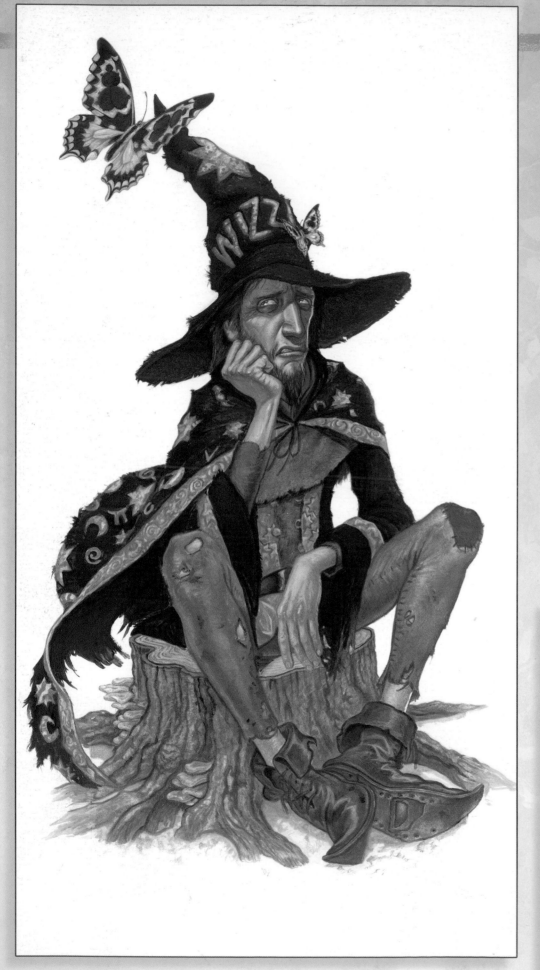

Rincewind

Rincewind is the first character that I ever drew from Discworld; he was so fully formed in my imagination after reading The Colour of Magic and The Light Fantastic that when I sat down to draw him I knew exactly what I wanted to achieve. I wanted my interpretation of this likeable loser to look as bedraggled and scrawny as possible; in hindsight his appearance has similarities to Ron Moody's Fagin, and also Catweasle (a 1970s children's TV character). It was also pointed out to me, at the 2002 Discworld Convention (by a young girl), that his appearance has much in common with Shaggy from Scooby Doo – a comparison I had never noticed but which struck me as true: both have a similar skinny posture and are terrible cowards.

Rincewind Screaming

This is a parody of Munch's famous painting The Scream. The twitchy Rincewind seemed to be the perfect character for this image. It was painted for the paperback edition of The Last Hero; a cropped version was used on the cover with the intention of showing the whole image inside the book. However, it appeared cropped even further inside. So here, for the first time, is the whole picture. Now it becomes apparent why Rincewind is screaming.

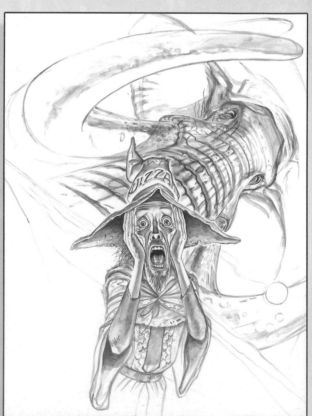

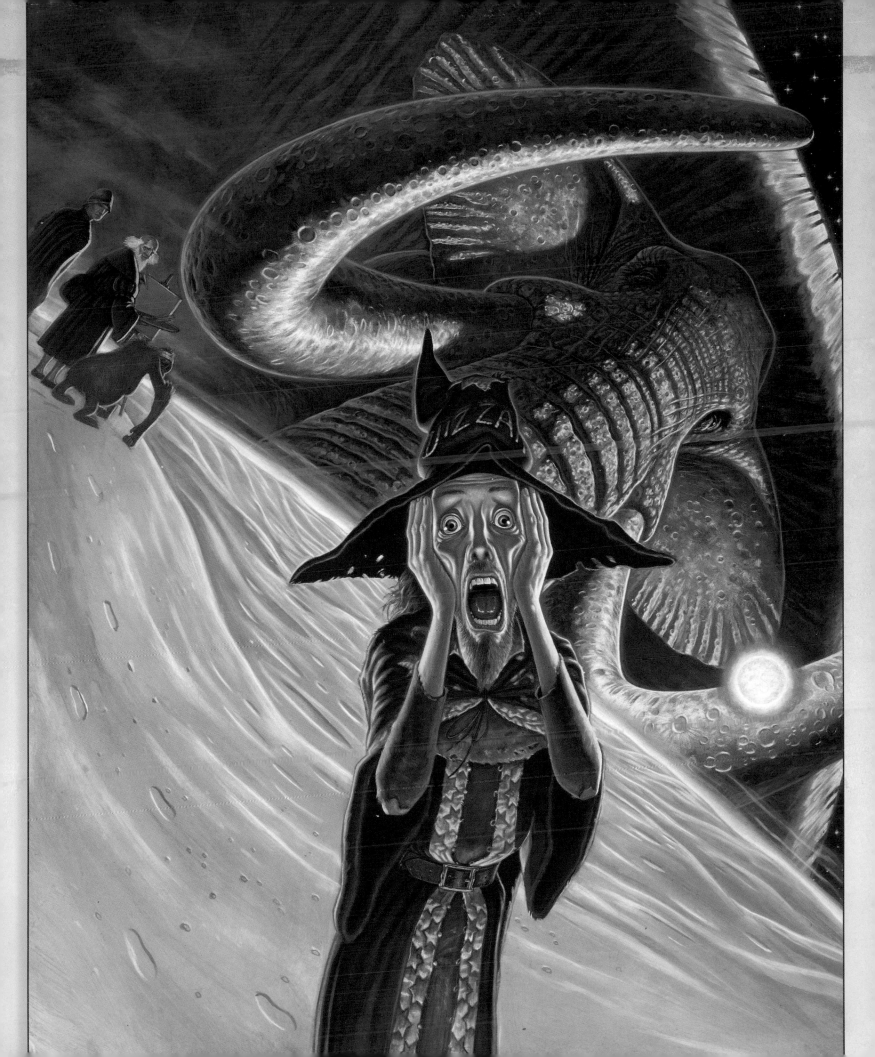

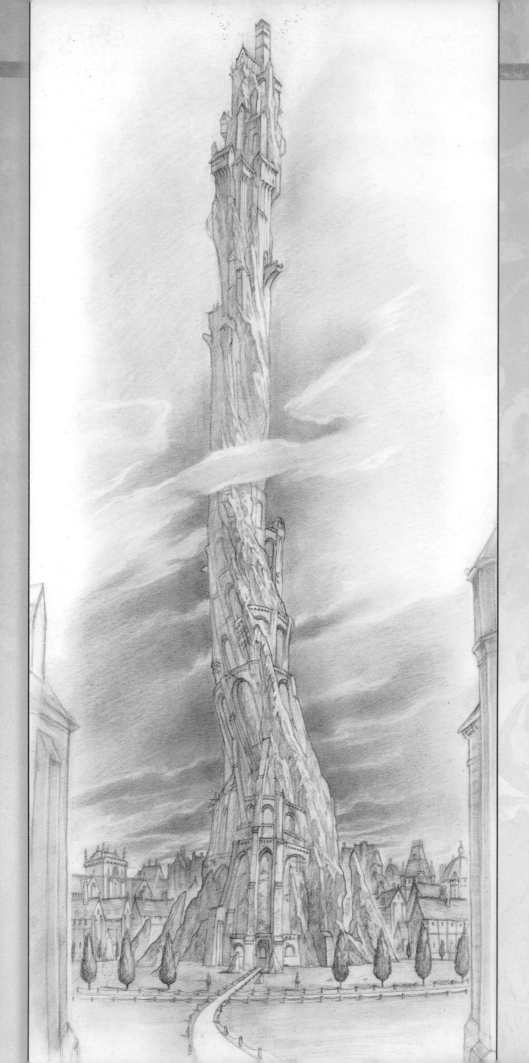

Alma Pater: Unseen University

The name comes from the eighteenth-century association of scientists and other learned men that was known as the Invisible College, of course, and the look of the place is generic Oxbridge.

UU wizards have changed a lot over the series. Its history over the first half a dozen books was positively volcanic, its turnover of Archchancellors quite worrying.

Things changed because, with amazing prescience, I saw no future in a series based around a college of magic and wanted UU to stabilise a bit to give me headroom for other stories. Officially, the reason was the accession to Archchancellor of Mustrum Ridcully and the development of the High Energy Magic Building, factors which led to a serious drop in the UU custom of killing your way up the academic ladder. The university has evolved along with the city under Vetinari; you can no longer afford to have a bunch of maniacs running the place because that's bad for business.

Ridcully runs UU with a light touch and a loud voice. UU teaches the use of magic, but also its non-use, which is quite hard. UU exists to *be*, rather than do, and Ridcully seems to be good at giving his colleagues harmless things to occupy their spite, like committees.

As with Ankh-Morpork and Discworld as a whole, UU was intricately defined long before it had any concrete form (which is how it should be). It has even been modelled, in a limited edition which now changes hands for serious money. It was accurately made down to the removable bricks in the wall used by student wizards to get inside after curfew.

There is no government interference. Not even the city's most notably insane Patricians have tried that. Currently the University agrees to pay taxes if asked, and the city agrees to forget to ask. The place is academic heaven, in fact, since the whole unspoken purpose of UU

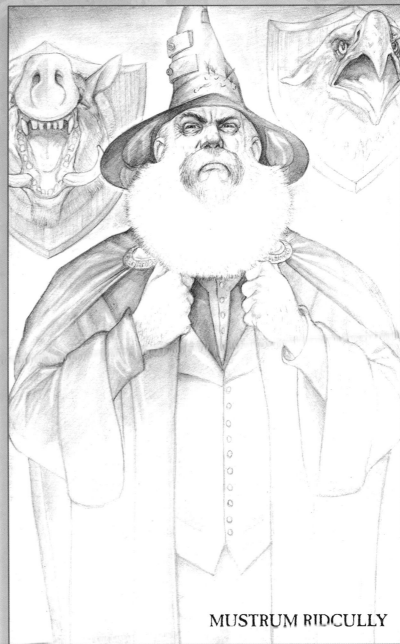

MUSTRUM RIDCULLY

Wizards

is to give wizards something less destructive than murder with which to busy themselves. Wizards don't lend themselves to organisation; paperwork is for piling up, not reading, and if you snuck in, found an empty office, looked busy, turned up for meals and could hold your end of a conversation you could probably merge seamlessly into the fabric of the place. I'm told that this was still just possible at Oxford in the Sixties.

Mostly, these days, wizards come from UU, although it is known there are other colleges of magic, including the up-and-coming Braseneck College in Pseudopolis.

Senior wizards tend to run to fat, or at least waddle to stoutness. UU does have a large gymnasium, which is there if anybody wants it. If nobody wants it, it isn't there.

They seldom do any magic above the level of illusion or small-scale levitation and fire-lighting, because doing anything much more serious is like taking one card out from near the bottom of a house of cards; the card you're taking is

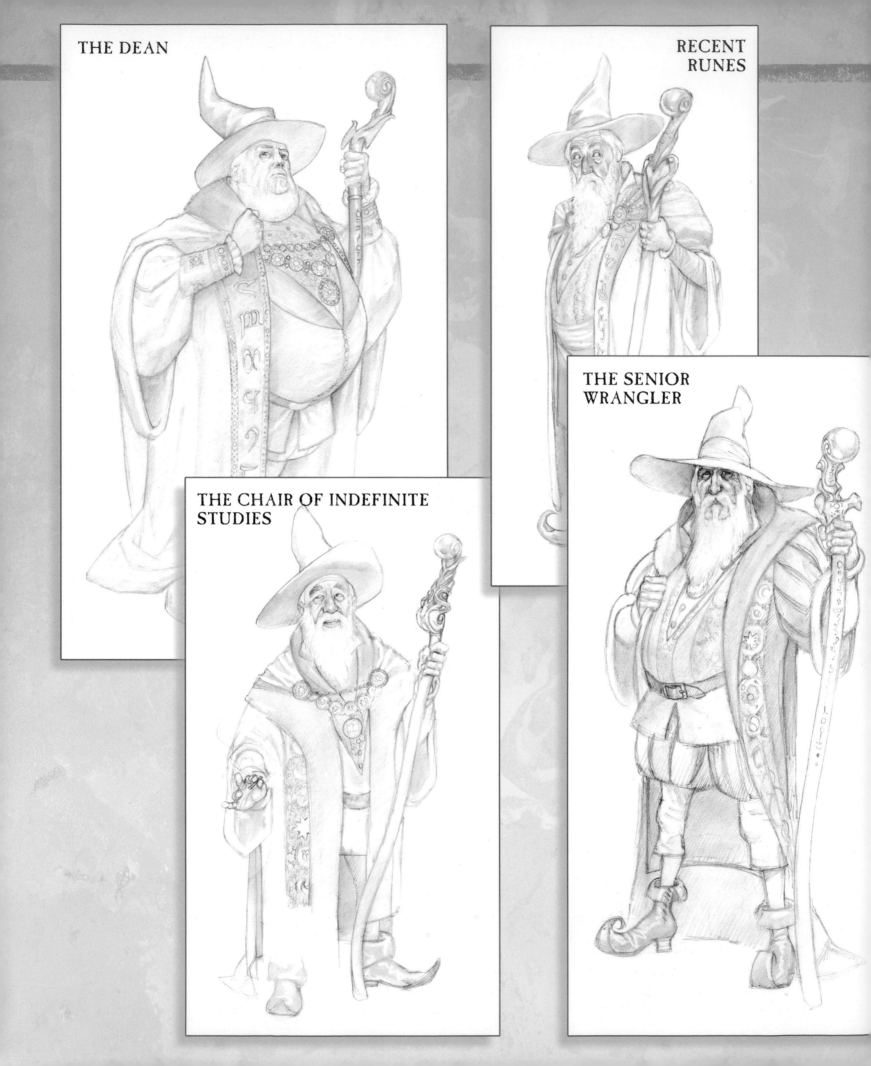

THE DEAN

RECENT RUNES

THE SENIOR WRANGLER

THE CHAIR OF INDEFINITE STUDIES

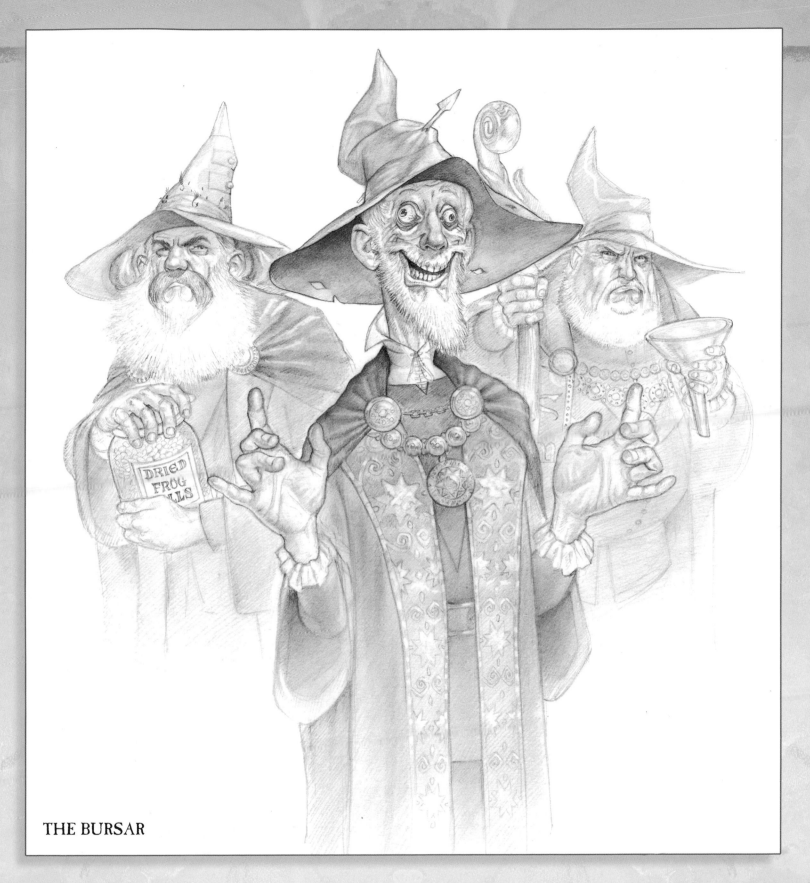

THE BURSAR

not the one you need to worry about. And now imagine that all the cards are razor-sharp.

Increasingly, these days, the thaumic side of UU has tended to revolve around the High Energy Magic Building, a purpose-built modern design which, therefore, leaks and sheds windows in a high wind. Many important discover-ies, including the sushi pizza, have originated there, and new developments are pushing back the boundaries of magic. Almost daily, quite large boundaries are pushed back almost twice as far as hitherto. Many of the discoveries are of immense benefit to humanity, or at least that part of it that lives in UU. The place even has central heating now . . .

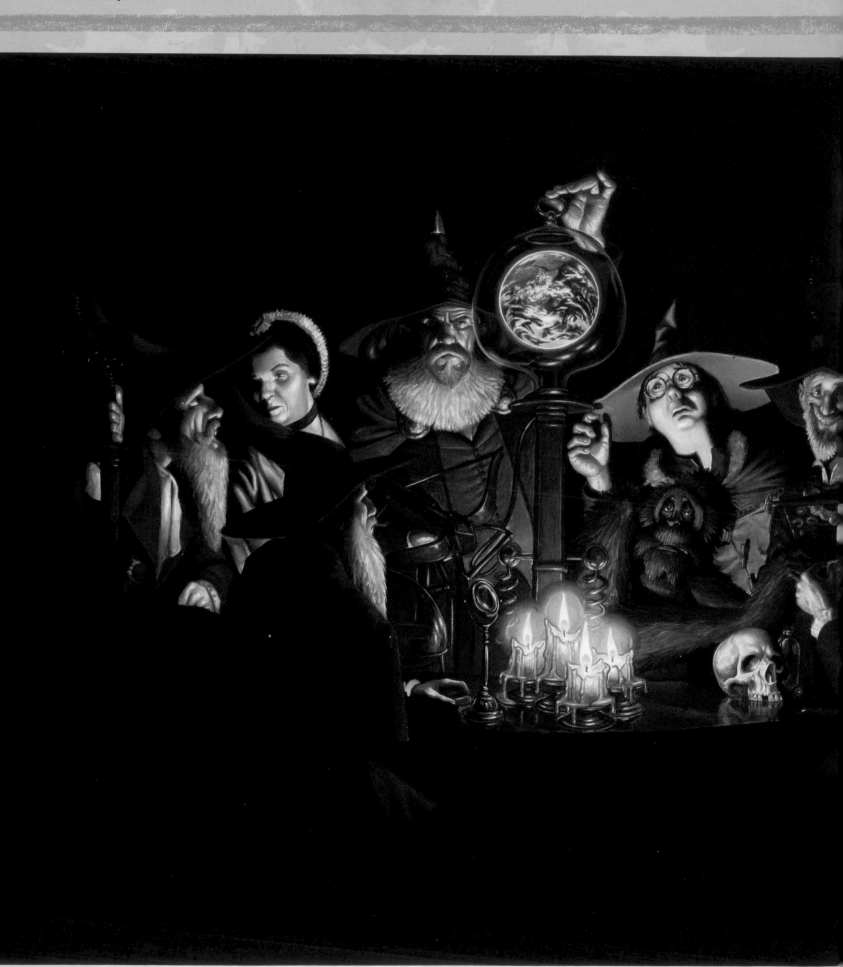

The Science of Discworld I and II

These two volumes, soon to be joined by a third, were written with biologist Jack Cohen and mathematician Ian Stewart, who did the science. I did the fiction. The springboard for it all was our belief that most people on Planet Earth think about the universe in ways that are far more appropriate to Discworld than to this reality.

I'm not sure now, since early planning consisted mostly of shouting to get a word in over a variety of Eastern foods, how we came to think of it. In reality Jack and Ian included just about anything that they thought was interesting, and since this means 'everything', the projects have been fun.

My job consisted of saying things like 'I don't believe that', 'That bit needs explaining' and 'Is that true?' Each book also contains about 30,000 words of 'canonical' Discworld story and gives me a logical (for, of course, a given value of 'logic') way for Discworld characters to interact with people from history. They fit in easily – as can be seen by Paul's pastiche of Wright's *Experiment with an Air Pump*. It appears that big men with beards who throw their weight around and act as though they're the top brains of the universe are at home in any century. Attitude plays a part

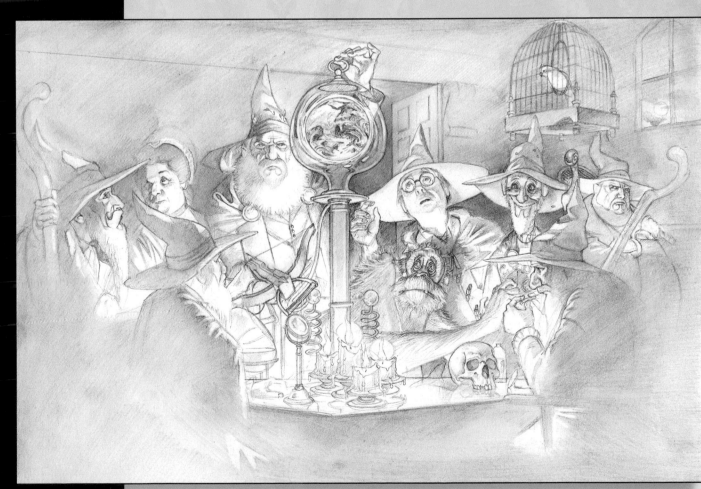

The Tech of Discworld

Discworld is a magical place, but little use is made of the stuff on a daily basis. Why? Because it's dull, unreliable and, if done properly, so incredibly hard to do that it's probably best to give up on the frogs, get your hair done, pay attention to make-up, posture and wardrobe and try for a real prince from the word go.

Magical creatures are allowed: the very best watches are pedal-driven by imps, which can also be bred to paint 'photographs' (iconograpy) and run a whole series of PDOs (Personal Dis-Organizers), each one with even more annoying features than the last. HEX, the thinking engine at Unseen University, still uses ants' nests and thousands of feet of glass tubing, but has redesigned itself so often that it is more or less completely magical (technically, it's a 'Cargo Cult' object; the wizards built something that looked sufficiently like a computer that computerness entered into it).

But generally, in a world where steam is so far unharnessed and electricity is used only by madmen in gothic towers or for sticking cats and small children to the ceiling, great ingenuity has to be used. Several generations who have grown up in an electronic world probably don't realise how sophisticated the non-electric (let alone non-electronic) world became. The Grand Trunk, which consists of more than 350 semaphore towers, is the Discworld's telegraph system and early Internet. It's expensive to use and expensive to run, but its engineers have already mastered the art of sending pictures. There's no magic in it whatsoever, except . . . well, maybe there is, of a sort. The wizards have Omniscopes, intensely magical mirrors that can see anything, anywhere. They are magical, and therefore not very interesting. Magic often isn't. It doesn't show the working, as my old maths master used to rant. But for the aforesaid apes who weren't very good at staying up trees to eventually come up with the technology and organisation to get a picture a thousand miles in a couple of hours *is* magical, in its way.

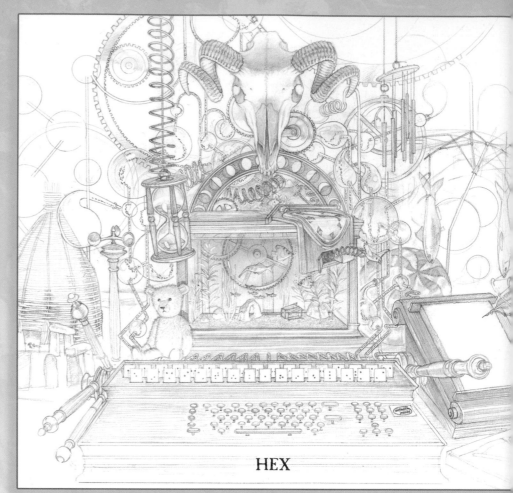

HEX

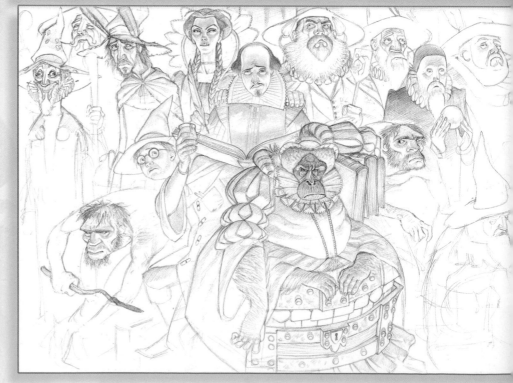

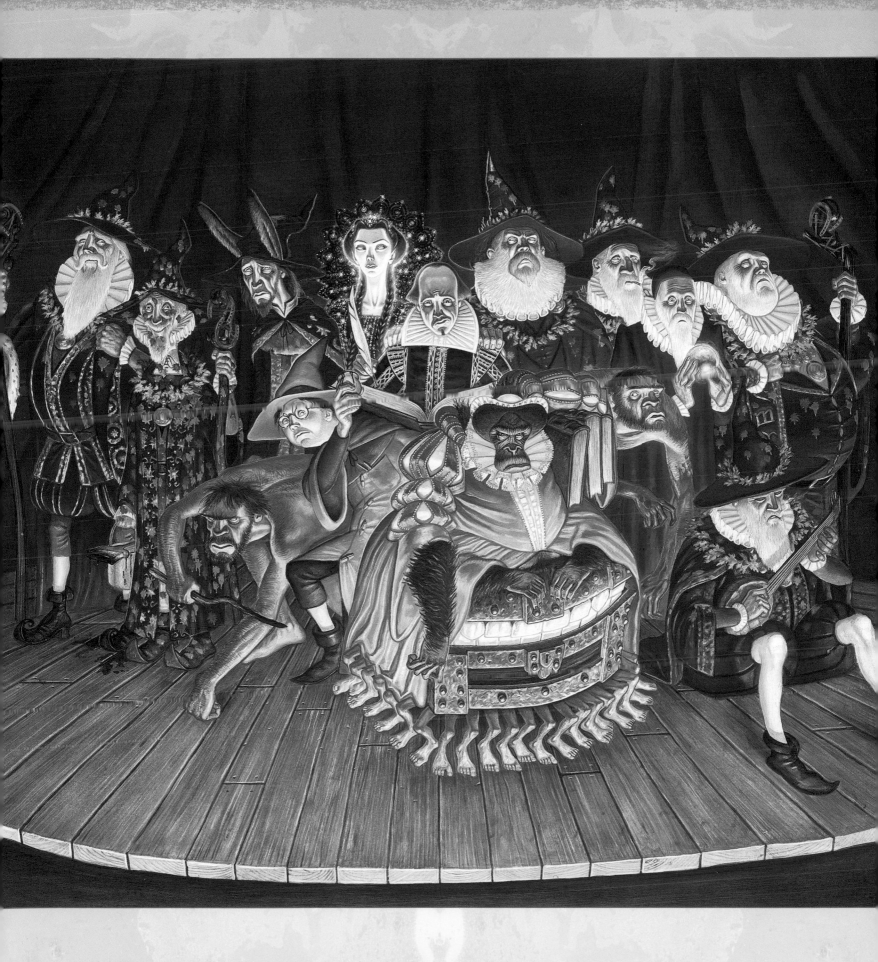

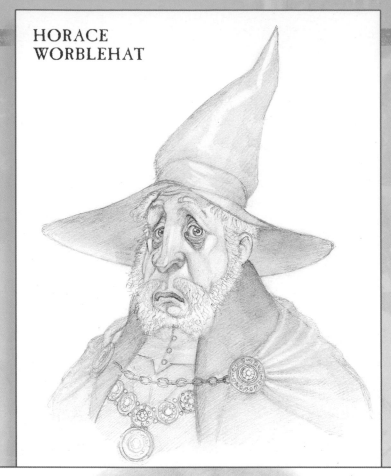

HORACE
WORBLEHAT

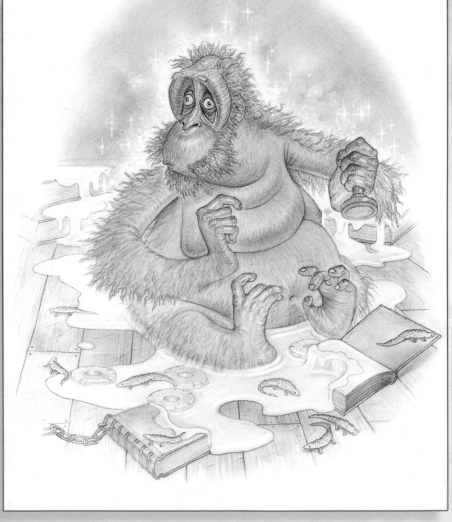

The Ascent of Man:
The Librarian

Discworld views on evolution hold that monkeys are clearly descended from humans who just couldn't be bothered to make the effort. This may well be wrong. But the Librarian of Unseen University is quite possibly descended from Dr Horace Worblehat, who led a blameless life before a magical accident ripped his genes.

This is subject to confirmation, because the Librarian is very happy as an orangutan and is worried that his old name could be used to turn him back into human form, in accordance with ancient magical practice. He has even gone so far as to deface UU records in an effort to cover his evolutionary tracks. His fears are groundless, but anyone with a name like 'Worblehat' clearly has a past they have no wish to revisit.

In any case, everyone is now quite comfortable with the idea of an ape running the largest library in the universe (it contains every book that has ever been, will be or potentially might be written in any language in this or any possible universe, although of course some of them might take a bit of looking for). The Librarian takes a keen interest in city affairs and is still a Special Constable in the City Watch.

An amiable character, he is welcome everywhere. Few doors are closed for long to a 300lb orangutan.

He was made up for a joke. Sadly, that's how it goes. I needed to turn a librarian into something funny, and an orangutan was good enough (having met real male orangutans in the wild, I now know that laughing or exposing your teeth in any way is not a sensible thing to do).

He is not alone. On Discworld, Death and Nanny Ogg were made up on the spur of the moment, more or less to make a scene work. Sam Vimes was never meant to be a major character. Lord Vetinari just happened. And then they go off and become favourites, while the author wonders what happened.

Like the Luggage and, indeed, Death, he has to be used sparingly. I get lots of letters from people who want to see him as a central character in a future book. Sadly, this is unlikely to happen. If a character has to carry a story, you need to be able to see their thoughts. An inner monologue consisting of 'ook' will not take us very far. Besides, he functions much better when you *can't* see what he's thinking.

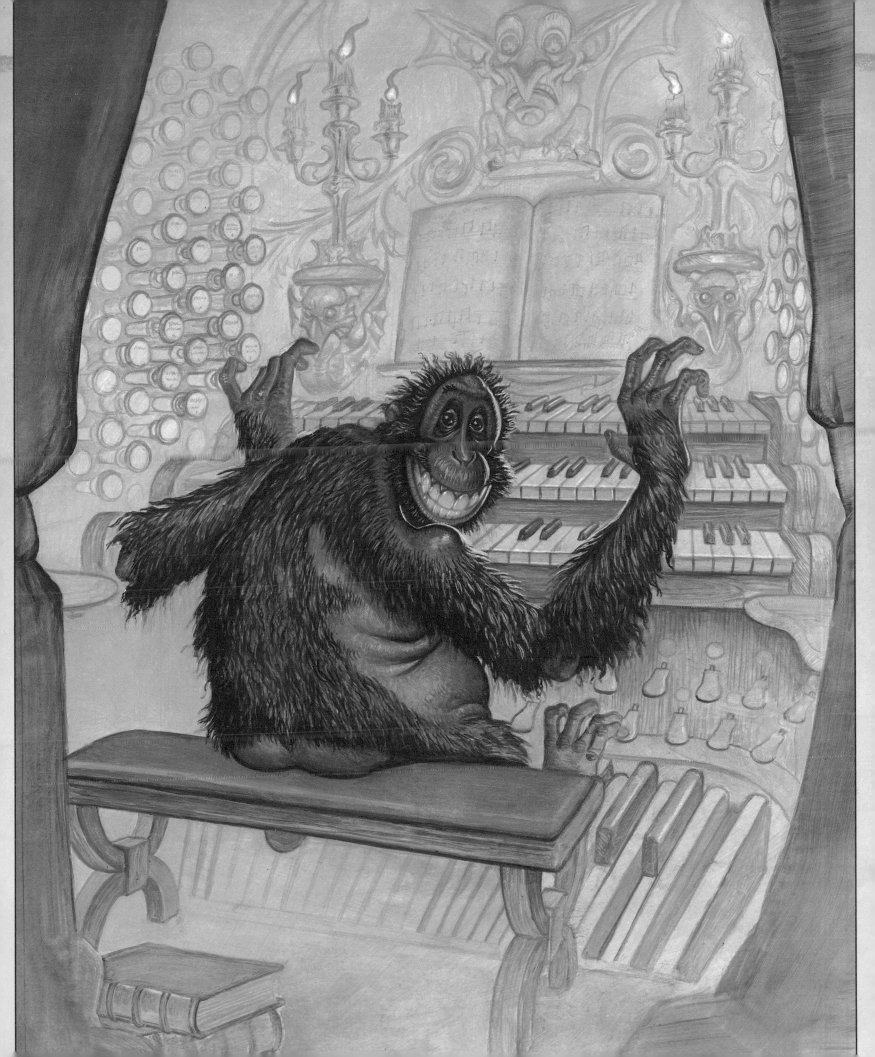

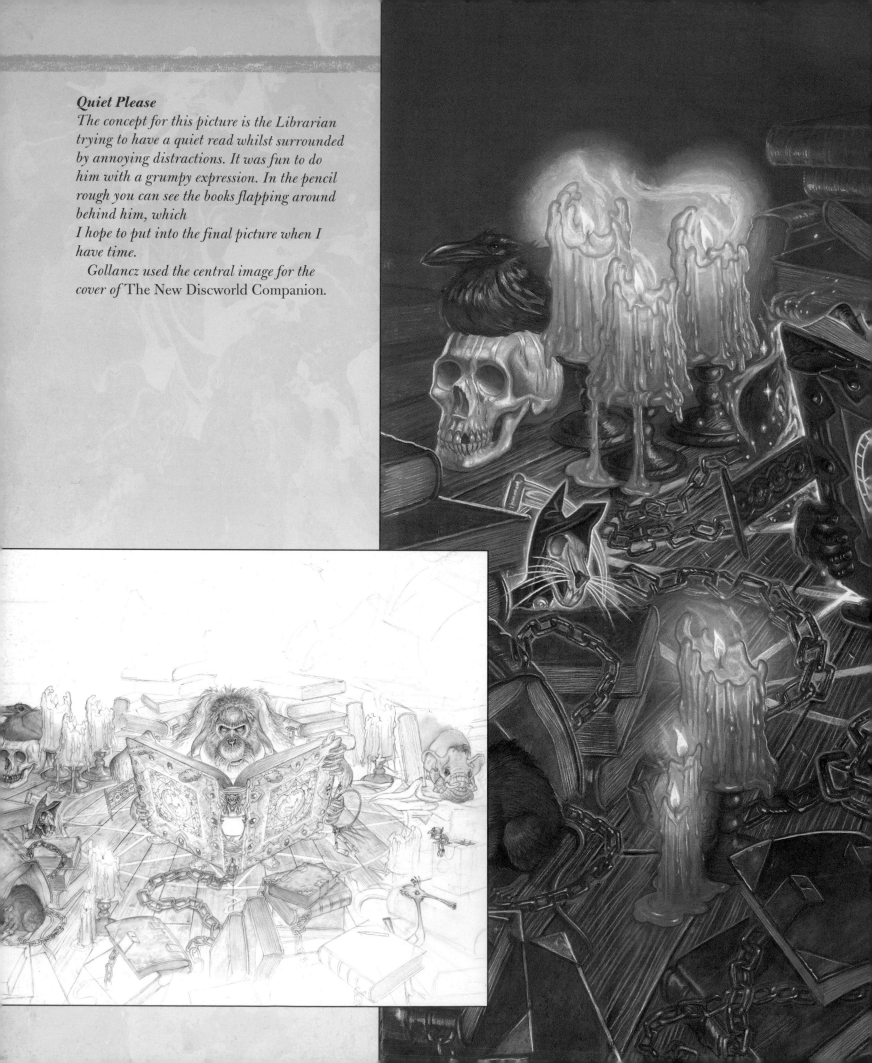

Quiet Please
The concept for this picture is the Librarian trying to have a quiet read whilst surrounded by annoying distractions. It was fun to do him with a grumpy expression. In the pencil rough you can see the books flapping around behind him, which
I hope to put into the final picture when I have time.

Gollancz used the central image for the cover of The New Discworld Companion.

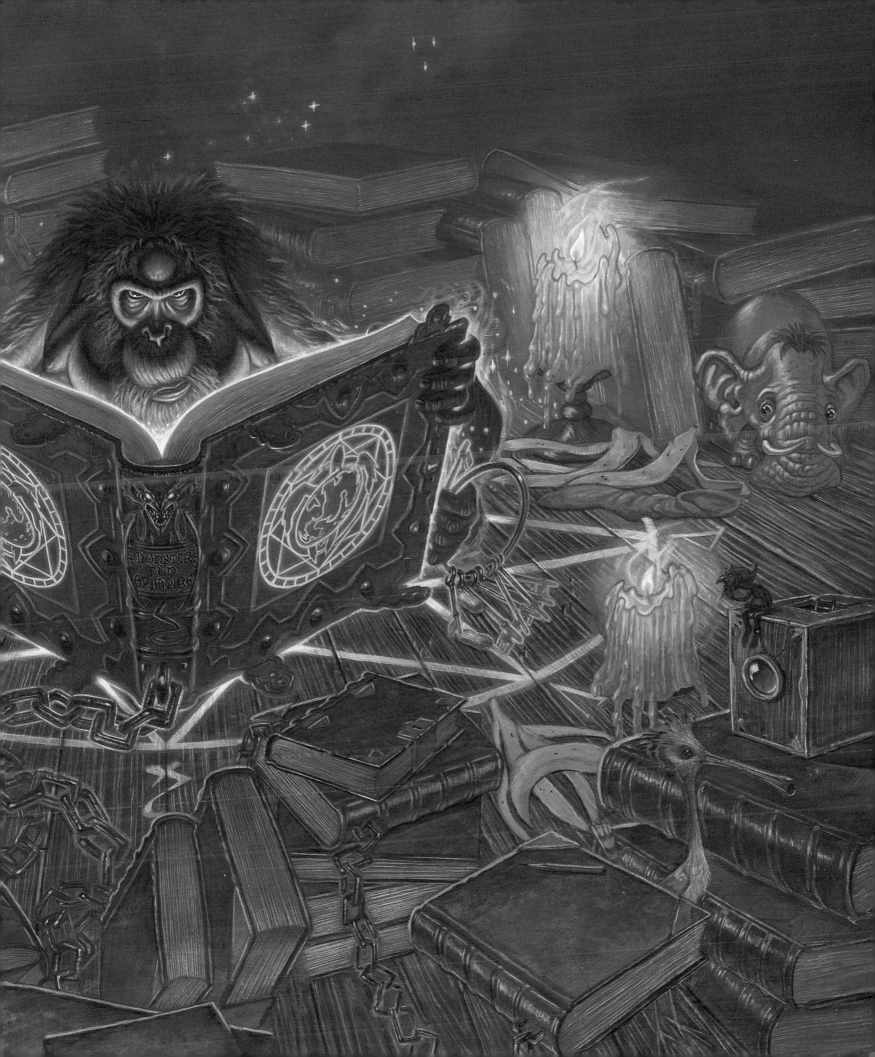

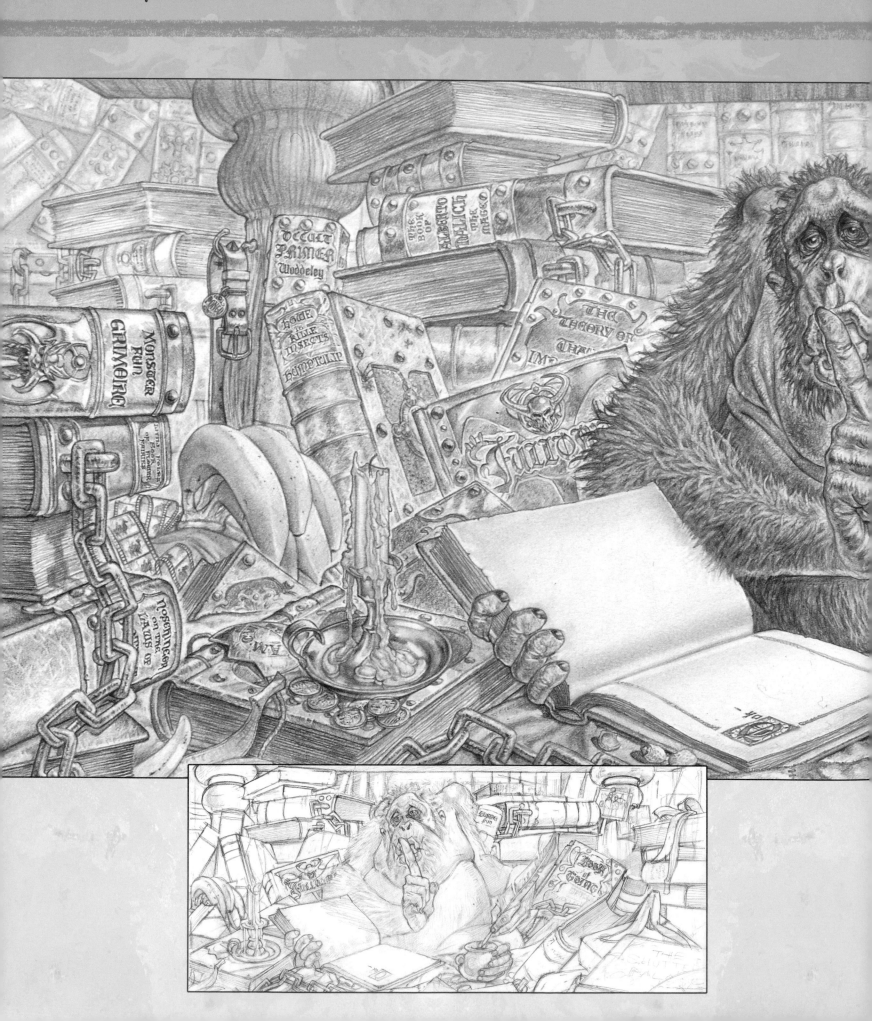

The Librarian

The Librarian took shape after looking through books on primates, watching nature programmes on television and a trip to Monkey World in Dorset to watch the orangutans. From my earliest sketches through to the most recent pictures of the Librarian you can see his development. Male orang-utans normally have large cheek pads to signify their dominance, but because the Librarian is not dominant (for reasons established in the books), I gave him a pronounced brow instead. This seemed to emphasise the look of an orangutan.

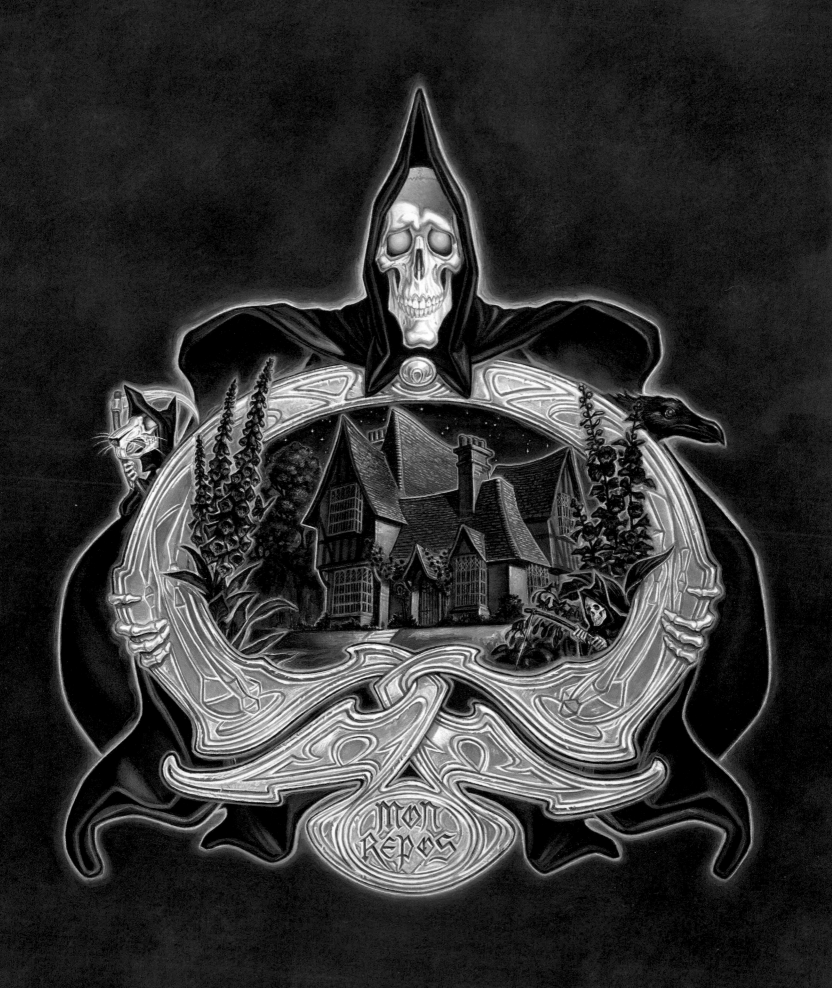

Death and Company

Death turned up in the Discworld books in order to make a joke work. That was in *The Colour of Magic.* Suddenly he was and, twenty-one years later, still is one of the most popular characters in the series. People ask me to forge his signature in books. Sometimes I get nice letters from people who know they're due to meet him soon, and hope I've got him right. Those are the kind of letters that cause me to stare at the wall for some time . . .

Anyway . . .

One thing leads to another. People say, 'Oo, you must have an imagination', but a lot of Discworld works because of a carefully applied *lack* of it. The approach is, literally, childish. Adults suspend disbelief; kids ask questions and require answers. If Death rides a white horse, where does it live? Does it go to the toilet? (A question of perennial interest.) How can he be in one place and everywhere at the same time?

And so by degrees Death's household, home and gardens were fleshed, as it were, out.

The Discworld version runs like this: Form defines function. If we personify Death we get a creature that will have, in some measure, human traits – like curiosity. He'll want to find out what makes humans tick, being well aware what makes them stop.

It's a moot point if Death can have emotions, but he does appear to be sentimental. Certainly he seems to be increasingly uneasy in his role and has been known to bend the rules very slightly, but who knows what he really thinks?

Thus Death's Domain was created. It has no precise location, although of course it is really, *really* close at hand. It looks familiar. It appears to be a gentleman's country house. But the seasons are optional, and are different in various parts of the garden. And no matter how bright and spring-like it might be, there is always a hint of late autumn.

Death can create nothing, but can copy anything. That is less useful than it might appear, because he can only copy what he sees. That's brought home to visitors who use the bathroom in his house; it is, of course, splendid, but Death didn't know that pipes were meant to be hollow and towels weren't meant to be rigid.

MON REPOS

WELCOME

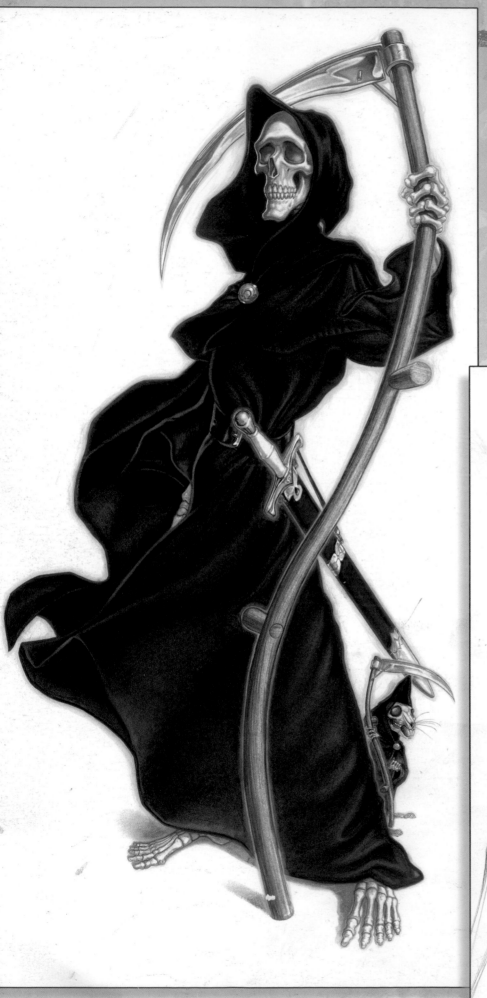

Outside there is a maze, although Death can't get lost, and a golf course, even though he has to try very hard not to win at games. His only weak spot in this area is in chess, when he always forgets how the knights move.

People laugh at Death – I should know, because when he did a tap dance in a professional Czech production of *Wyrd Sisters* the audience insisted that he come on for an encore – but skulls, although they grin, aren't very funny. I've always been pleased with the way Paul draws him – clearly a skull, and certainly grinning, but nevertheless kindly disposed to the viewer.

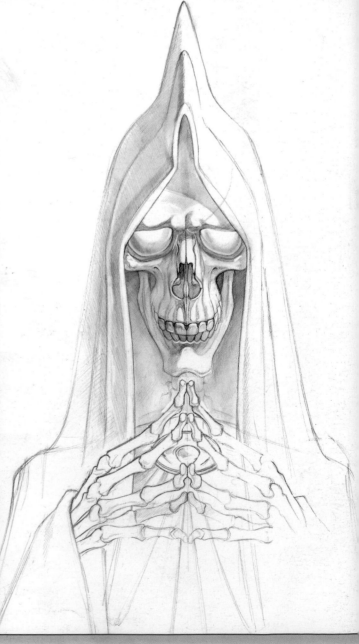

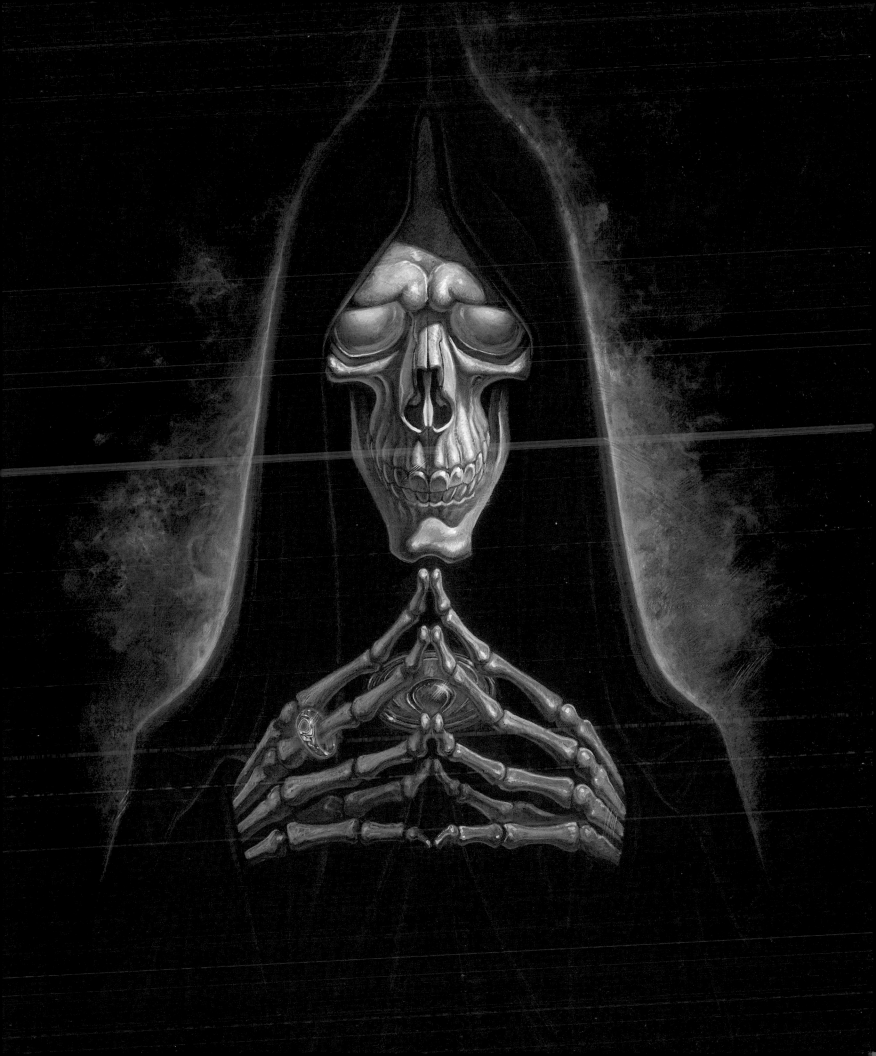

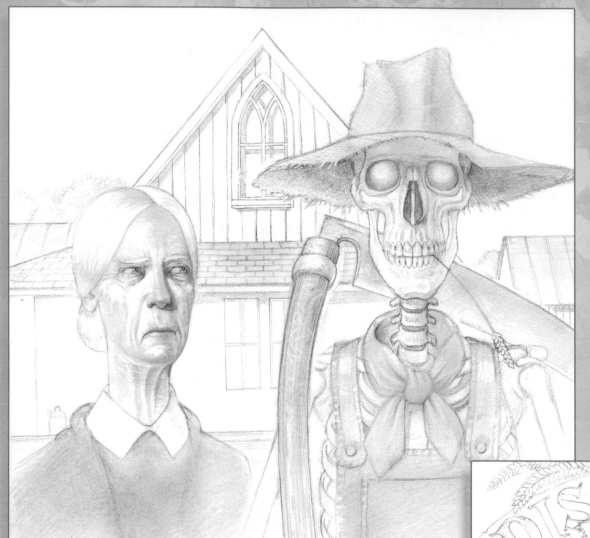

Lancrarian Gothic
This is a parody of Grant Wood's American Gothic, *one of the most famous paintings in the history of American art. This was an idea of Terry's and I enjoyed trying to capture Miss Flitworth's expression.*

Death
Death is one of my favourite characters: he has evolved over the years I've been drawing him. It's always fun to illustrate Death because you are working against hundreds of years of established iconography depicting the Grim Reaper. Terry has made him so endearing that it is always a challenge to capture those characteristics that make one sympathise with him, rather than eliciting the standard reaction to a skull.

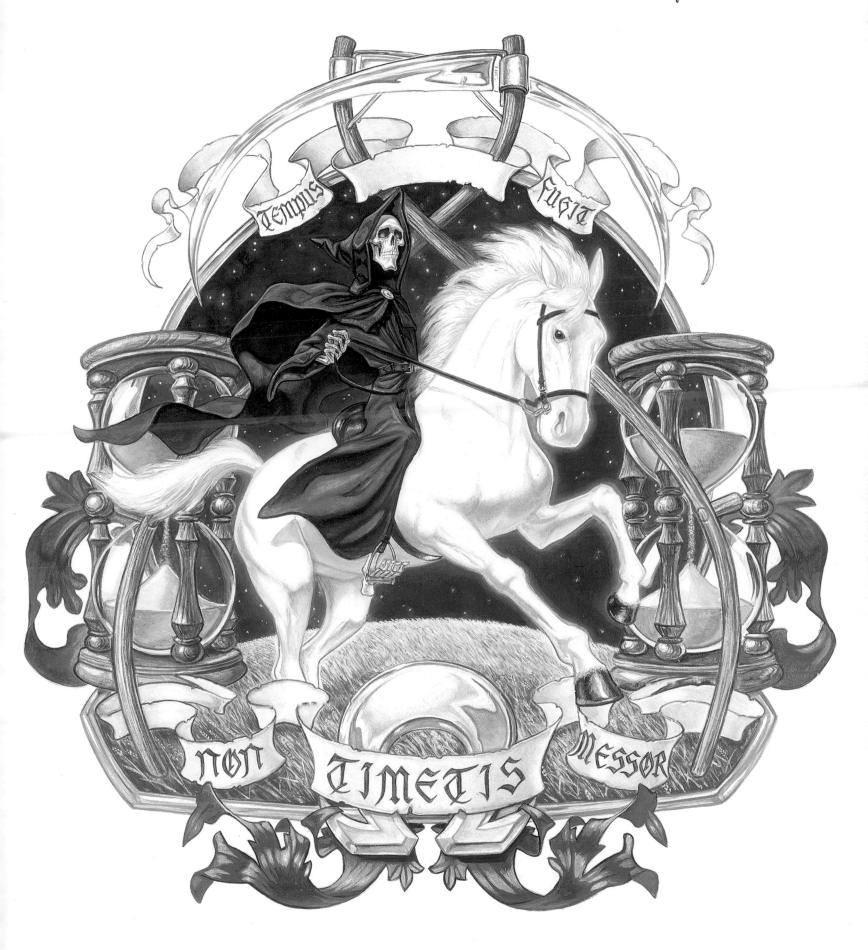

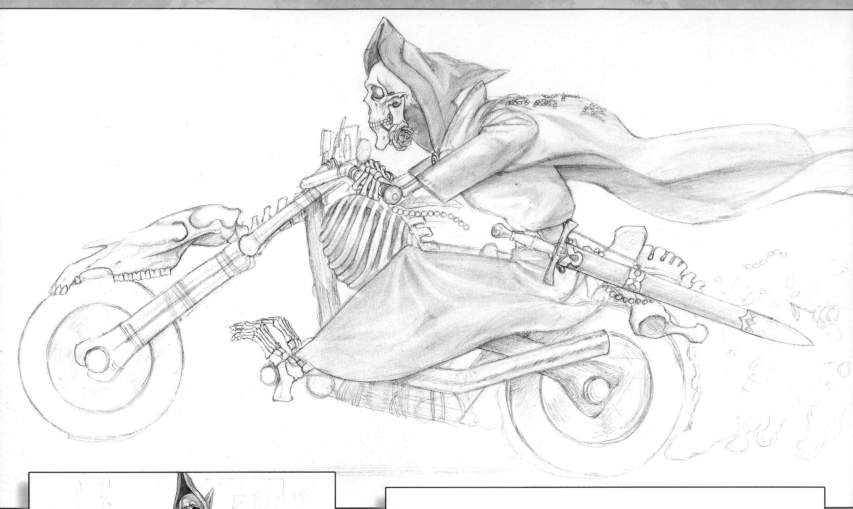

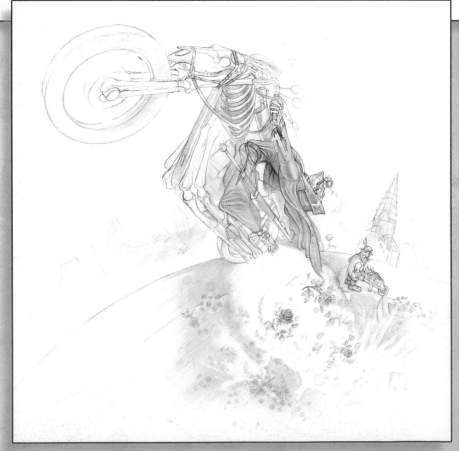

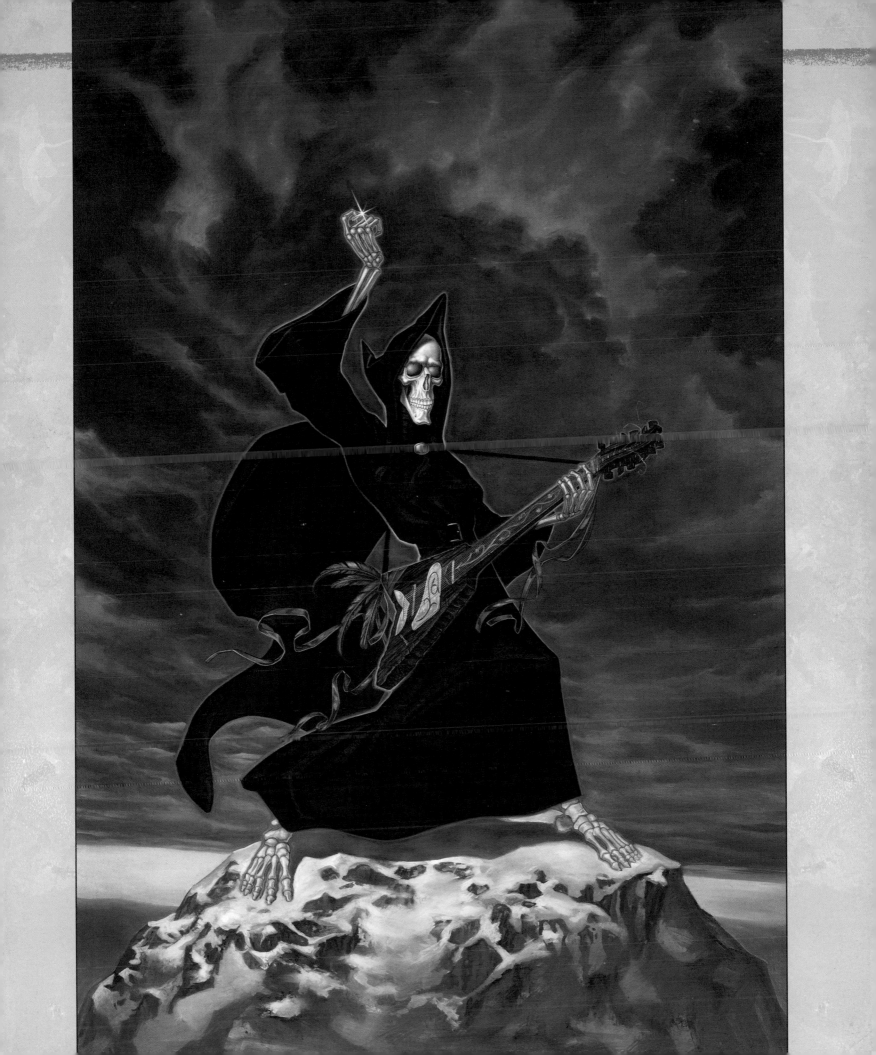

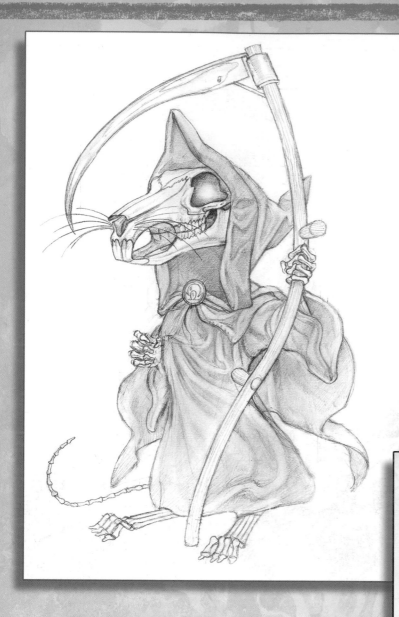

The Grim Squeaker

It's the hood. There's something about the snout coming out of the hood that's funny. Sorry, but it is. And so another character joined Death's household.

A warning to young writers: always be careful of the minor characters you create, because you may still be writing about them years later. But you can't help having a soft spot for a character so resolutely cheerful who comes with his own dialogue.

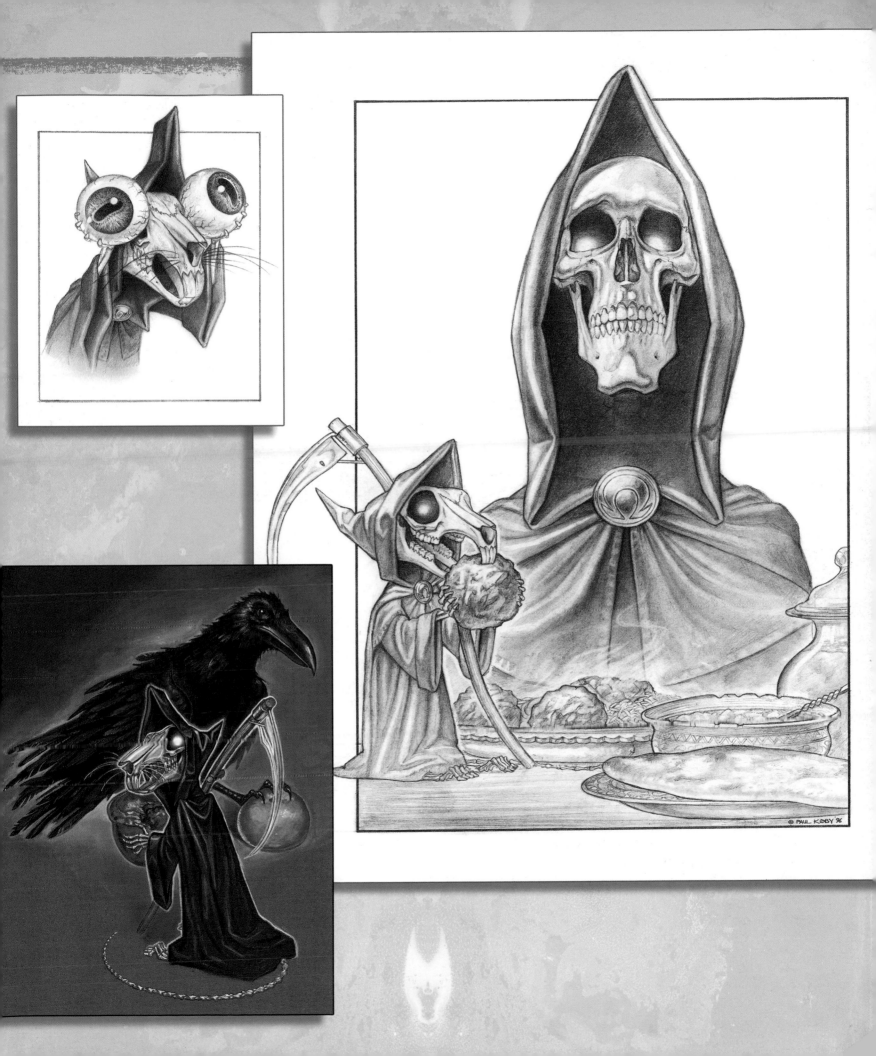

© PAUL KIDBY 96

Albert

Once a powerful wizard, now a cook, valet and gardener, Albert reckoned it's better to be by Death's side than in his way. As a former wizard, in the times when they were not as gentlemanly as they are now, he made a lot of enemies. Quite possibly, he made a lot of enemies dead. He is in no hurry to catch up with them again.

As Death's manservant, immortality of a sort is part of the job, and his duties are easy. There's probably not much in the way of laundry, and while Death has been known to enjoy a curry, he's really only a social eater. If he *did* eat, it's doubtful whether he'd eat anything cooked by Albert, who fries more things than a Texan grandmother – he will even fry porridge.

Albert has hidden depths, although it's probably not a good idea to fish around in them.

He's Checking his List
When painting this I really felt I had finally achieved the look for Death that I had long been trying to capture.

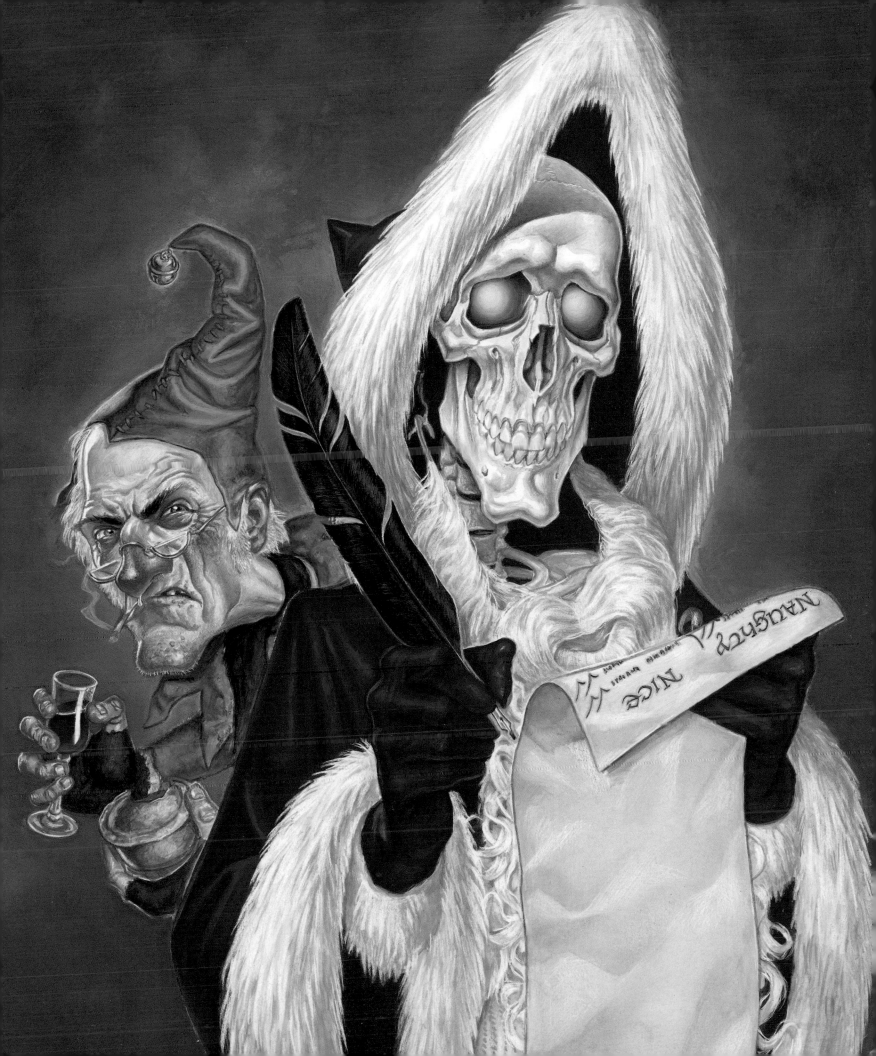

Mort And Ysabel

Death's former apprentice married Death's adopted daughter. They had a daughter, and what appears to have been a happy life together, and then they died.

Presumably they then went somewhere else. Death refuses to be drawn on subjects of this nature.

Mort
Mort's appearance had to be developed so that I could age him for the Family Values *painting. Terry had specified that he should wear pantaloons, so I gave him an Elizabethan appearance.*

Ysabel
Another drawing produced to develop the look of the character prior to starting on the Family Values *painting.*

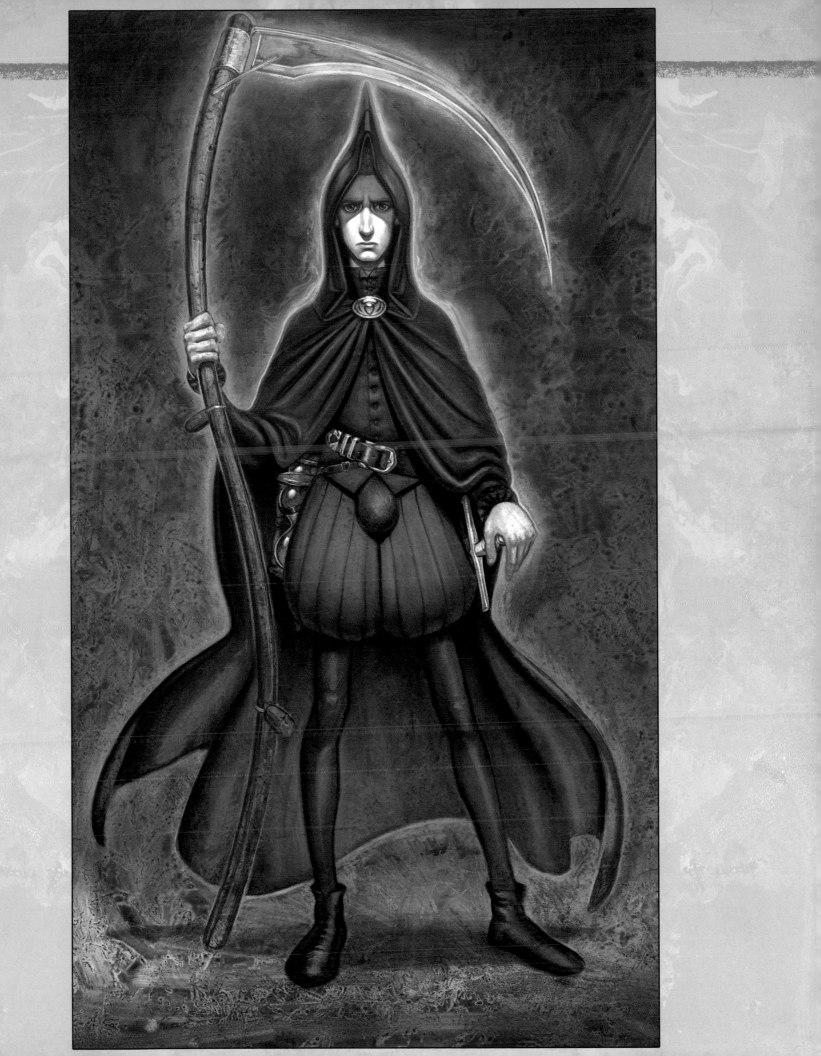

Susan: It's In Her Bones

Susan Sto Helit, Death's granddaughter and off-spring of Mort and Ysabel. Ordinary genetics should not allow any supernatural traits to be passed on, but things are different when there's a Death in the family.

Certain . . . *talents* have been handed down.

So, by day, she's a not-at-all mild-mannered teacher. But sometimes tiresome duty calls. She can step outside time. She has a foot in this world and the next. She can see bogeymen, tooth fairies and other twilight creatures, and, if necessary, hit them hard. She can walk through walls. It's hard to stay human with a life like that.

On the positive side there's plenty of time for marking, classroom discipline goes without saying and history and geography lessons have a genuine extra dimension. Susan prefers to teach younger children, because when they go home and report 'Miss Susan took us to this old battle and there were men in armour and everything and you could see the heads being chopped off and everything and then we did Silent Reading', parents are more likely to say 'what an imagination the child has' than call the Watch. Parents' Evenings at her school are subdued affairs; parents go along to be told by Miss Susan how they are doing, and may well feel they're not shaping up.

Teaching, for Susan, is an anchor in reality. The mixed smells of chalk, salt dough and elementary toilet training are a powerful antidote to the timeless twilight world of her other life.

Susan was another character who developed with the books. She's rather chilly, partly because I can't write 'soft' female characters easily (they're all tough underneath) but also because, well, she'd have no other choice. It seemed to me that when you find out that Death is a relative and you have some talent for doing his job you can either go totally mad or completely sane, which can be more frightening. She's ending up, via that unconscious evolution that dogs my characters, as a kind of Goth Mary Poppins.

Paul nicely picks up that 'steel magnolia' look, the feeling that a word out of place will be your last . . .

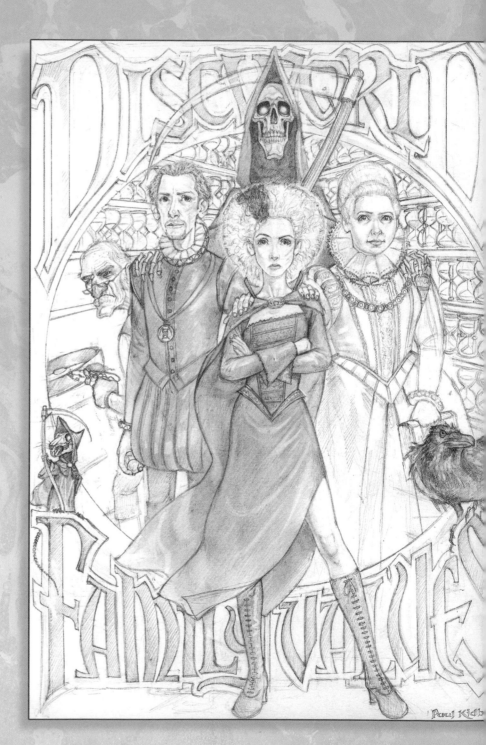

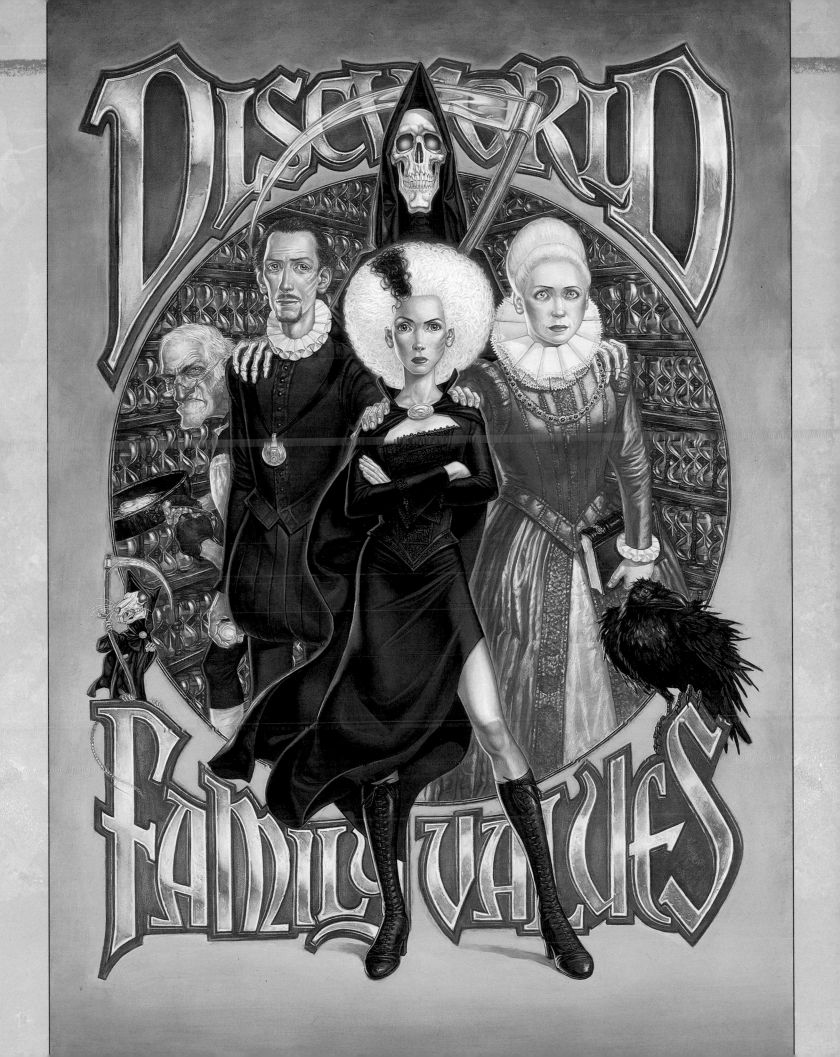

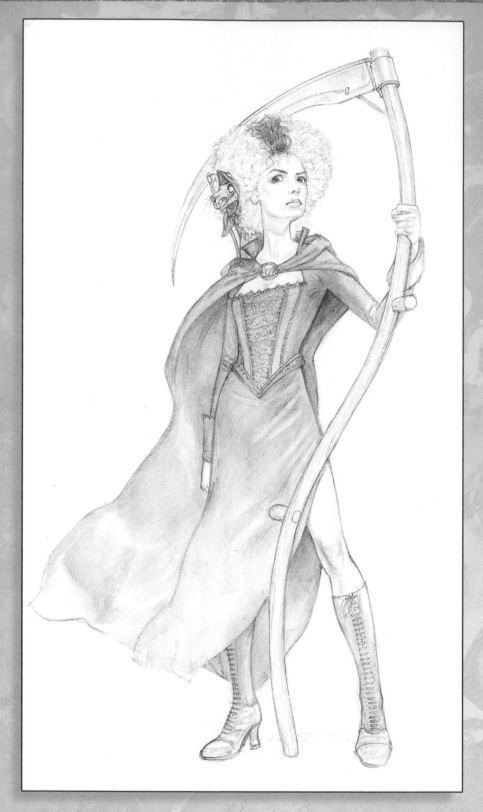

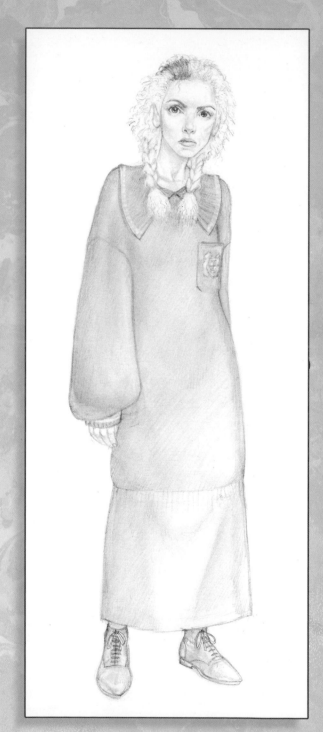

Susan II

I drew this version of Susan to develop her costume, posture and physique in preparation for the Family Values picture. She exudes more of the attitude of Death's Granddaughter than the picture on the right where we first see her, in school uniform.

Susan from Hogfather

This is my rendition of Susan as she appears in Hogfather, surrounded by Bogeymen. I dressed her in a Victorian outfit, as it seemed fitting with her role as a nanny.

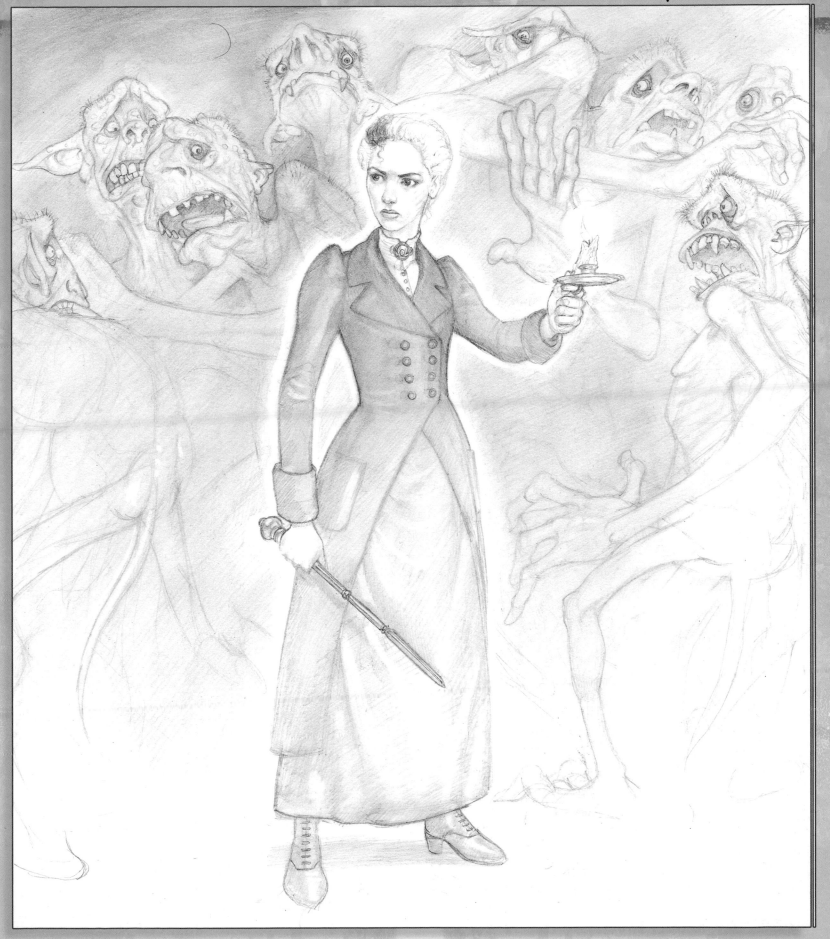

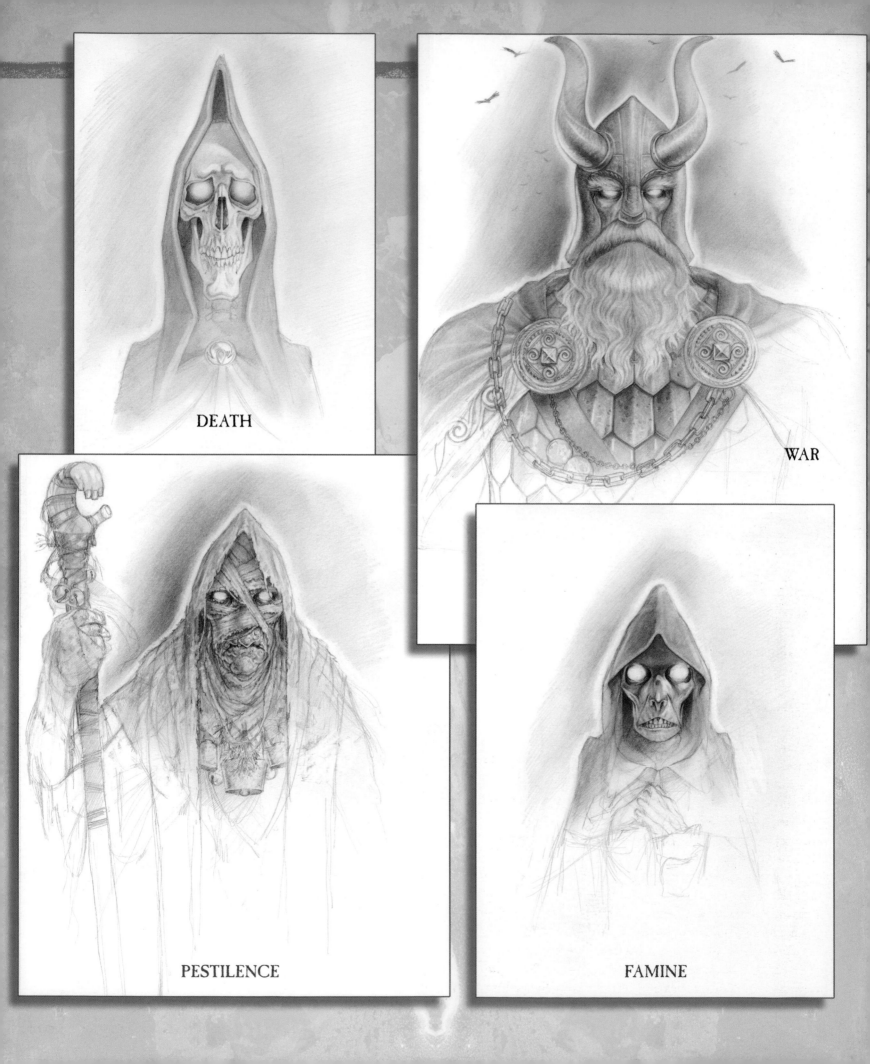

DEATH

WAR

PESTILENCE

FAMINE

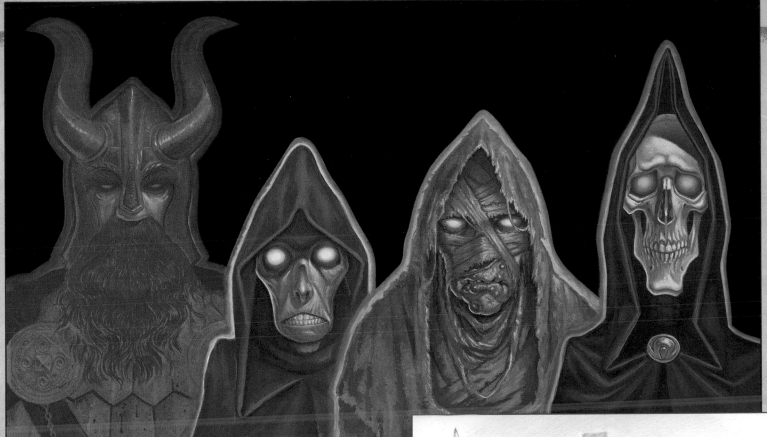

One Left Before They Became Famous

As with Death, the rest of the four horsemen also turned up as a joke. They're first seen making up a four at Bridge. They are the classic – or at least what people think of as the classic – famous four out of the Book Of Revelation.

Famous Four. There's a clue, right there. For probably fifteen years after *The Colour of Magic* was written I cherished the idea that there was a fifth. For a long time he was known as 'Roadworks on the M5' since in the late 1980s I spent altogether too much time parked on that damn road.

And I was certain that he'd left before they became famous. Note to people not as old as me: 'The man who left before they became famous' was a classic rock and roll phenomenon that began in the early 1960s with Pete Best, a former Beatle. There were a number of others, who tend to turn up occasionally on TV saying they don't begrudge their old mates their later success, which is jolly decent of them. And you can see why it happens. After a few nights sleeping in the back of a van with the drummer's foot as a pillow that job at the Co-Op must seem really attractive.

In *Thief Of Time* Ronnie Soak, formerly the Horseman known as Kaos, works as a milkman. That was another after-effect of the explosion of groups in the Sixties: the down-on-his-luck ex-rock star Doing An Ordinary Day

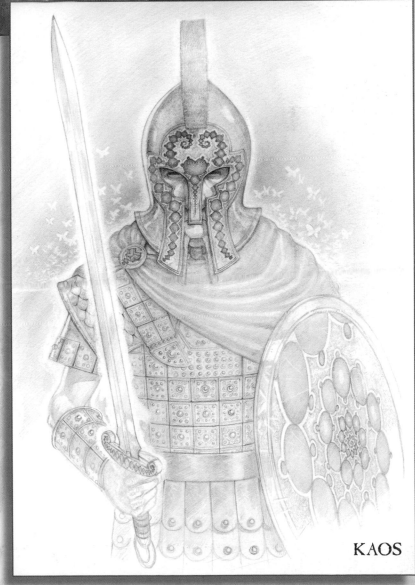

KAOS

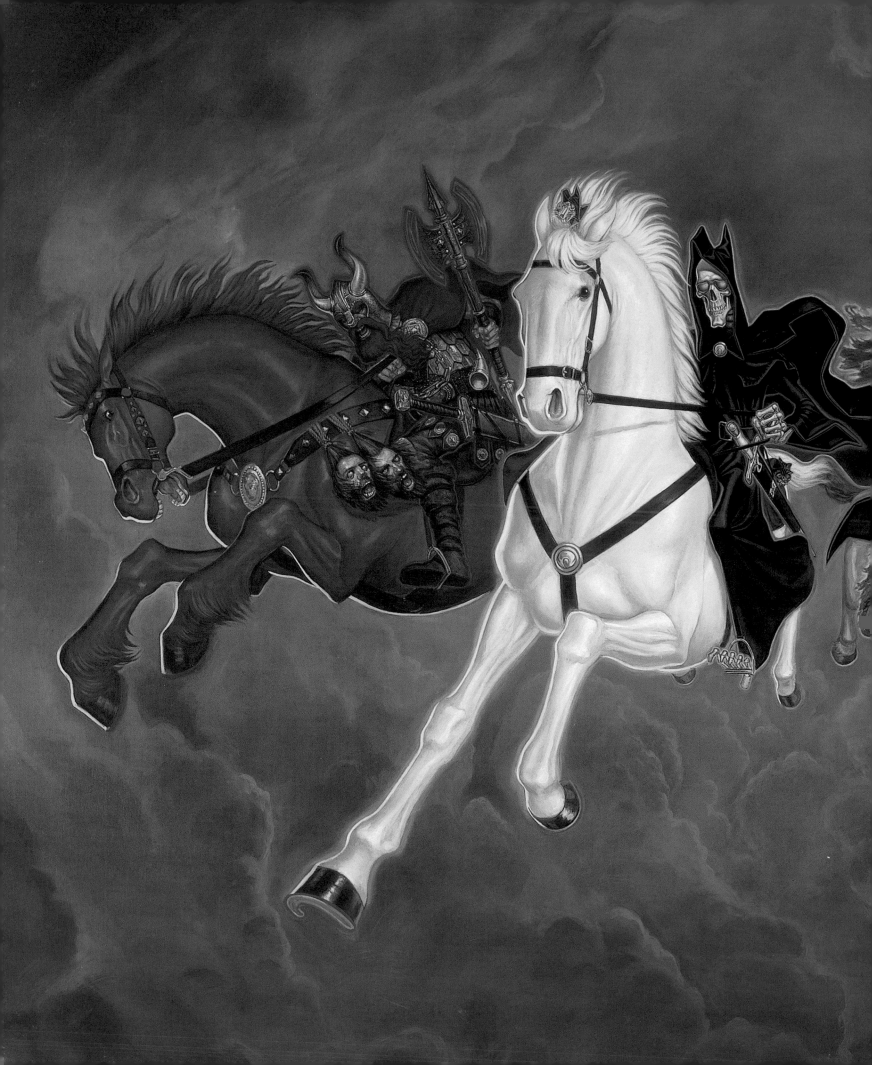

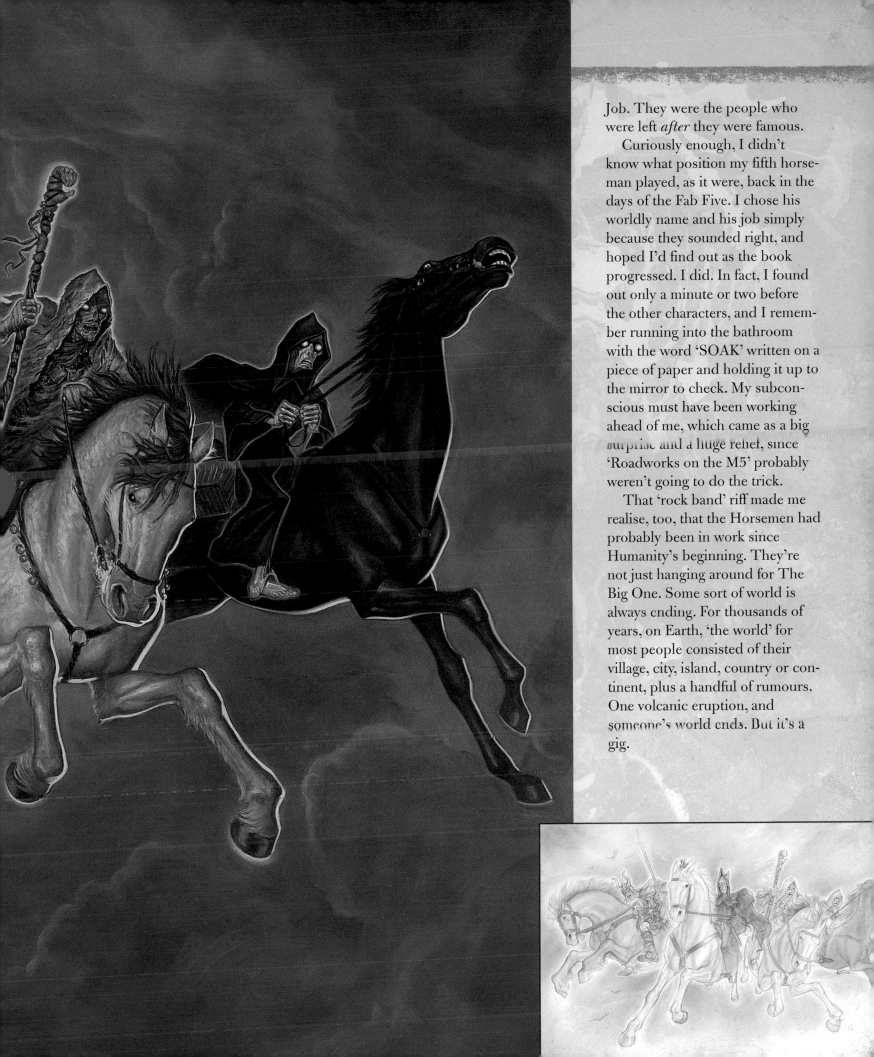

Job. They were the people who were left *after* they were famous.

Curiously enough, I didn't know what position my fifth horseman played, as it were, back in the days of the Fab Five. I chose his worldly name and his job simply because they sounded right, and hoped I'd find out as the book progressed. I did. In fact, I found out only a minute or two before the other characters, and I remember running into the bathroom with the word 'SOAK' written on a piece of paper and holding it up to the mirror to check. My subconscious must have been working ahead of me, which came as a big surprise and a huge relief, since 'Roadworks on the M5' probably weren't going to do the trick.

That 'rock band' riff made me realise, too, that the Horsemen had probably been in work since Humanity's beginning. They're not just hanging around for The Big One. Some sort of world is always ending. For thousands of years, on Earth, 'the world' for most people consisted of their village, city, island, country or continent, plus a handful of rumours. One volcanic eruption, and someone's world ends. But it's a gig.

Lancre

Tolkien's Shire is said to be the south Midlands countryside; Lancre, therefore, may well be a few select corners of South Bucks. The area I knew as a kid, really *knew*, to the extent of recognising every kind of tree and where each type of mushroom grew, was probably only about a mile and a half across. Apart from a pond big enough to float a raft on, it had everything the pre-TV generation needed.

Then I just added mountains and a deep river gorge to keep it penned in, and that was Lancre. There are no real borders to defend, apart from a couple of nominal road blocks. Any country smaller than Lancre, which would mean one about the size of a football field, wouldn't dream

of attacking; any country big enough to invade couldn't be resisted. Attacks on Lancre tend to be a little more metaphysical.

I suppose I wanted it to be everything that Ankh-Morpork wasn't – small, peaceful, law-abiding, and slow to change. I wanted it to be what people like to think England was, back in the days when cabbage was boiled until it was yellow and in the evenings people sat and waited for television to be invented.

It's a pragmatic kind of place. People stick with what works. Monarchy seems to work, so they go along with it. They're loyal to the crown, just so long as the crown is loyal to them. If the king does things wrong, then they'll be bound to tell him.

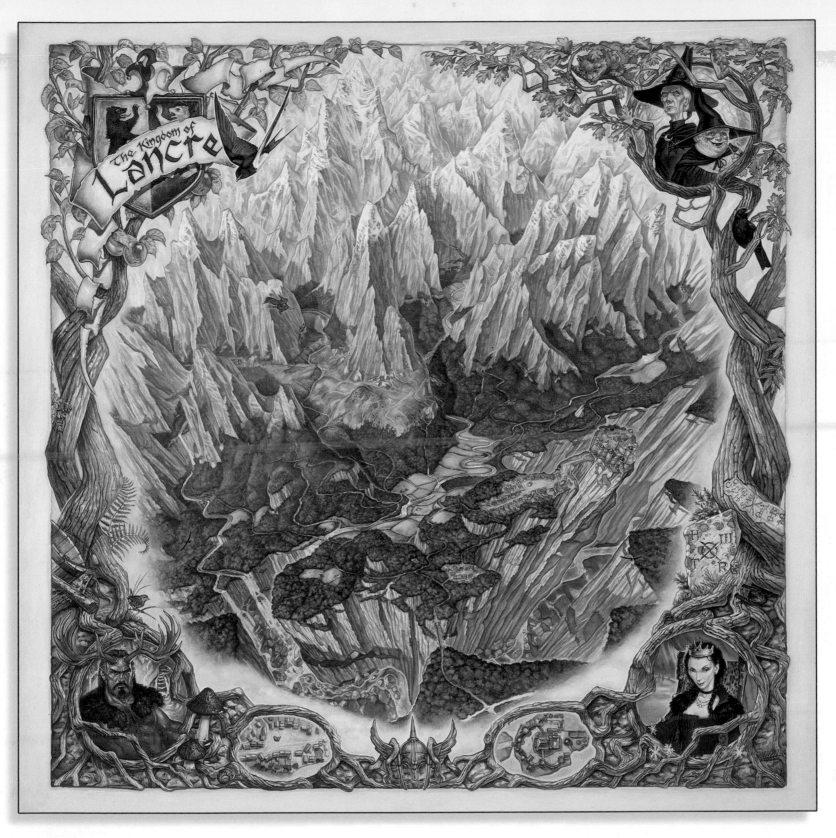

And it's a place where all the folklore is true, even if mutually contradictory. Again, there's a lot of my childhood there, and the childhood too of every country kid before the car and the telly really changed the world. You invest the landscape with little local gods and monsters. Every detail is important. But beyond the last hedge or distant wood – beyond the fields you know – there are strange and unknown places. Of course, they'll turn out to be the same, only different. But, for a brief while, they could turn out to be anything.

In such a country, you get witches, good solid witches with mud on their boots. They'd be witches that look on the full moon as little more than a great saving on candles and who would be far less superstitious than the people who *believe* in witches. It wouldn't be the place for magic that needs money, or books. It would be the place for magic that can cure cows.

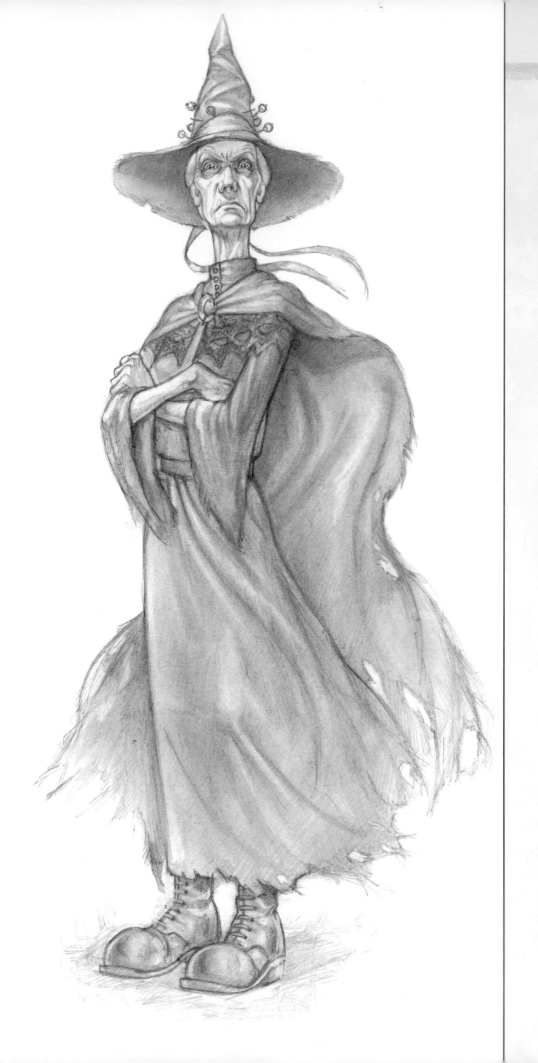

The Lancre witches are made up, but out of real ingredients. They can do magic, but it shades rapidly into illusion, misdirection and Granny Weatherwax's headology, and their main function is to be the local midwife, nurse, doctor herbalist and the spiritual equivalent of a coal mine canary. Witch ultimately means 'one who knows', especially one who knows something you don't know. How to catch a unicorn or what herb cures nosebleeds, it's all witch-craft.

They bring to a story an ability to get to the bottom of things, a total refusal to be awed by circumstances, and real common sense (which is actually quite uncommon now, having been ousted from many of its old habitats by the False Common Sense, which is another name for 'a ponderous and bloody-minded lack of imagination').

In this I pretty much went for the classic model: the older woman who, in a community where all knowledge is passed on orally, knows more than anyone else. Not being burdened by a family, she does have time to think, and maybe experiment. She finds that a little bit of theatre helps the medicine go down, and the hocus-pocus that makes the medicine work may also encourage people to be just a little bit careful around you. You are, after all, a woman living alone.

Now add real magical talent, and that's Granny Weatherwax.

Several readers have told me that they don't like Paul's drawing of Granny Weatherwax because she looks like a crabby old woman.

This, I think, misses the point, which is that Granny Weatherwax, whatever else she is, *is* a crabby old woman. She's sharp, sulky, cunning, a natural and shameless cheat with a huge ego that eats away at itself from inside. She's a good witch because she's too proud to be any other kind, but it doesn't mean she has to be nice about it. But, as others have said, having her on your side is worth three wishes.

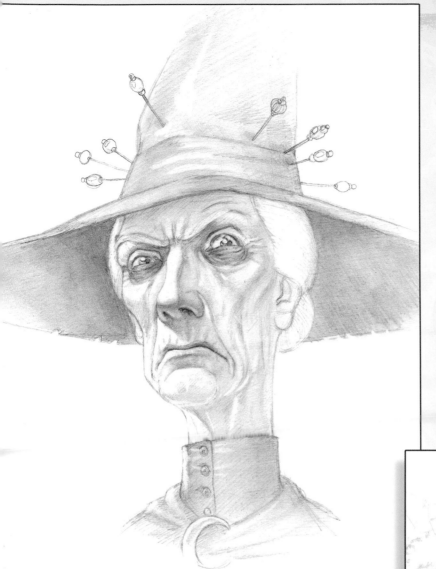

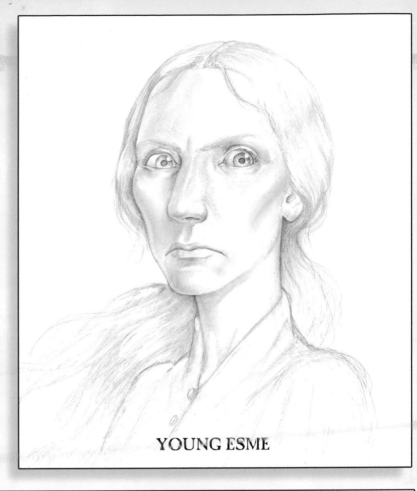

YOUNG ESME

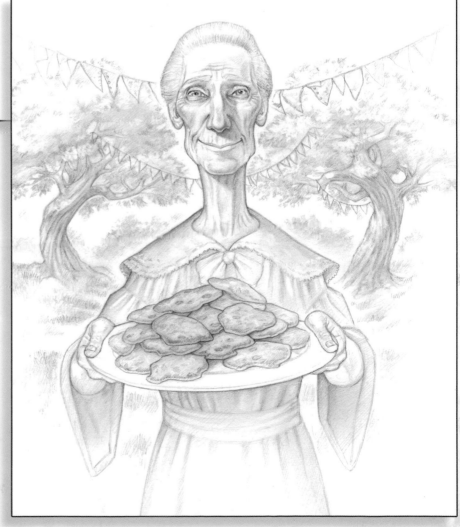

There's no harsher judge of Granny Weatherwax than Granny Weatherwax. Paul's depiction of Granny Weatherwax is, to me, exactly, shockingly right; his rendition of Granny as a girl astonished me, because it was so clearly her. You could see her future in her eyes.

Granny is the proverbial old gunfighter who has to walk down Main Street every day. She's the best that there is, but the world is moving on, and the generations are crowding behind her . . .

As a character she, more than any other in the series, came closest to evolving by herself. I don't know where a lot of her came from.

I think Magrat came from a hippie commune somewhere in the late '70s. There were lots of her about, when 'Flower Power' wilted. I don't think Paul's Magrat is definitive, but just about every Magrat I've seen drawn, sculpted or staged has been pretty close.

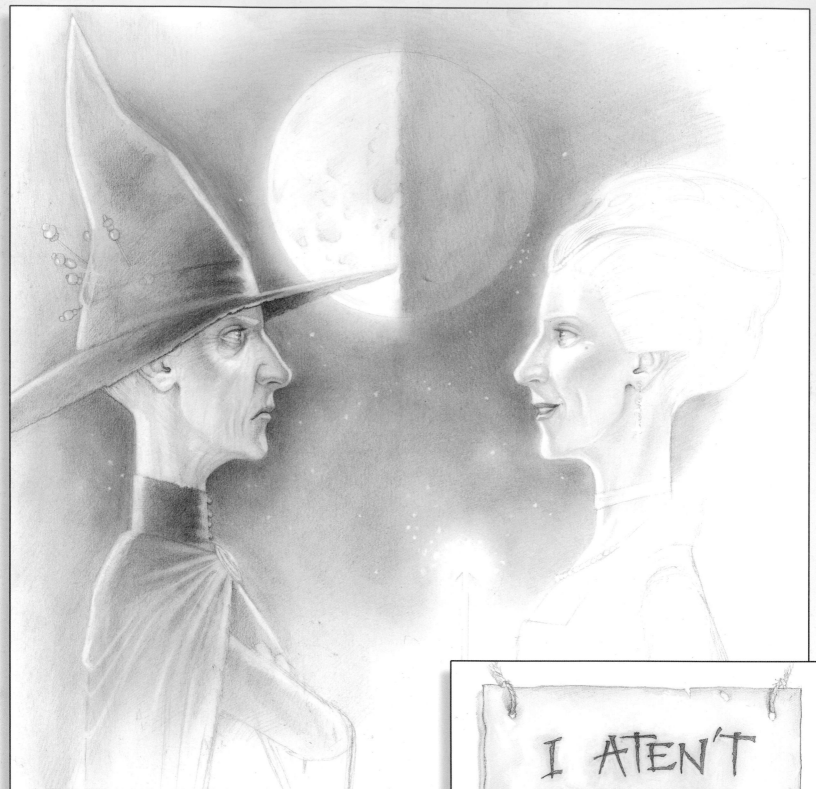

THE WEATHERWAX SISTERS:
ESME & LILITH

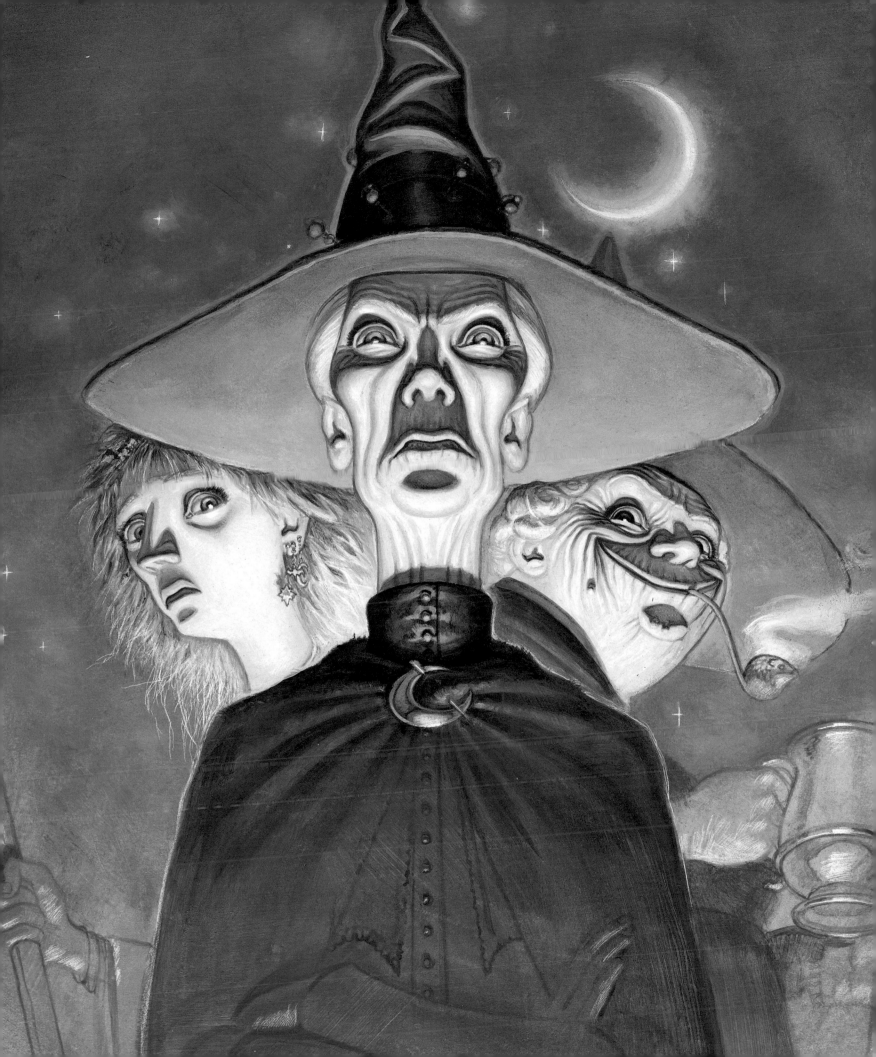

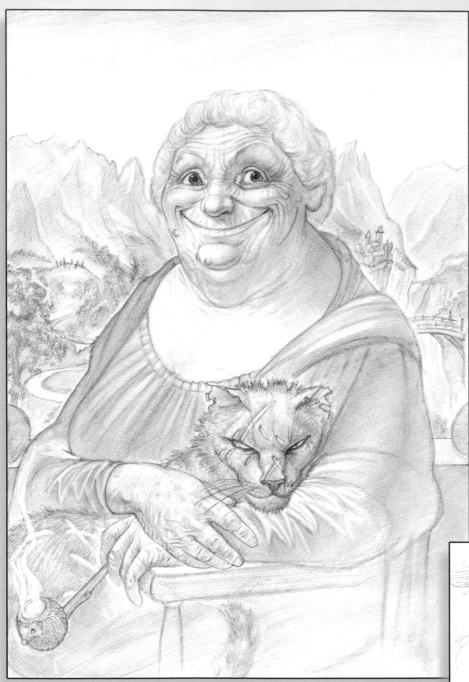

Nanny Ogg, on the other hand, *did* have a counterpart in this world, an old lady who liked a drink and a good laugh, but so many readers have told me that they know a Nanny Ogg, are related to a Nanny Ogg or in some cases, *are* a Nanny Ogg, that I suspect you could find someone like her on any street. She's *slightly* cartoony, but not as much as some American readers have declared. We still turn out old ladies like that over here. Trust me on this. They drink Guinness, or some local stout. They have the kind of laugh you can hear in the next building. Again, the young Nanny (the Mona Ogg) *is* her. You can see she grabs the most out of life.

I've always suspected that Nanny is, deep down, the most powerful of the witches, and part of her charm lies in the way that she prevents people from finding this out. She doesn't appear to have found a family a burden, but is more than happy to be a burden to her family.

With her broad mind and vocabulary full of single-entendres, she's fun to write for; it's her job to make the story work while Granny Weatherwax gets all the big scenes.

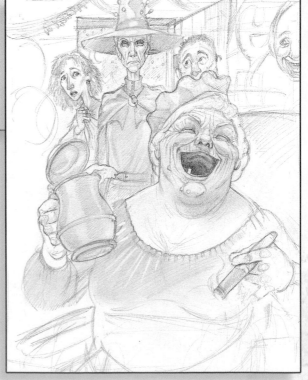

Magrat is a state of mind; I was once privileged to make an award to a Magrat of the Year, and all the contestants could have won (except for the bloke, but he clearly had the right idea).

Agnes Nitt is a sensible girl. I though I'd better get another young woman trained up when Magrat embraced motherhood, and I still think she's got some evolving to do. The third member of any Lancre coven is there to do the leg-work. Like Magrat, she's made up of general observations, with, as far as I know, no actual counterpart in this world (although you see her about a lot, especially in the USA).

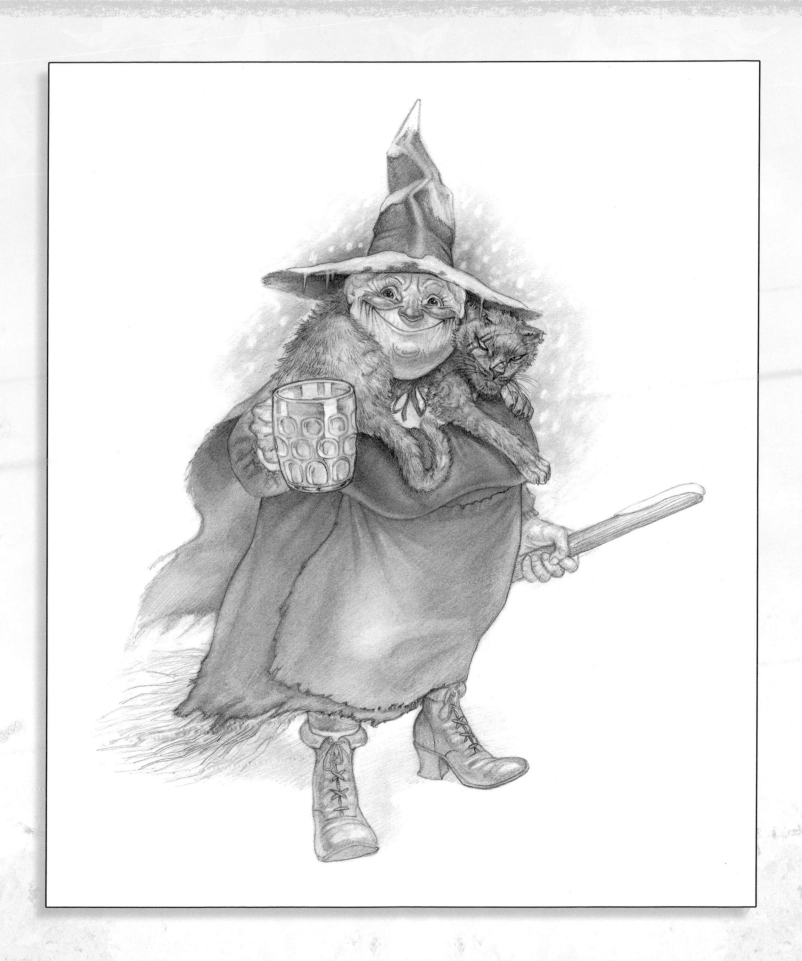

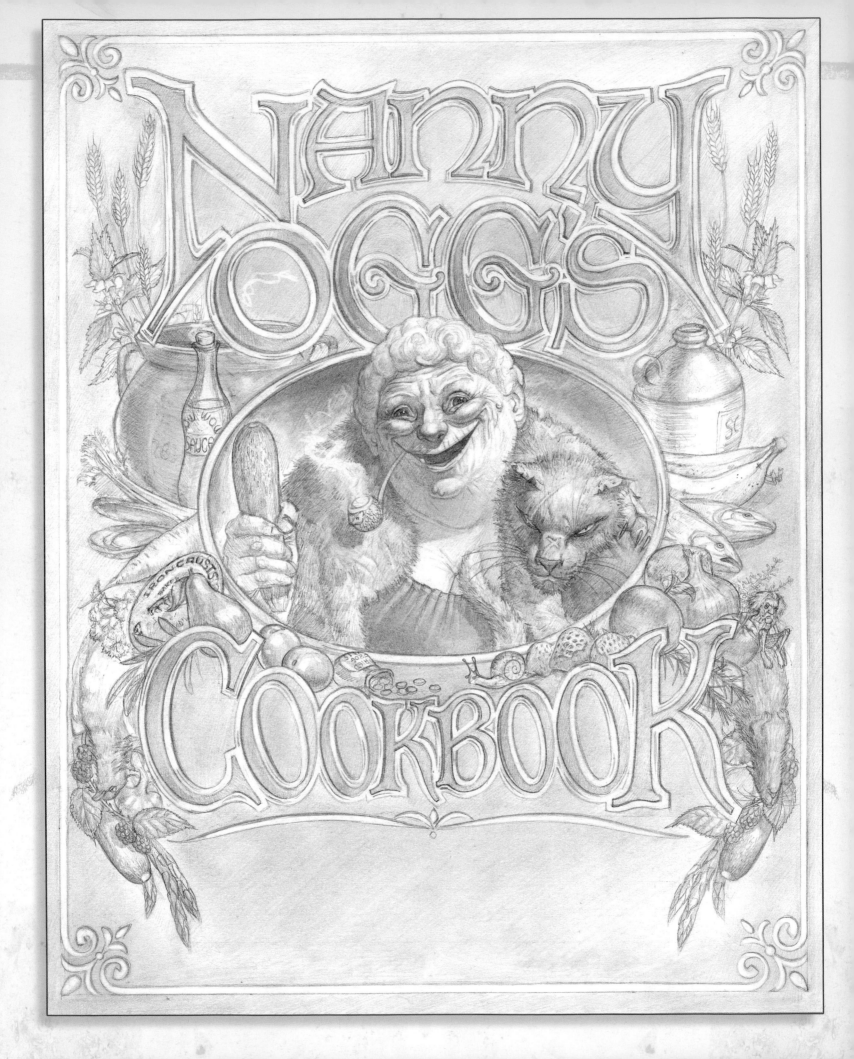

Oggfact 1: *Nanny Ogg's Cookbook*, a happy little venture to raise some money for the Orangutan Foundation, was not originally intended to be written largely in Nanny Ogg's voice. When everyone said, 'Hey, it sounds better that way', the translation of most of it from English to Oggspeak was done one Sunday with the assistance of a bottle of Brown Brothers' Flora Muscat, for that authentic tone.

Oggfact 2: The Gaelic for hedgehog is granniéog. This is a pure coincidence.

Oggfact 3: Readers of Discworld are sometimes in a position to wield a little power in unusual places. That is why a fossil species of Mesozoic flora is officially known as *Gingoites nannyoggiae*.

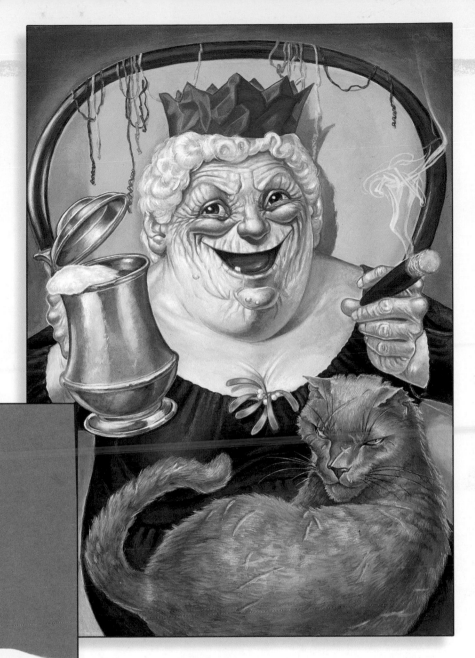

Nanny Ogg

She is one of the easiest characters to illustrate because she is so straightforward, and I have always had a very clear visual impression of her. Wrinkles are good for defining an expression, especially laughter lines, and she has a great many of those. I like to think we all know someone like Nanny Ogg, a person who enjoys a drink and has led a happy and full life.

Nanny Ogg's shape is a good contrast to Granny Weatherwax, and seems to echo the difference between their temperaments.

SOME-
THING
WICKED
THIS
WAY
COMES

Greebo

Discworld is full of minor characters that came on to help a plot along, and stayed. Greebo began as a witch's cat, cruel, devious and manipulative like most cats but, also like most cats, a cuddly bundle of fluff to his owner. His career really took off when he was given the ability to turn into a human being in times of trouble and confusion, which has become a talent that he can't control. His body knows that there is bound to be one shape that will get you out of trouble.

He was based on an old tom cat I knew, who had been in so many fights his face was like a bunch of knuckles with hair on. He'd ingratiate himself to humans, and then stroll out and nearly slaughter any other cat he found. But in looks he's like our hand-some Russian Blue male, who once dragged a large live rabbit in though a window three feet above the ground, can cover sixty feet of lawn before a pigeon can flap its wings and has the brains of a rubber band, and at that I'll probably be accused of being offensive to stationery equipment. In the presence of a human he knows, though, he'll go into mad, roly-poly displays of affection.

Paul's drawing of Greebo in human form is one of the most definitive in his notebook, and has impressed a number of lady fans who wrote to me very wistfully about him. He is one reason why, I suspect, we get a lot of requests from groups to do the theatrical version of *Maskerade* and *Lords and Ladies*, in which he appears fully, swash-bucklingly, trousered.

Personally, I can't see the point of a boyfriend who eats his meals under the table and claws at the door when he wants to go out. Perhaps I have missed the point.

Greebo

The visual inspiration for this character was our own cat, Dan, who had the expression and character that helped me shape Greebo. I observed him over many years and it made capturing the typical feline qualities easy.

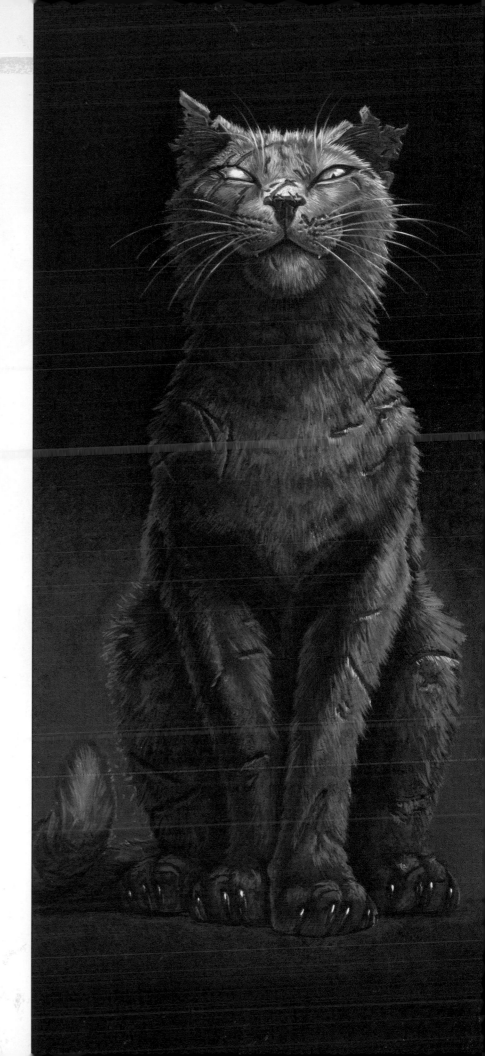

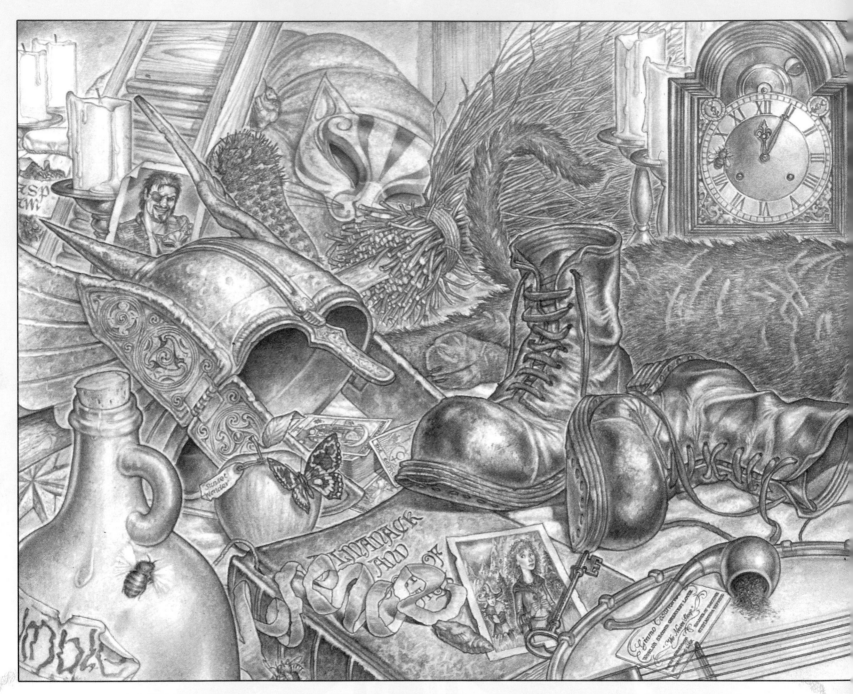

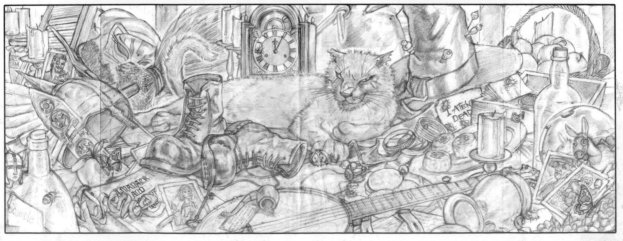

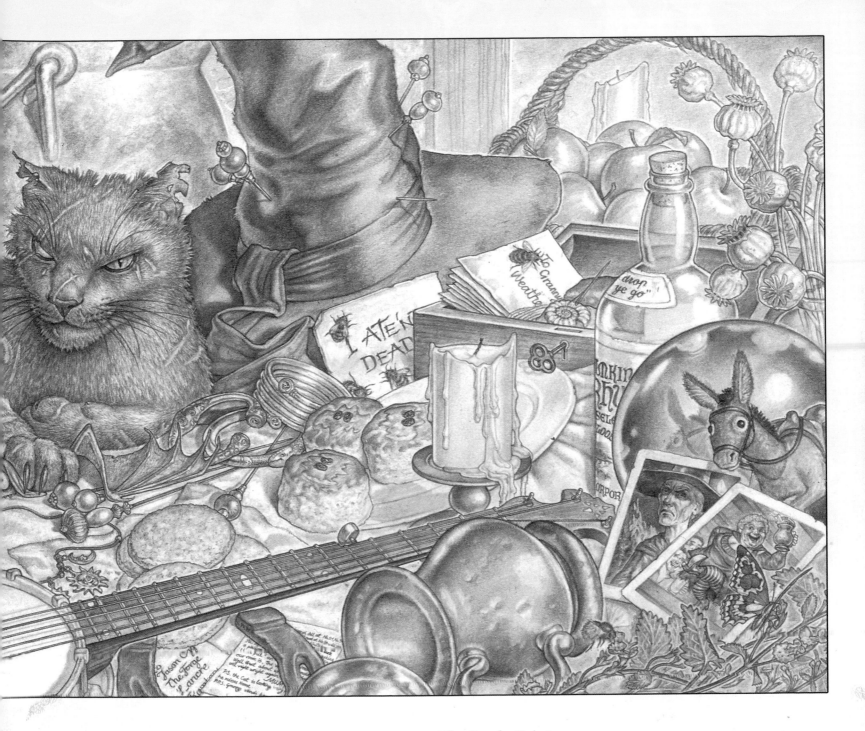

The Greebo Print

I drew this in 1995 as the second in a series of prints. I had a lot of fun deciding what to include in the picture. The objects are all relevant to the Witches, to Granny, Nanny and Magrat.

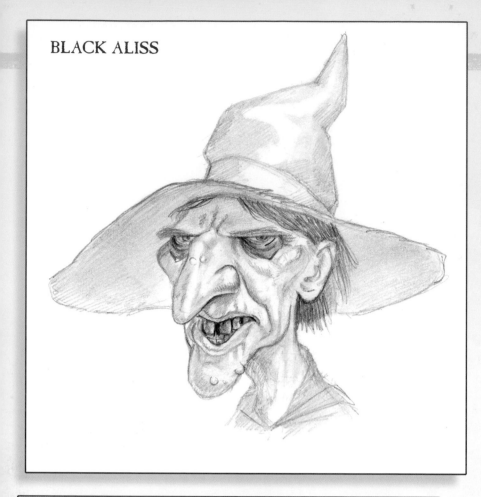

BLACK ALISS

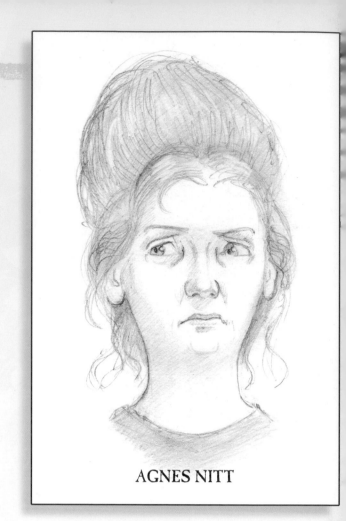

AGNES NITT

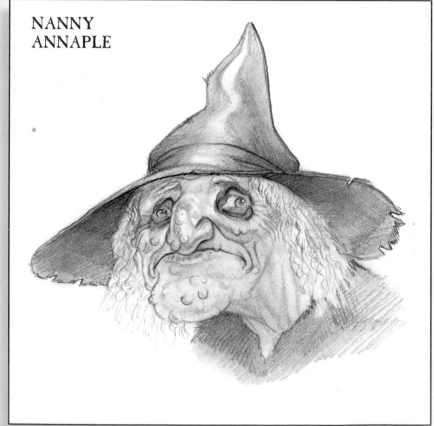

NANNY
ANNAPLE

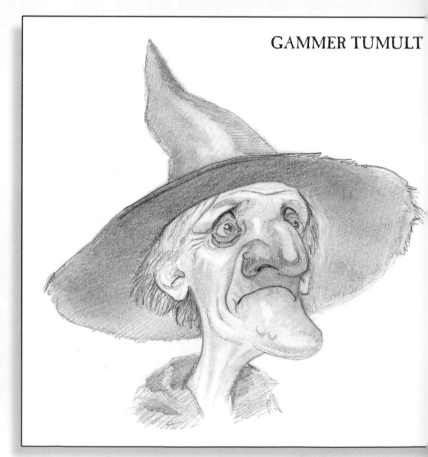

GAMMER TUMULT

Real People

A common question authors get asked is: 'Are there any real people in your books?' To which the only sensible answer, from a thinking author, is, 'I hope so.'

Some, though, are more real than others, and walk in both worlds.

Dave Hodges became Hodgesaargh because I needed advice about falconry for a book, he advised me, and somehow he ended up *in* the book. He's still a falconer, but now also bangs huge pieces of metal together. He looks just like Hodgesaargh, which is not surprising, and has the former's straightforward approach to life.

There are a select few others. The key is to have an interesting name and/or an interesting shape and cross my path at some time in your life. They know who they are. They get small roles, though, because otherwise that would be unfair to a rather larger group who got into Discworld via a process known as 'tuckerisation', which involves a large sum paid to charity. This is not unique to the genre, of course, having become quite popular in recent years. Ken Follett paid big money to be Dr Follett, politically astute head of the Guild of Assassins.

It's good fun, but has to be done with care, and the characters have to slip in easily.

An American journalist once mentioned the 'funny names' in Discworld. I said that, funny though they may sound, I'd bet I could find at least one of them in the phone book in a matter of seconds. It certainly took less than a minute to turn up a Weatherwax.

There was once a New York financier called Preserved Fish. That'd be quite hard to make up.

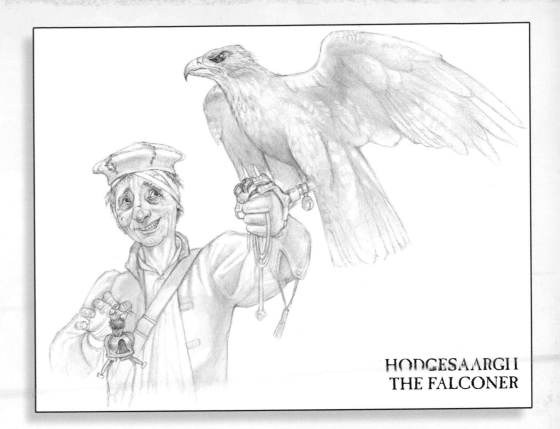

HODGESAARGH
THE FALCONER

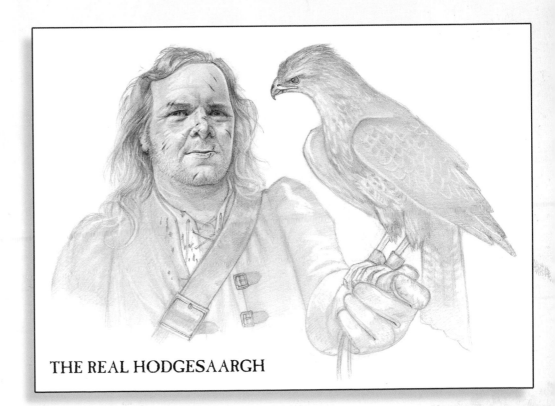

THE REAL HODGESAARGH

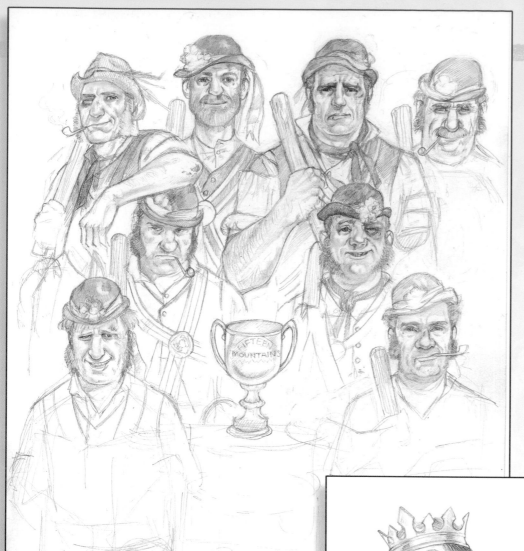

The Lancre Morris Men

They take Morris Dancing seriously in the Ramtops. It's a competitive sport; those sticks are there for a purpose. Of course, everywhere drinkers run away when they hear the sound of morris bells, but in Lancre they do so because you don't want to be between the morris men and the bar. And they are the only side that know enough to dance the Dark Morris, the one that must be danced to welcome in the winter …

At least, they were. It's been danced a few times on Planet Earth since it was first mentioned in *Reaper Man*. I've seen it done once, with black clothes, silent bells and, after a few beats of the drum to establish the rhythm, no music. It was, without a doubt, a strange and disconcerting experience. I'd swear it made the place colder …

Uneasy Lies the Head …

… that wears the crown of Lancre, when the crowned head knows that it owes such a lot to the witches who helped to put it there. But King Verence has been a very good king, by the not-very-demanding standards of kingship; his sombre and careful approach owes much to his upbringing in the Guild of Fools, which can sap the laughter from any man's soul. Most notably, it has left him with a morbid dread of custard pies.

King Verence is pictures with Nanny Ogg in playful mood.

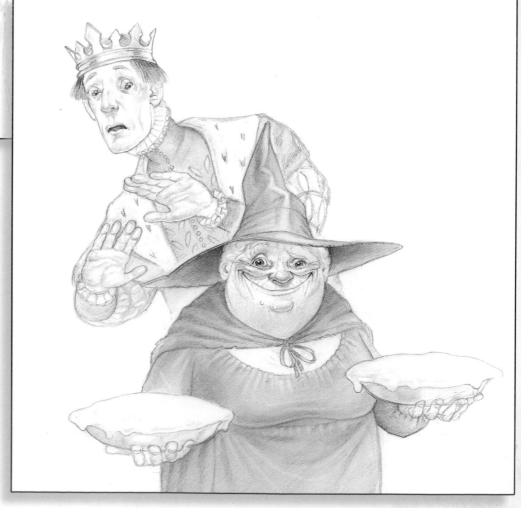

She Who Must Be Avoided

I'm not sure if there is one Queen of the Elves, or many, many Queens of the Elves who are all, in some way, one. She doesn't even *really* look like the image you see. We're not dealing with your average royalty. She has probably never visited a hospital or launched a ship.

My source was probably Irish mythology, and some consideration of the connotations of the word 'fey'. As, I think, Granny Weatherwax says: *You can trust demons. You can trust them to be demonic. But you can't trust elves to be anything.*

Discworld elves are capricious and totally without empathy. Like their 'real world' counterparts, they'll see nothing wrong with kidnapping a child to be a sort of toy. They have the same self-centred decision-making processes as the average cat. Because they have charm and style, because life is *easy*, they seldom have to think. And, like cats, if you can get past their claws and through their composure – that is, their hypnotic singing and their glamour – they're easily bewildered.

I don't make too much use of the Queen. She's a colourful adversary, but not a terminally dangerous one to anyone who knows their own mind. She's only going to be really interesting if she has to think. I suspect a lot of C-list celebrities are elves – indeed, the concept of celebrity is elvish in itself: you're famous because you exist. Elves see that as the way the universe should be.

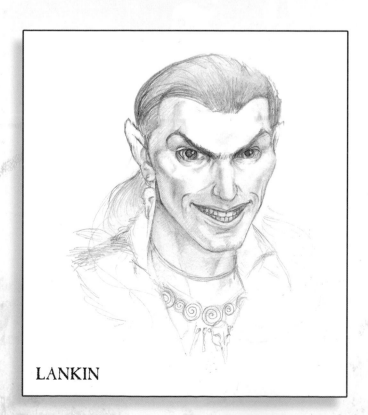

LANKIN

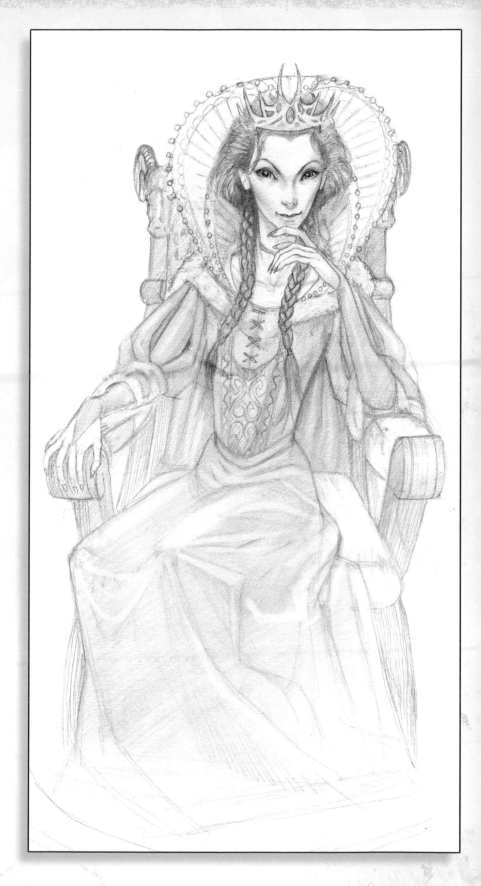

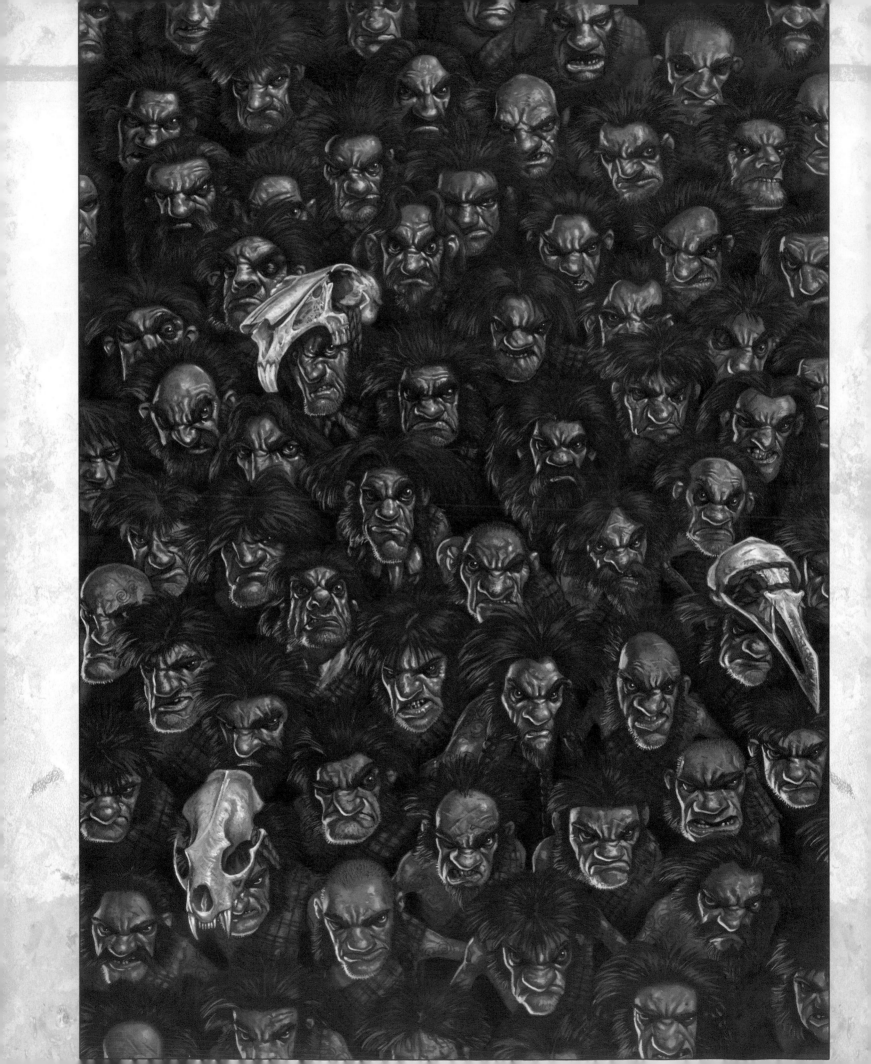

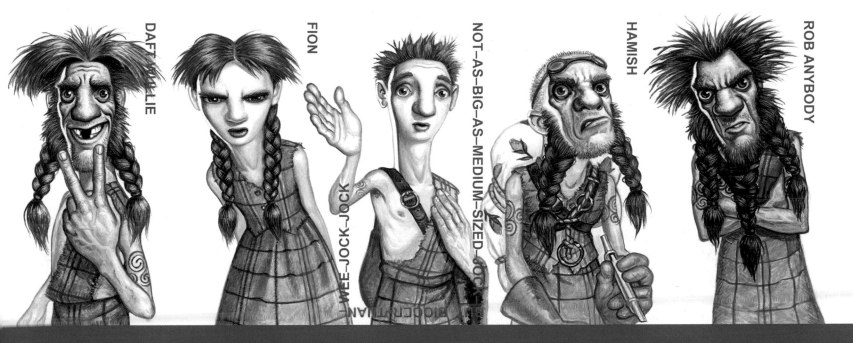

DAFT WULLIE

FION

WEE-JOCK-JOCK-...-BIGGUGULIAN

NOT-AS-BIG-AS-MEDIUM-SIZED-...

HAMISH

ROB ANYBODY

Feeglespotting

The Nac Mac Feegle

The Wee Free Men was launched at a signing in Inverness, to see if I survived. I did.

The Feegles owe a lot to Wee Mad Arthur, the rat catcher in *Feet of Clay*. Very small, very strong, permanently angry and quite able to beat up a full-grown human, never mind a rat, Arthur was one of those minor characters who wouldn't go away.

By *Carpe Jugulum* there were hundreds of him, and the Nac Mac Feegle began to evolve.

It's quite probable that their distant ancestors were the gnomes out of *The Little Grey Men* and *Down The Bright Stream* by Denys Watkins-Pitchford. They could talk to animals, but there was nothing tinkly about them; they lived in a world of dangers.

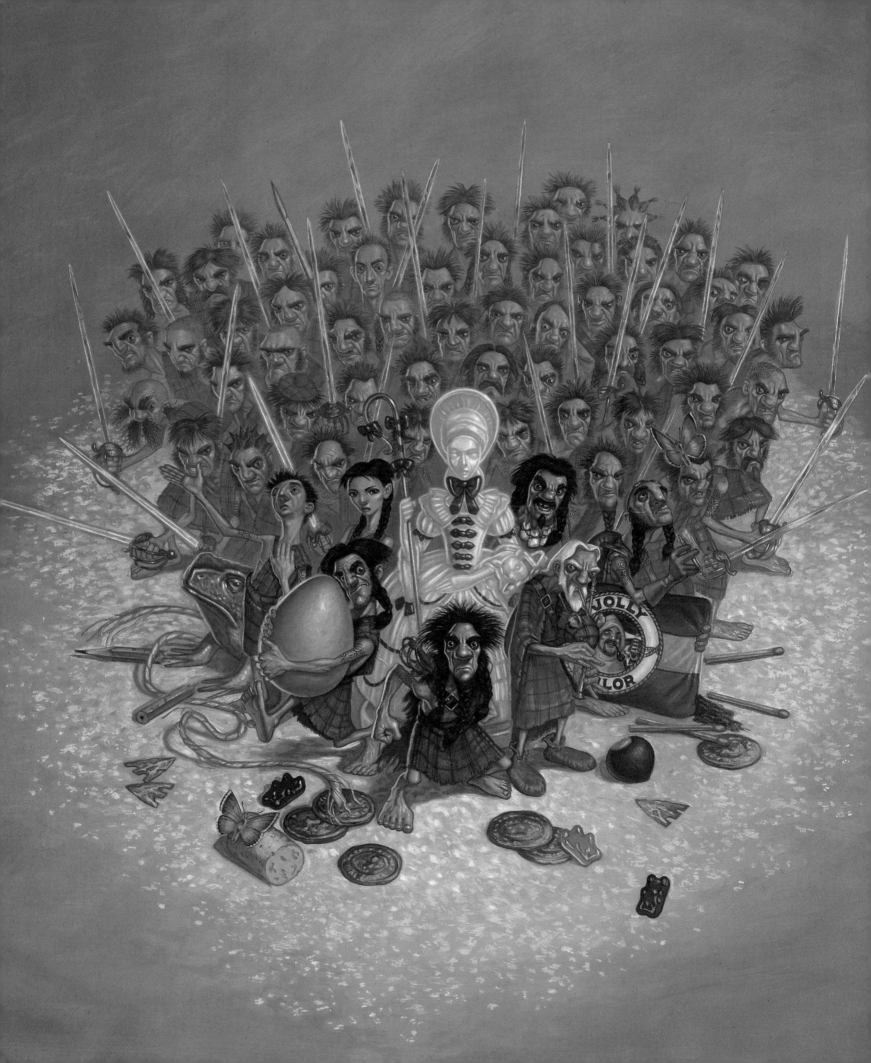

The Feegles had to be mound-dwellers, and they had to conform to the genuine fairy stereotype of North-West Europe – i.e., not automatically friendly, and fond of drink. As females seem rare, I had to come up with some kind of bee-like social structure. And then there was, I felt, a need to answer the question of *why* they're so insanely courageous and brave, which was this: they think they're dead, and in their equivalent of Valhalla, where boozing and fighting are all part of the daily routine. You don't have to be nice and quiet and good any more, you've *been* all that and now you're here for your reward. At least, that's what they think, and when it comes to being dead or alive, then the opinion of the subject must count for something. Besides, I quite liked the idea of one world doubling as the heaven for another one.

I'm not sure where the Glaswegian bit came in, but once it did, it was as though it had always been there; their language is gibberish, but sometimes quite carefully crafted gibberish, made up out of slurred Gaelic, fractured Auld Scots, a certain amount of Glaswegian slang and some nonsense, but nonsense made out of real ingredients.

They are brave, fearless and loyal, but they are not *nice*. Fairy folk, on the whole, never have been. The Feegles would be unlikely ever to pose for a couple of little girls with a camera, but would be a lot more use than a flower fairy if it came to a fight.

Paul pretty much got them spot on. He actually sculpted Rob Anybody, who sits on my bookshelf and menaces me.

Nac Mac Feegle

After reading Carpe Jugulum *I was compelled to start work on the Nac Mac Feegle. I wanted them to have a tribal appearance, with a strong Scottish feel. Their appearance is a culmination of famous Scots – Billy Connolly, Ewan McGregor and Lulu. The Mac Feegle stature is wiry and sinuous with large hands and feet, bulging veins and protruding elbow and knee joints, all of which makes their incredible strength feasible. Despite them being only six inches high, I wanted their posture to show their potential energy, like a coiled spring.*

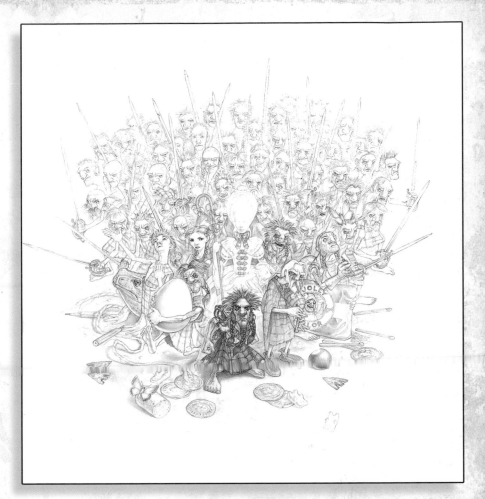

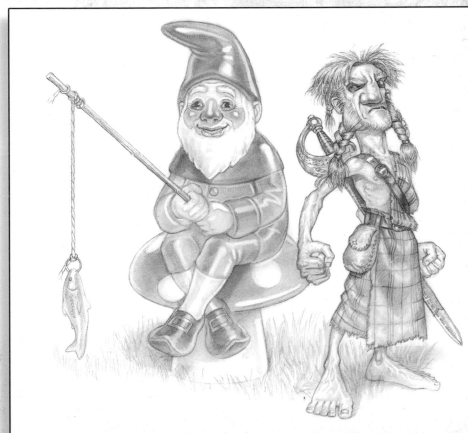

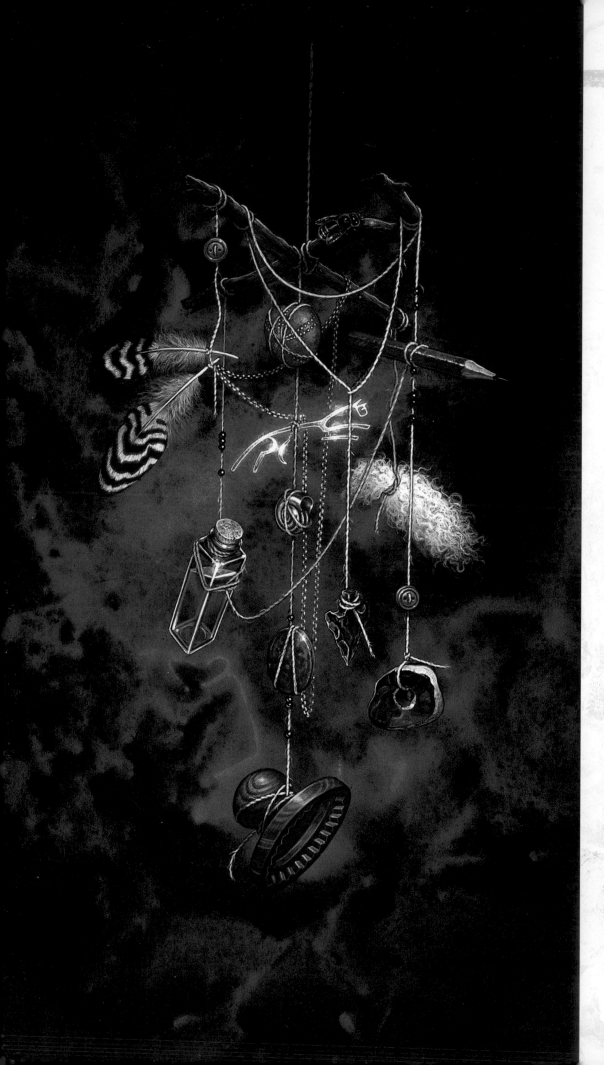

A Complete Shamble

Discworld witches – the older ones, at least – operate without anything very much in the way of paraphernalia. Witchcraft is something you do, not buy. A casually picked-up stick is a wand, a muddy puddle is a crystal ball. Sticking a star on something doesn't make it magical, it only makes it expensive.

Nevertheless, when Miss Perspicaceia Tick made a shamble in *The Wee Free Men*, it seemed . . . appropriate. It's all headology, as Granny Weatherwax would say, a way of getting your mind right. A shamble is a cross between a cat's cradle and a mobile, made on the spur of the moment out of anything you have in your pockets, although it must include something living, such as a fresh egg, or a beetle that you might, by sheer accident, have conveniently by you in a matchbox. That's the art of the shamble, of course: making sure that you nonchalantly have, in your pockets, a interesting supply of attractive things that might make one without even letting yourself believe you are *deliberately* doing so.

The finished shamble can be used as a magical finder, a means of summoning or even as protection; it is the Lancre Army Knife of magic items. Younger witches like to carry small ones for swank and show, but a working shamble has to be made fresh every time.

Wizards would say it's just a primitive way of ensuring cuspic fixing in thaumic phase-space, but what do they know?

Shamble note: Paul came up with the idea that the fossil in Tiffany's shamble should be the type of ancient sea urchin called a Shepherd's Crown. Of course it should.

Tiffany Aching

. . . started with a girl lying down by a river, on the first page of *The Wee Free Men*. It sounds amateurish to say that characters invent themselves, and in truth they don't. That's just a short-hand phrase. *Of course* the author invents them. But while the creative channel is being held open, all sorts of memories and thoughts creep out, somewhat to the owner's surprise.

There was a chalk pit on the way to school when I was a little kid, and it was my introduction to geology. This crumbly white rock with the tiny fossils in it was the floor of an old sea. It was made up of the bones of tiny little dead things. I mean . . . *Yuk.*

Actually, it fascinated me. I kept thinking I could still hear the sea. And I too learned to read a lot of words before I could pronounce them; it was years before I learned the damn monsters in many traditional fairy stories weren't called ogrees.

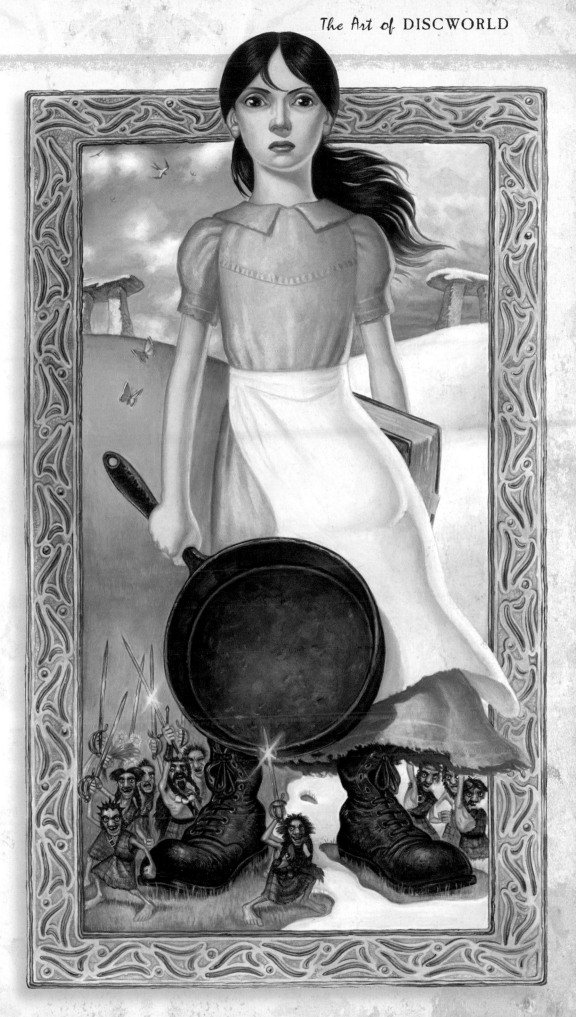

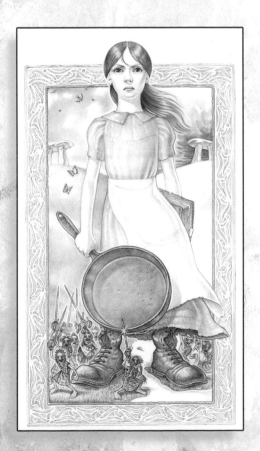

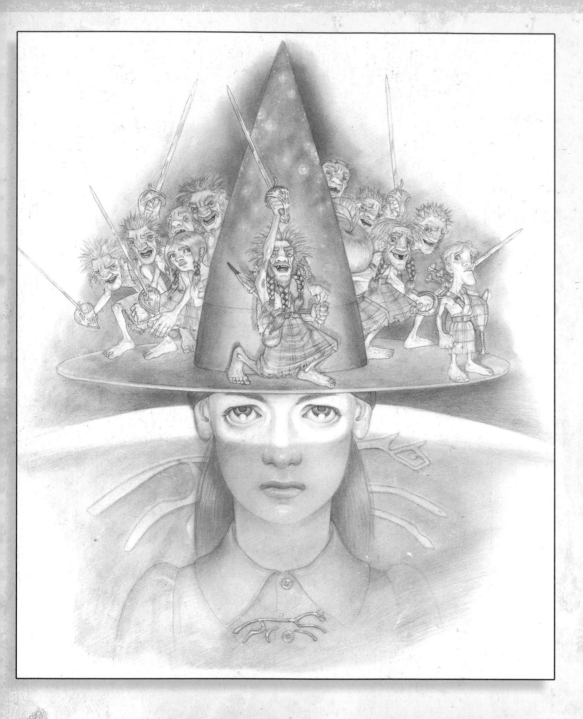

There's a lot of my past in some of the descriptions in the book; even that gravelly shore on the river I could point to on a map. A lot of places in the book are places I could walk to now.

I rather like Tiffany, and so do the Brownie pack I happen to be a honorary member of, who agreed that I'd written a real nine-year-old girl (look, I helped them out with an item for their gang show and they were kind enough to honour me, okay? I have the scarf). She's clever, but not hugely so, quiet, observant, good at making cheese and possessed of a determination as hard as teak. I though it would be interesting to watch her development over perhaps four books, aging her by a year or two each time.

I also thought it would be useful to restate the Discworld view of what magic is all about (magic is all about not doing magic if you can possibly avoid it) and the relationship between wizards, witches and what might be called, with some care, the common people (just because you've got a pointy hat is no reason to give yourself airs).

Finally, it's a way of looking at Discworld from a new direction, and a different squint always helps.

Wintersmith and *I Shall Wear Midnight* may or may not get written, and may or may not have those titles. As they say: so many books, so little time . . .

Paul's image of her is definitive – you can see defiance just edging ahead over fear.

Experimental colour roughs for the *A Hat Full of Sky* cover

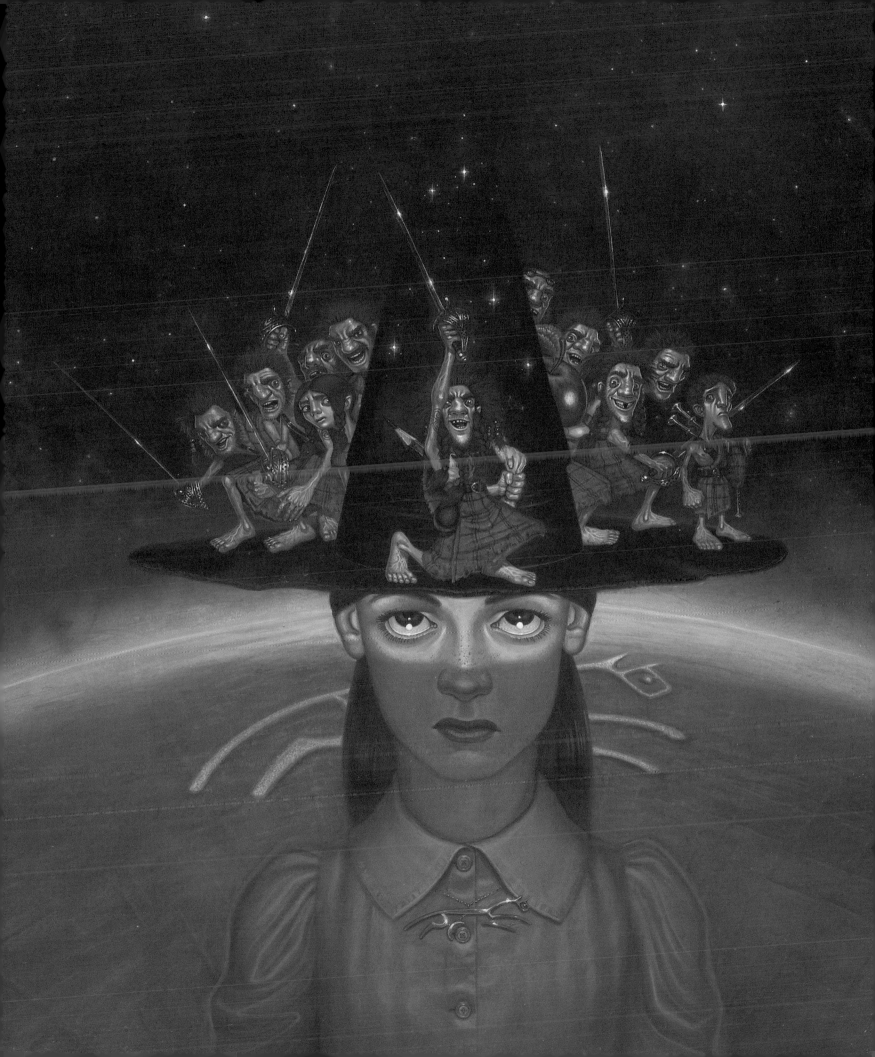

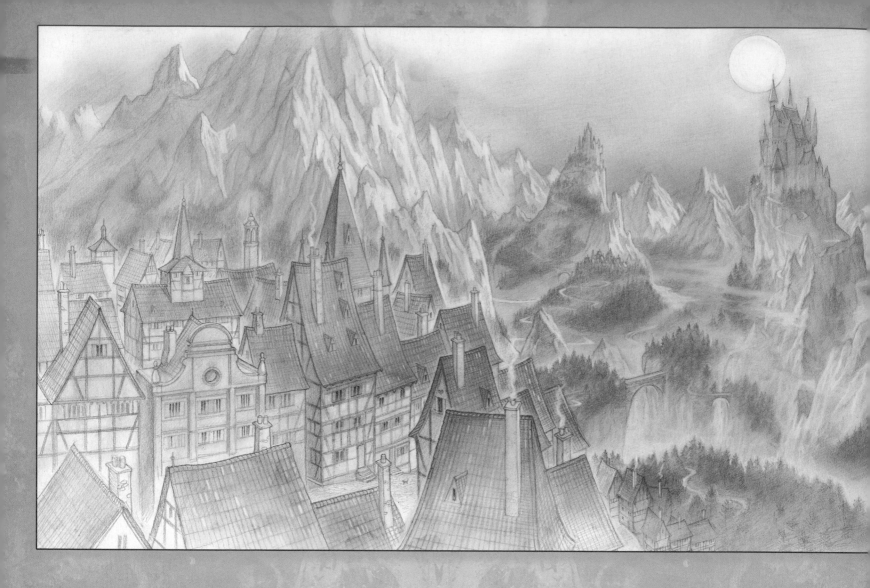

Welcome to Uberwald, Land of Fat

Uberwald is, of course, the Discworld version of Transylvania, and means more or less the same thing. It's been on the Discworld map for some years but began to take form with the writing of *Carpe Jugulum* and *The Fifth Elephant*.

It's certainly not based on any one country, but the fat mines and the whole 'fifth element' legend arose when I was touring Poland. Despite the warnings of my editor, I opted to go to a 'typical' Polish restaurant. The menu seemed to contain rather more fat than I normally encounter, including a starter that consisted of two kinds of the stuff (dripping and cream cheese). Then we drove around the country where you can see, plonked down in the fields, old factories from the wonderful, life-enhancing, eco-friendly days of communism. Well, on a tour everyone gets in a weird state of mind in any case, and they got christened 'the fat mines' . . .

Uberwald is a collection of countries. Most of them are mountainous and full of rivers. There are hot springs. There are vast dwarf caverns honeycombing the area without regard to the national boundaries on the surface. Deeper in, there are the ancestral troll lands, and the homes of even stranger things. And there are, of course, vampires and werewolves, whole societies of them. They are not considered unnatural, which is not the same as being considered popular.

There are rather a lot of thunderstorms up in the mountains. Really a lot.

Uberwald, in other words, is based on all the classic horror movies you can remember, most particularly those made by Hammer Films, when no coach could go faster than five miles an hour along a suspiciously familiar road without shedding a wheel, half the population were nubile 18-year-old girls and I swear there was one very large, ornate, floor-standing candlestick that *appeared in every movie*. In the one and sixpenny seats (about £500 in new money) I must have watched Christopher Lee die in a dozen different ways. I learned that turning into a heap of wind-blown dust need not put a huge crimp in your life plans.

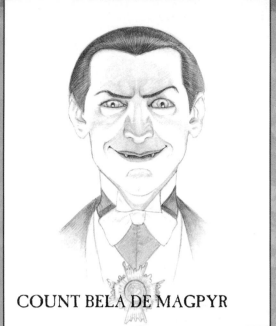

COUNT BELA DE MAGPYR

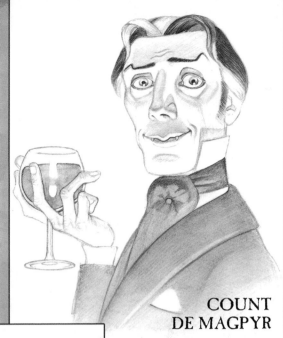

COUNT
DE MAGPYR

LACRIMOSA

VLAD

Thus Don'tgonearthe Castle was invented. It has, of course, running water in the moat, a whole slew of things that could be easily converted into religious objects, and a big window facing the sunrise with insecurely fastened curtains. It was clear that Dracula was quite a sporting fellow. It was all a game.

A world away from the Slasher movies, the Hammer movies were, on recollection, quite domesticated, and as stylised as a mummers' play. You knew exactly what you were going to get, including the candlestick. Hammer Horror was *set* in Uberwald, where blood is bright red and you don't get too much of it . . .

Probably Uberwald was created by the time I was fourteen. Somewhere up in the attic there may still be the exercise book it was doodled in. There was the mysterious Count, of course, and an Igor – just one at that point – and a complete troll society, right down to troll horses and troll ducks. Troll ducks didn't float, so they walked around on the bottom of ponds. There was a race of tiny creatures, all apparently male, who used to mine cheese. There was even an area that, now, seems to have been a lot like Lancre. Hmm. That would all be very useful to a research student. Perhaps it would be a good idea if it stays hidden.

Igor: a Man of Many Parts

Every mad scientist has an assistant called Igor. Everyone knows this (even though it's not true, but in Discworld it's what everybody knows that is important). So there must be *lots* of them, and by now they must have got surgery down to a fine art. It seemed to me that in an agrarian society, where sharp tools are in constant use, people might realise that Igors would be useful chaps to know. If the bandsaw has just taken your arm off, then the voice behind you saying 'Can I be of athithtanthe?' is going to be a *welcome* voice. Of course, the price will involve allowing an Igor to help himself to any useful bits when you eventually pass away, but you'll be dead, right?

The Igors are useful. They understand electricity, they can patch a hero up in no time and they're pretty bright. I doubt if I could write a book with one of them as a major character, but they wouldn't want that. They exthitht only to therve.

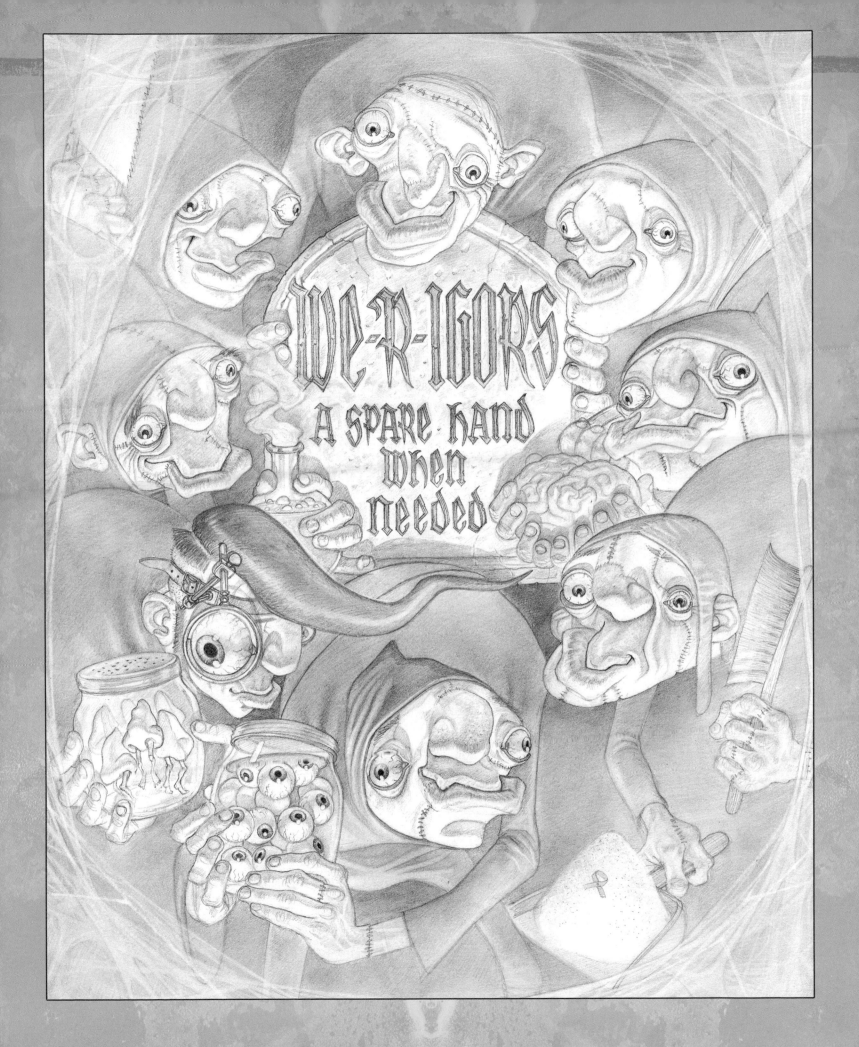

The Dying of the Light

In some quarters there were objections to the cover of *The Last Hero* because it showed a glowering old man with knobbly knees and didn't say 'fantasy'. It seemed to me that it definitely showed comic fantasy. I couldn't imagine any other cover working so well.

Old men acting as though they're still as young as they think they are, are funny (I tell myself this when my knees click on a long walk). I knew when I introduced the Silver Hoard in *Interesting Times* that all I would need to do was wind them up and let them go, and I was looking for an opportunity to bring them back into the series. There's

something inevitable about them. They've been everywhere and done everything and stolen everything else, and the only concerns they have about the Valley of the Shadow of Death is whether or not there's a toilet there. Yes, they had to die, and I was sad to see them go. On the other hand, King Arthur died too, but it doesn't appear to have done his career any harm; it seemed to me that death, for that bunch, didn't have to be final.

One of the joys of Paul's work is that he remembers details, so that minor points of character description from earlier books are automatically included.

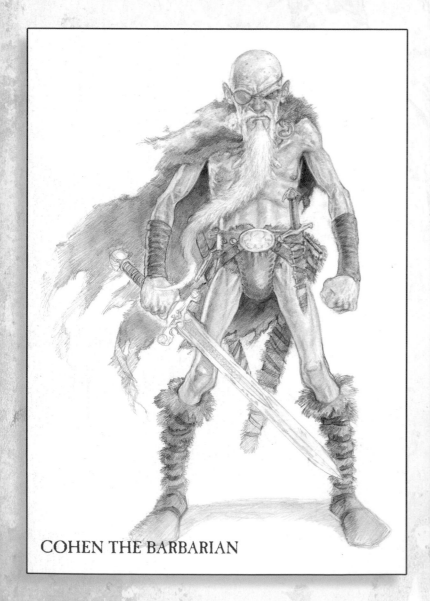

COHEN THE BARBARIAN

TRUCKLE THE UNCIVIL

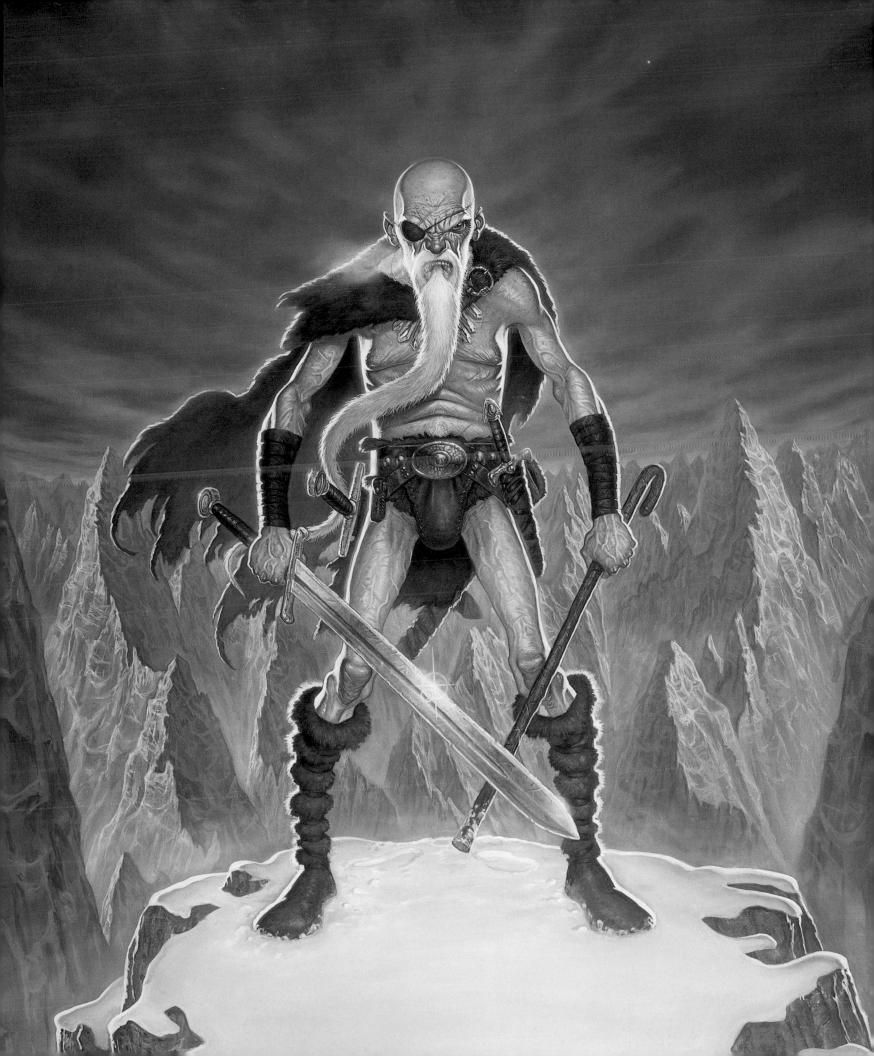

Odd Gods

The Discworld pantheon started out with a Hellenic feel, and grew from there. There is not a lot of logic to it, because this is an area where logic cannot apply.

Isofar as there is a a *little* logic in it, it runs like this: Gods (as opposed to Creators) evolve to fill a need. But old gods do new jobs. The Hogfather, the jolly pork-giving spirit of Hogswatch, was once the dark god of the midwinter sacrifice, born in the blue shadows at the dark time of the year. Now he hands out marzipan sausages to children and his fearsome wild boars are positively tame and never gouge anyone to death. Blood on the snow becomes a jolly red and white costume. Retraining and redeployment, that is the key to survival (just as, in what we are pleased to call the real world, the old gods of Britain had a wash, a change of clothes, did something about their hair and became saints of the new religion. It's important to keep busy and be seen by the public, in case they forget you.). When millions of kids send you letters ever year, your survival is assured.

I'm less certain about the verruca gnome. But the basic idea is sound: there has long been a Tooth Fairy to take away teeth, so why not an equally pervasive spirit that *brings* things? No one said fairies had to be nice; after all, they used to steal babies. Once, people believed in the *lares* and *penates*, the household gods. All it took was a bit of thought and maybe a few tiny offerings of food. Frankly, it would be worth the occasional bowl of milk to find my car keys where I left them.

Jack Frost has a far healthier lineage. How many kids in the temperate Western world have even seen frost on the window panes? But it's obviously done by *someone*, because the mere process of freezing water couldn't possibly have created that wonderful fern-like effect on the glass. How could water know what ferns look like, anyway . . .

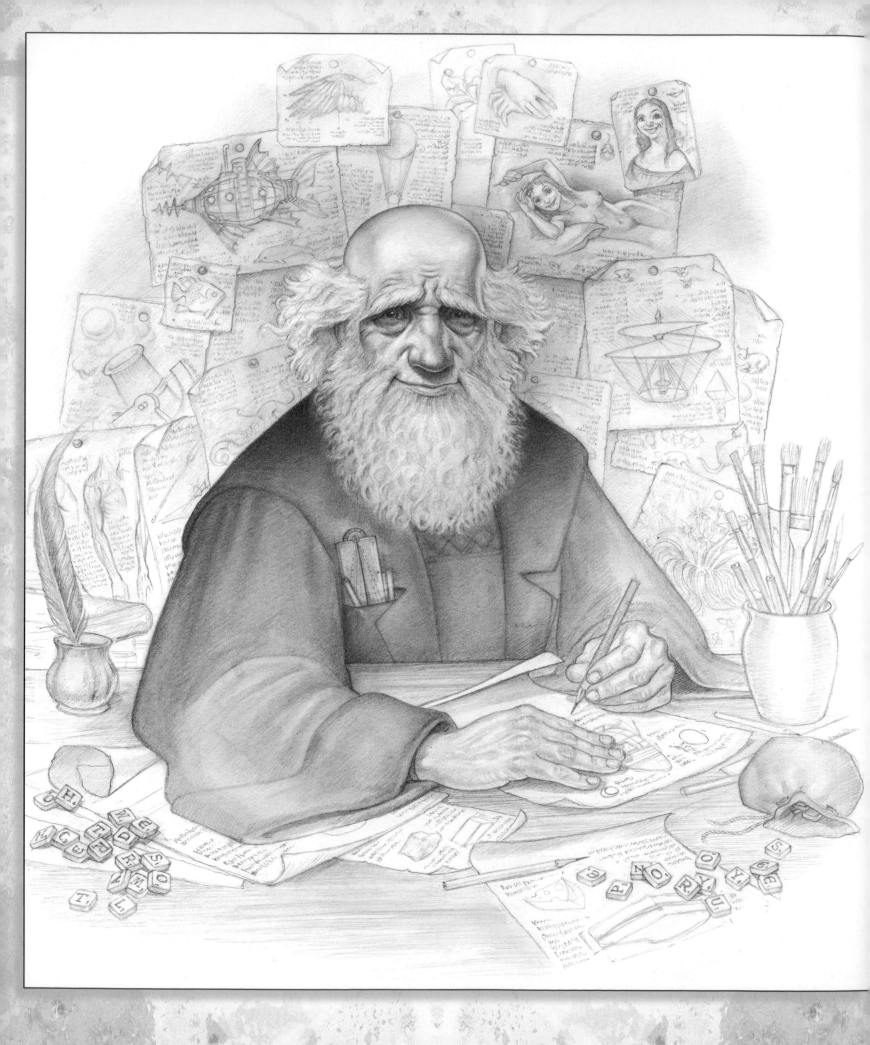

Leonard of Quirm

Leonard of Quirm is obviously the Discworld's Leonardo da Vinci, who is surely a semi-fantastic figure in his own right. He fits into Discworld easily enough; the man who invented lock gates and ball bearings, never mind tanks and flying machines, would have flourished on a world where even space travel is only one incautious step away.

The nice thing about da Vinci as a model is that he *did* throw off ideas like sparks. If some Medici really had wanted a submarine, and had been prepared to pay for it, Leonardo could have built him one. Leonard of Quirm is just Leonardo with the right tools and encouragement. Some of that might well have come from Gytha 'Nanny' Ogg, witch and lady of difficult virtue (that is, she's traditionally found virtue difficult). His two pictures of *The Mona Ogg*, past and present, and his sketch for a work that *very coincidentally* is reminiscent of Holman Hunt's *The Hireling Shepherd* do indicate that in his younger days he spent some happy times in Lancre.

(Discworld's Leonard has a little bit of Sir George Cayley added, too. He was *the* genuine father of aeronautics; he worked out the science, did the maths and only failed to build the world's first man-carrying flying machine because the internal combustion engine wasn't invented until after his death. He *did* investigate the possibility of a engine powered by gunpowder, however – just like Leonard.)

And so, as the sun sinks slowly over the Rim…

… we say farewell.

I'm never sure where Discworld is going next. I used to think it was fantasy. Now I think it uses fantasy, making me a fantasy writer in the same way that Donald Westlake or Carl Hiassen are crime writers. Anyway, who cares? Writers shouldn't think about that sort of thing.

 I said at the start that it had always been visual to me. It seems to be that way to the readers, too. I've lost count of the Discworld costumes I have seen and, for that matter, the number of Discworld plays that have been and are being performed around the world, on every continent, including Antarctica (by the Australians, I understand). There are theatre groups out there that are working their way though the entire canon. People see Discworld. Perhaps we don't need the movies. Perhaps the books come with the movie built in.

Terry Pratchett

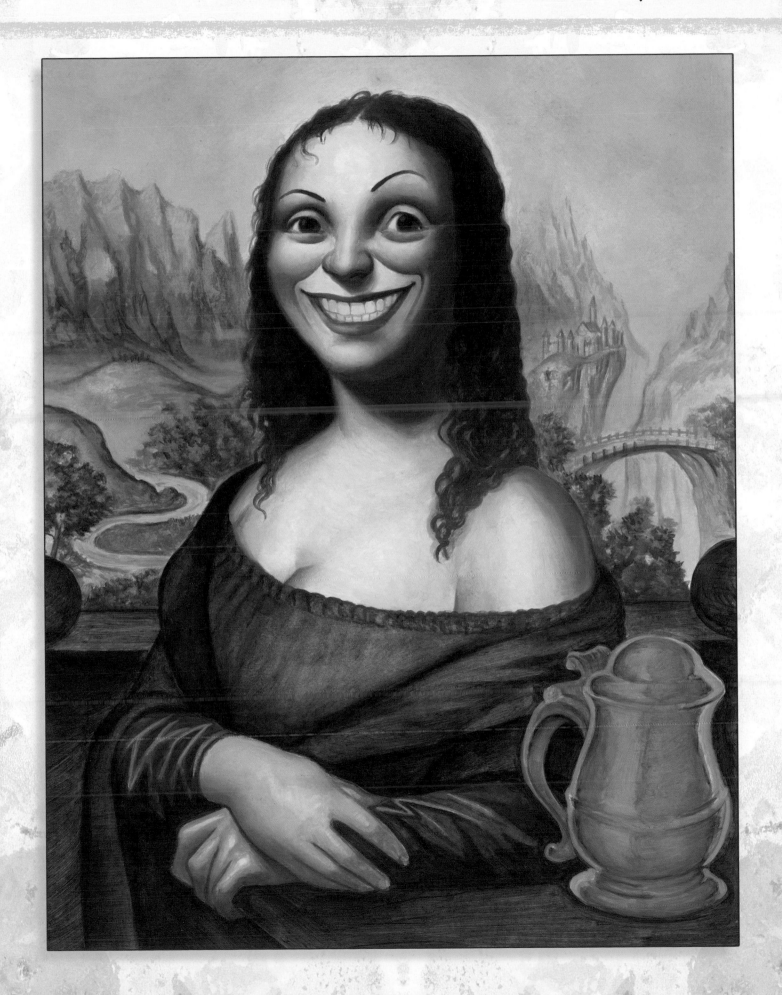

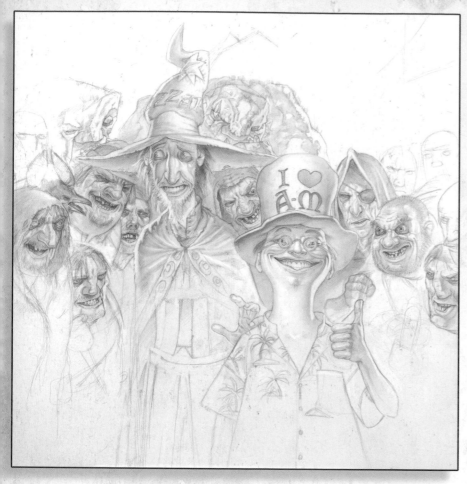

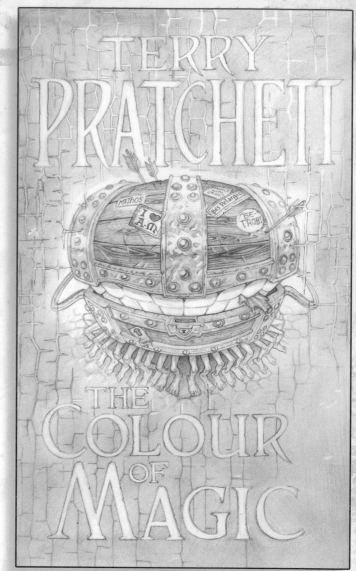

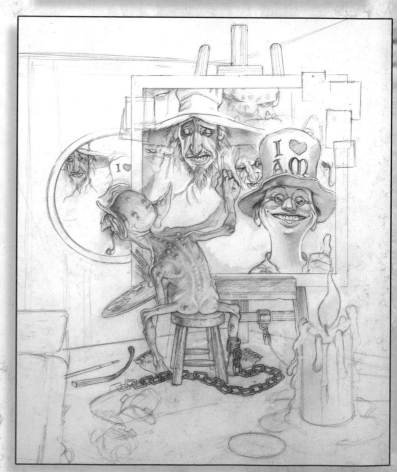

Possible visions of the future, or ghosts from the past. The search for new cover designs never ceases. Do graphic covers work best, or would something iconic be better? Are we moving with the times, or are they moving with us?

They may happen, or perhaps they didn't. The future is a closed book . . .

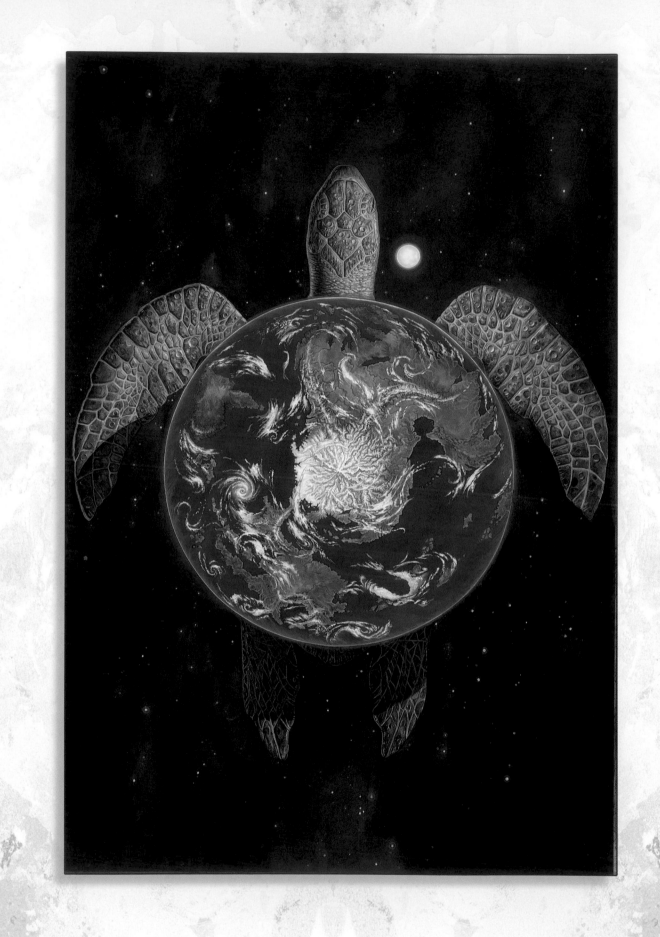